THE ENTHUSIAST'S GUIDE TO iPHONE PHOTOGRAPHY

63 Photographic Principles You Need to Know

SEÁN DUGGAN

THE ENTHUSIAST'S GUIDE TO iPHONE PHOTOGRAPHY: 63 PHOTOGRAPHIC PRINCIPLES YOU NEED TO KNOW

Seán Duggan

Project editor: Maggie Yates
Project manager: Lisa Brazieal
Marketing manager: Mercedes Murray
Copyeditor: Maggie Yates
Layout and type: WolfsonDesign
Cover design: WolfsonDesign
Indexer: Maggie Yates
Front cover image: Seán Duggan

ISBN: 978-1-68198-358-5
1st Edition (1st printing, December 2018)
© 2019 Seán Duggan
All images ©Seán Duggan unless otherwise noted

Rocky Nook Inc.
1010 B Street, Suite 350
San Rafael, CA 94901
USA

www.rockynook.com

Distributed in the U.S. by Ingram Publisher Services
Distributed in the UK and Europe by Publishers Group UK

Library of Congress Control Number: 2018930685

For my daughter, Fiona.

Your love, kindness, humor, and creativity
bring so much light into my life!

As you follow your path in this world,
may you always find the sweet light,
in photography and in life.

CONTENTS

INTRODUCTION

Photography has been around for just under 200 years. As both an artistic and technological medium, it has seen a lot of changes in that time. The advent of the iPhone in 2007 is one of the more recent developments. The iPhone has changed the way we take photos, how we creatively reinterpret them, and how we share our images with the people in our lives and the world. It's a camera, a digital darkroom, and a publishing platform (oh, and it's also a phone!). It has democratized photography by making it widely accessible, similar to the groundbreaking Kodak Brownie camera, which introduced easy snapshot photography to the public in 1900. The camera phone in general, and the iPhone in particular, is one of the most exciting and revolutionary things to happen to photography.

That's what this book is all about: the intersection of the iPhone in your purse or pocket and the world of photography. Specifically, it's about learning how to take advantage of the technical possibilities the iPhone camera offers and understanding how to use the many available photo apps to make better photos. Though this book is about exploring and explaining the capabilities of this technical device, it's more about the photography than it is about tech.

WE'LL BEGIN WITH an overview of some of the creative potential of this very capable camera. We'll take a look at all of the controls in the native iOS camera app (and a few other camera apps) and how to use them to influence the appearance of your photos. With these skills, you'll be able to capture a scene the way you envision it rather than settling for what the camera gives you.

After this important foundation, we'll move into chapters on composition, light, and creative explorations. Photography is about looking and seeing, both in terms of how you frame a shot and understanding how different types of light in a scene will affect the image—and how you can work with the light to make more effective photos. The last part of the book covers the video features of the iPhone, sharing your photos with family and friends through social media platforms, photo cards, books, and prints, as well as some insights on processing your images in a range of photo apps to improve them and reinterpret them through creative enhancements.

Photo apps are a big part of iPhone photography. I'll certainly be referencing many apps that offer a wide range of technical and creative possibilities, but this is not a step-by-step "recipe" book for creating specific effects in different photo apps. Instead, my approach is to provide information and examples, showing you what is possible with certain camera and processing apps. In some cases, I may even mention some of the basic "dance steps" to create an effect, but the intent is more to show you the path so you can follow it to your own creative discoveries. You can find tutorials on creative app processing at my website: seanduggan.com.

No matter what type of photos you like to make, my hope is that this book will open your eyes to the wide range of photography and image-making possibilities the iPhone offers. Through the application of fundamental photographic principles, as well as those more specific to the camera that's always with you, you'll be able to create more effective and meaningful images.

— Seán Duggan

1

THE BIG PICTURE

CHAPTER 1

iPhones are amazing devices. The list of incredibly useful, fascinating, and just plain fun things they can do is expanding all the time. One of those things, of course, is photography. For all its photo capabilities, however, many people (new users and veterans, alike) find that their iPhone photos remain grounded in the realm of quick and casual snapshots. There's nothing wrong with that, but the iPhone is a tool that is capable of taking excellent images.

In this book, we're going to explore some fundamental photographic techniques and principles that will help you capture great iPhone images. We'll begin with an overview of key concepts regarding what an iPhone camera is capable of, as well as where it may fall short—depending on the type of photos you want to make. This book is more about photography than it is about apps, but in the course of our exploration we'll also look beyond the native iOS Camera app to see how other camera and processing apps can be instrumental in expanding your iPhone photography horizons.

1. YOUR IPHONE IS A CAMERA

ALL JOURNEYS BEGIN with a first step, and the journey that will take your iPhone photography beyond the snapshot starts before you take any pictures and requires only a simple shift in your mindset. It has nothing to do with lenses, image sensors, lighting, composition, photo-processing apps, or accessory gadgets. It has everything to do with *seeing*. By seeing, I am not referring to how you compose a shot (we'll get to that soon enough), but rather how you see your iPhone.

One of my favorite quotes that can apply to many aspects of life (and certainly to photography) comes from the writings of Henry David Thoreau: *"It's not what you look at that matters, but what you see."* Looking and seeing are a big part of photography, and this basic concept is a good place to start.

When you pull your iPhone from your purse or pocket, what do you see? It's an iPhone, of course—a wonderful and very capable pocket computer that lets you stay in touch with family and friends, check your email, catch up on the latest news, track the weather, and explore the internet. It also can serve as a music player, a way to read books and other publications, a gaming device, a way watch movies and TV shows, and, of course, a camera.

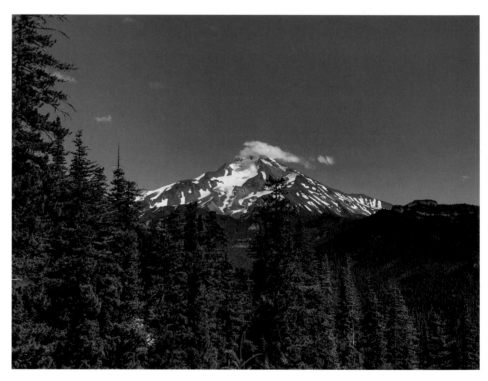

1.1 The built-in telephoto lens on an iPhone 7 Plus allowed me to get a closer view of Mt. Jefferson in the Oregon Cascade Range.

That's what I see when I reach for my iPhone: a camera. I also use it for all its other cool and useful functions, but one of its primary purposes for me is as a camera and digital darkroom in my pocket. This perspective is tied to the fact that I've been a photographer for many years; the camera part of the iPhone is the reason I wanted to get one in the first place. It has its limitations, of course, and we'll be taking a closer look at those later, but it also has a lot in common with more conventional cameras, as well as many advantages not found in other types of cameras.

Changing how you see your iPhone is the first step to making better photographs with it. It's not just a phone that you can take snapshots with; it's an amazing camera that you can use to create meaningful, well-composed, beautiful, impactful, and fully-realized photographs that are just as good as (and sometimes better than) images made by "real" cameras. The iPhone *is* a real camera! Once that all-important shift in perspective happens, it opens the door to curiosity and creative exploration.

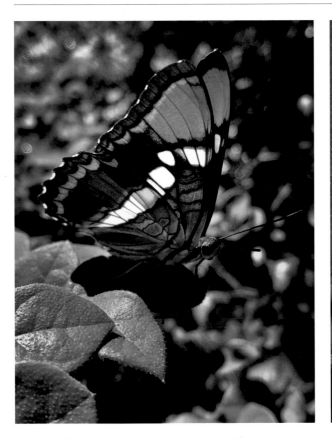

1.2 The iPhone did a wonderful job of capturing the fine and delicate details of a butterfly visiting my garden.

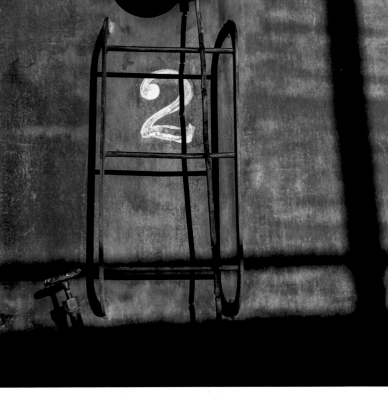

1.3 Shadow play and subtle colors on an old locomotive. Because the iPhone is with you most of the time, you'll start seeing image possibilities all around you.

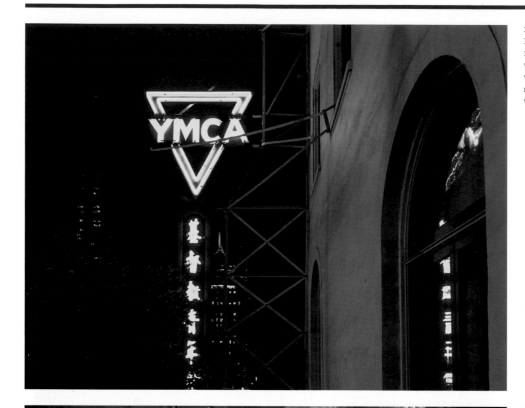

1.4 An evening image taken in San Francisco's Chinatown. Although night photography can be challenging with an iPhone, if you know how to work around the limitations, you can still get very good night images when the conditions are right.

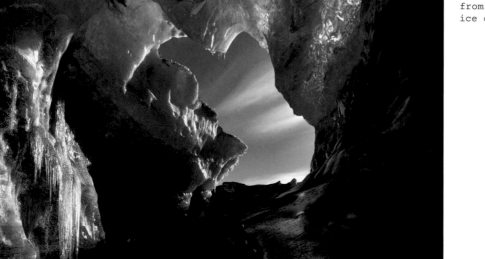

1.5 A panorama image looking out from the entrance to a glacial ice cave in Iceland.

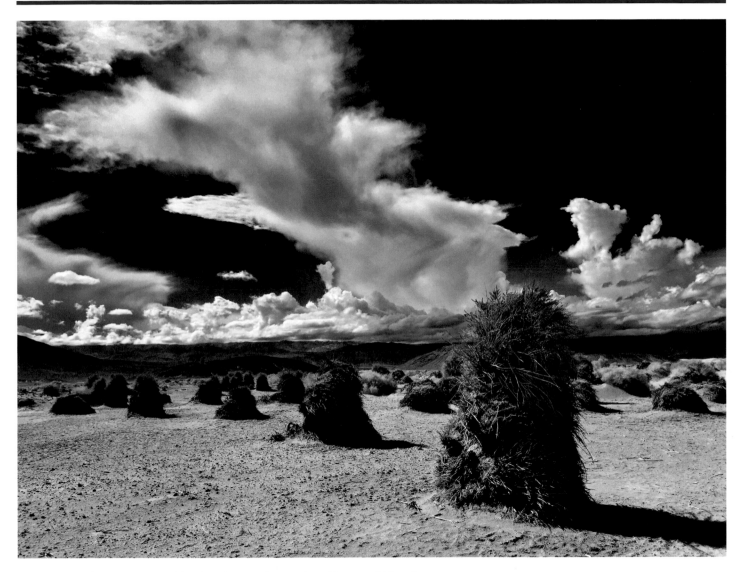

1.6 A dramatic black-and-white landscape in Death Valley, California.
The original photo was captured using the HDR mode in the iOS camera and
the conversion from color to black-and-white was made in the Snapseed app.

2. EMBRACE THE POSSIBILITIES

PHOTOGRAPHY IS ALL about looking and seeing; about searching for just the right combination of light, form, and gesture at just the right moment in time. Some of those moments are unexpected and fleeting, and you might capture them spontaneously; others may be pre-visualized and planned out. We'll be looking at a variety of photographic approaches in this book, but no matter which method you use, or what type of images you prefer, the iPhone is uniquely suited to help you explore the world of photography and your own creativity. Embracing the many possibilities it offers will reveal new creative pathways for image making.

Exercise Your Eye

The more you look, the more you see, and learning to see in terms of what might make a good photo is a big part of becoming a better photographer, no matter what type of camera you use. The most obvious possibility that your iPhone provides is one of simple opportunity and proximity. Likely it is with you, or close by you, most of the time. Having a camera with you means you can immediately act on the impulse to make a photo when something catches your eye. In terms of learning to see and discovering which approaches yield satisfying photos, having a camera with you is important so you can pursue different photo ideas (**Figure 2.1**).

2.1 In photography, as with so many creative endeavors, one idea often leads to another, which leads to another, and so on. Having a camera with you makes it much easier to act on sudden photographic impulses, or follow a new idea. Who knows what new visual destinations you may discover!

License to Explore

The license to explore means that no matter where you find yourself, with a camera close at hand, you will be seeing with a photographer's eye. This is your super power! Learn to embrace it and see where it takes you. Even subjects and locations that are not picturesque or beautiful in a traditional sense can reveal their own type of beauty when you're looking for a photograph. I cannot tell you how many out-of-the-way places, odd little side streets and alleyways, or unremarkable paths I've made a point to explore, simply because my iPhone camera was pulling me along. Frequently in those unremarkable places, I've been fortunate enough to see remarkable things (**Figure 2.2**).

Creative Explorations

The iPhone is both a camera and an image-processing platform. Beyond giving you the opportunity to take photos conveniently, it also lets you immediately process those photos and explore ways to improve, enhance, or radically transform your images. The ability to take a shot and then process it right after you take it, before you leave the location, is the photographic equivalent of plein air painting, in which an artist sets up an easel in the landscape and paints the scene as they experience it. For some ideas, trying out a quick creative treatment on the spot may reveal that you need to take the photo in a different way to achieve the look or effect you have in mind. One afternoon on the beach, for example, I took and initially processed the simple double-exposure blend in **Figure 2.3**. After photographing the man in the water, I shot a series of images looking straight down at the surf until I captured the advancing water in the way that best matched the sky area above the man.

2.2 You never know what you'll find around the next corner.

2.3 After photographing the man in the surf, I knew that I could easily blend another image into the blank area of the sky. The simple blend was made in the Union app, with some customized sepia toning added in Snapseed.

Be Ready for the Moment

One of the things that iPhone cameras have brought to our world is the ability to document the fleeting moments in our lives, no matter how ordinary, or extraordinary, they may be. Having an iPhone in your pocket or purse means you can be ready to capture the unexpected and serendipitous moments that cross your path, whether it's a bright splash of color when you least expect it (**Figure 2.4**) or transcendent scenes that are magical and wondrous (**Figure 2.5**).

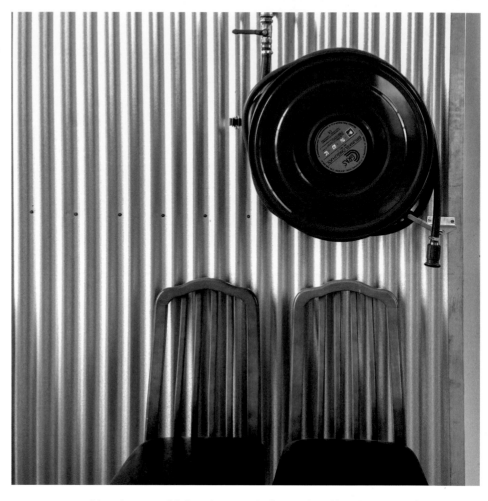

2.4 In a corridor in a small hotel, two chairs and a fire hose provided an interesting arrangement.

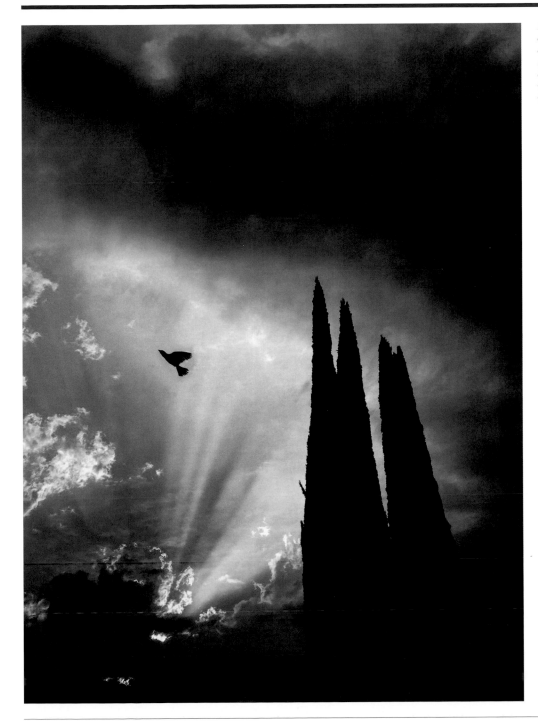

2.5 The photographic serendipity of fleeting moments: On an otherwise ordinary street, the sky did something quite extraordinary, and at the instant I took the photo, a bird flew through the scene.

CAMERAS ARE A bit like cars in that they're based on constantly evolving technology, they come in different sizes, and they have different capabilities. No one type of camera is perfect for every use, and the same is true for cars. I have a mid-size SUV that is great for the mountains of California where I live; it has high clearance and 4-wheel drive, it's good for driving in the snow, and I can pack a lot of stuff into it. But when I take it into San Francisco, finding an on-street parking space that I can fit into is a challenge. A smaller car would be much better for city driving, but it would lack some of the features I appreciate (and need) in my SUV.

As cameras, iPhones have much in common with other types of digital cameras, but in certain respects, they are also very different. Understanding the capabilities of a camera will help you make the most of what it does best. Knowing the limitations of a camera will allow you to modify your expectations for photo tasks it's not well suited for. With that in mind, let's take a look at some of the main technical limitations of the iPhone camera.

Lens Focal Length

The most common limitation you're likely to run into on a regular basis is the fact that an iPhone lacks a zoom lens for telephoto shots. The basic lens is good for wider-angle shots that take in a lot of a scene or for photos where the subject is relatively close by. It's not that great if you want to get a shot of something that is farther away, such as wildlife subjects in the distance. Beginning with the iPhone 7 Plus, some iPhone models have dual cameras that offer a second lens with a portrait focal length, but that's still not ideal for getting a closer shot of distant subjects. The images in **Figure 3.1** show two iPhone views of a pileated woodpecker in my yard. In the wider shot, the bird is barely visible; even in the shot made with the portrait, or moderate telephoto, lens of the iPhone 7 Plus, the bird is still fairly small in the frame.

The iPhone has a digital zoom feature, but it is not the same in terms of quality as an optical zoom, like you might find on a compact camera with a built-in zoom lens or a larger camera that accepts interchangeable lenses. With an optical zoom, closer, tighter framing is possible from the glass elements in the lens that magnify the scene. A digital zoom feature is just a software enlargement of what is seen by the basic wide-angle lens (think of cropping in on just the center of a photo). Enlarging a digital image through software interpolation can lead to a loss of sharpness and detail resolution. With a significant amount of digital zoom, the image quality will be much less than if the same shot was taken with an optical zoom lens (**Figure 3.2**).

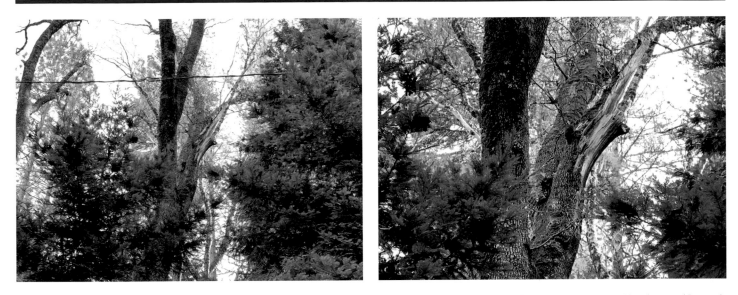

3.1 The image on the left was shot with the normal wide-angle lens in an iPhone 7 Plus. (Yes, there really is a pileated woodpecker in that tree!) The image on the right was shot with the portrait, or moderate telephoto, lens.

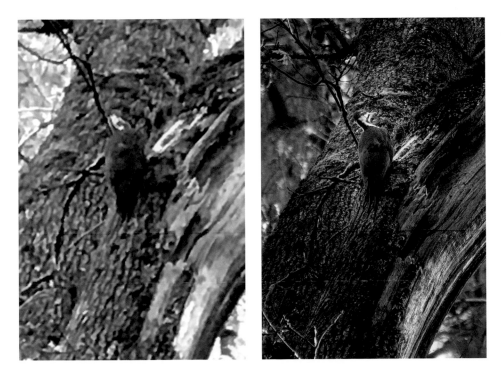

3.2 The image on the left is a cropped section of a digital-zoom photo made with the iPhone 7 Plus (12 megapixels) using the portrait lens (DSLR equivalent = 57mm). After switching to the portrait lens, I used the on-screen zoom slider to artificially "zoom in" for a closer view, but the quality of the interpolated digital zoom was very disappointing. The image on the right shows a cropped section of the same scene made with a 22-megapixel digital SLR with a 135mm lens.

Creating a Shallow Depth of Field

Depth of field refers to the area of an image that appears in focus. In landscape photos, it is common to have a lot of depth of field from the close foreground to the far background. In a shallow depth-of-field shot, the background behind the main subject is often rendered as an indistinct, creamy blur that is not only very pleasing, but also very effective at removing visual distractions from a scene (**Figure 3.3**).

The character of the depth of field that is created by a camera and lens is influenced by three factors: the focal length of the lens and how close it is to the image sensor or film; the size of the image sensor or film; and the aperture of the lens. The very small image sensor in iPhones, as well as the sensor's closeness to the lens, means that they cannot optically create the classic look of a shallow depth of field that is easy to do with traditional cameras. This is true even though the aperture for the standard wide-angle lens on the iPhone 7 and later is $f/1.8$, an aperture that would normally create a pleasing, shallow-depth-of-field effect with a DSLR (**Figure 3.4**).

The good news is that the advent of computational photography in iPhones with dual cameras allows those models to use a special Portrait mode to create a live, software-generated, shallow-depth-of-field effect that can work well for some subjects, particularly portraits (**Figure 3.5**). It's not the same thing as true optical blurring, and there is some subject matter that can present challenges for this software-based, shallow depth of field, but it's a welcome addition to the imaging toolkit for some scenes. We'll examine using the Portrait mode in a later chapter.

Low-Light Photography

Just as the small sensor and lens in the iPhone affect shallow depth of field, they also can affect the ability of the camera to make a good image in low-light conditions. There are two main factors that can impact how well a camera does in low-light situations: lens aperture (the opening that gathers light) and the size of the image sensor.

Unlike other types of cameras, in which lens aperture can be changed (either automatically or by the photographer), the lens aperture in an iPhone is fixed. In the iPhone 6 and 6S, the aperture is $f/2.2$. In the iPhone 7 and 8, the aperture is $f/1.8$ for the wide-angle lens and $f/2.8$ for the telephoto lens in the Plus models. The iPhone X has the same $f/1.8$ aperture for its wide-angle lens but offers a slightly wider aperture of $f/2.4$ for its telephoto lens (**Figure 3.6**).

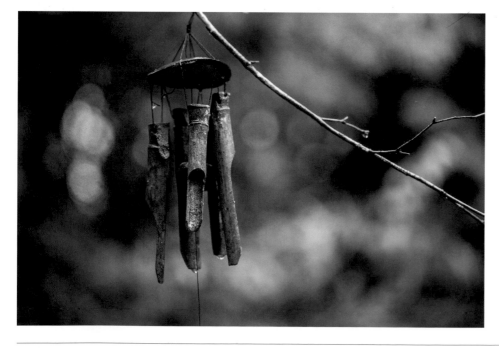

3.3 The wind chimes were photographed with a full-frame sensor digital SLR and a 100mm lens set to $f/2.8$. The wide aperture, combined with the focal length of the lens and the size of the image sensor, creates a very pleasing, shallow depth of field that removes all the distractions from the busy background.

3.4 Two iPhone 7 Plus shots of the wind chimes seen in Figure 3.3. The image on the left was taken with the wide-angle lens, and the image on the right was made with the portrait lens. The lack of shallow depth of field results in a very distracting background that competes with the subject.

3.5 Two versions of a portrait image made with an iPhone 7 Plus and the Portrait mode available on dual-camera iPhones. The first shows Portrait mode blurring applied to the image. In the second example this effect has been turned off in the Edit section of the Photos app.

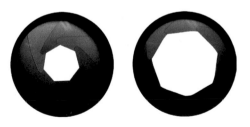

3.6 The bladed aperture of a traditional camera lens (but photographed with an iPhone!). The smaller opening on the left is $f/2.8$. The larger opening is $f/1.8$.

In terms of low-light photography, you'll get better results with the wide-angle lens than with the telephoto, because the larger aperture gathers more light and the camera can use a faster shutter speed. Slower shutter speeds in low light can lead to blurring due to camera motion (**Figure 3.7**).

The physical size of the image sensor is important, because a larger sensor can have larger pixels, which are more efficient at gathering light. Because of their compact forms, iPhones have very small image sensors. This results in photos where the speckled pattern of noise is much more noticeable, and potentially more objectionable, than it is in a photo made with a larger sensor (**Figure 3.8**).

This doesn't mean that you can't photograph in low light or that the photos will always be bad. For example, you can make really interesting night photos with an iPhone (**Figure 3.9**). Knowing the limits of the camera's performance in low light can help you work around them, or realize when the camera is not ideal for specific conditions. We'll be looking at night and low-light photography in more detail later in the book.

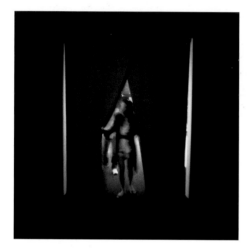

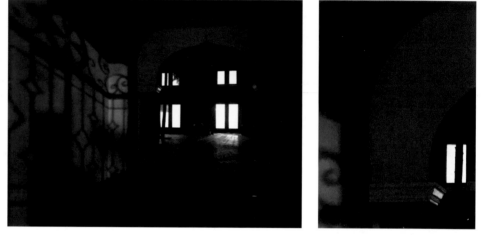

3.7 In this room, the light levels were very low and the iPhone camera had to use a slow shutter speed of 0.5 seconds for the shot. The slower shutter speed blurred the woman entering through the curtain. Although in many shots this might be seen as a defect, in this case I feel that the blur adds a bit of mystery to the scene.

3.8 The entrance to a courtyard, shot with the wide-angle lens of an iPhone 7 Plus that was steadied on a metal gate. Existing ambient lighting created an interesting scene with colorful accents and shadows. Some noise is noticeable when the photo is magnified for a close view (right), but at normal viewing distance it is not objectionable.

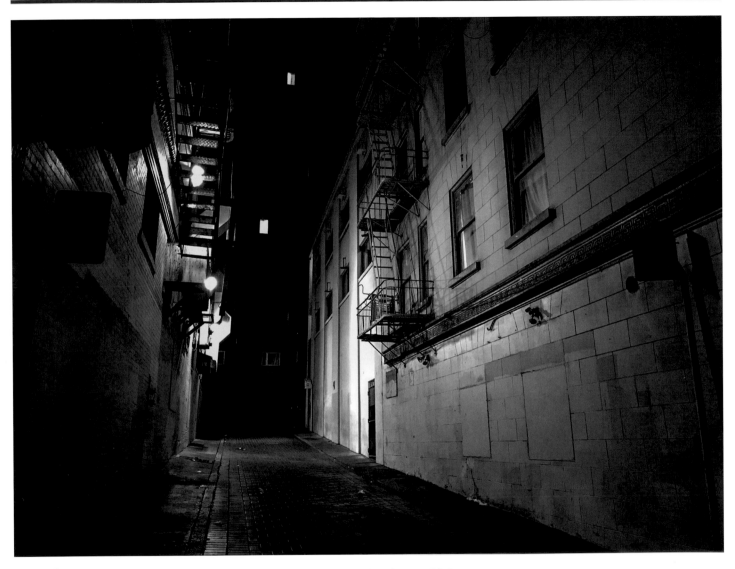

3.9 City locations often provide plenty of artificial illumination to light up your night shots, as seen in this image of an alley in San Francisco.

4. FIVE ESSENTIAL PHOTO APPS YOU NEED

ONE THING THAT puts the iPhone in a different class from other cameras is that it is also a very capable image-processing platform. This is fundamentally a different paradigm from using more conventional cameras, where you don't work on the images until you've downloaded them to your computer. With the iPhone, or any smartphone, you can improve, enhance, or re-interpret a photo right away, as well as share or publish it.

The wide range of quality photo apps available for iOS are one of the best things about iPhone photography, and there's no getting around the fact that you will be using apps to process your photos. This is not an app-centric processing book that offers in-depth tutorials for how to accomplish specific looks, but I will be mentioning certain apps throughout the book as they pertain to certain topics or types of photography.

The types of apps you use will vary depending on the type of photographs you like to make, as well as your own creative sensibilities in terms of how you like to process images. The very nature of apps, and the fact that they are developed by different people, mean that there is no one app that will meet all your needs—but there are a few that come close. There are also some that do specific things very well. In addition to the apps that I'll be referencing throughout the book as they relate to specific effects or types of processing, here is a short list of some of the go-to photo apps that I use on a regular basis.

The iOS Photos App

You already have the Photos app: It comes installed on your iPhone. This is where you go to view your photos, either by the date- and location-based views, or in the albums view, where you can create albums based on criteria that make sense to you. You can also create photo Memories here in the form of slide shows or movies, complete with titles and music (or have the iPhone do it for you automatically), and you can use iCloud Photo Sharing to create shared albums that multiple people can view, comment on, and contribute to.

In terms of making your images look better, the Photos app also has some very decent overall image-editing capabilities that you can access by tapping Edit when you're viewing a photo (**Figures 4.1** and **4.2**). In addition to cropping your photo and applying one of the nine filter looks, here you can also modify light and color, and settings for black-and-white conversions (the B&W icon). Tap the menu button (the three lines) or the small downward arrow to reveal additional sub-options for each of these adjustments. In all, there 14 ways to apply image adjustments within the three main categories (Light, Color, and B&W), which apply a combination of multiple adjustments using a small image thumbnail-based slider (**Figure 4.3**). Changes are non-destructive for images on your iPhone and can be accessed and modified again, or you can revert back to the original image.

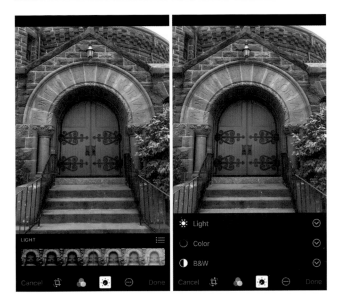

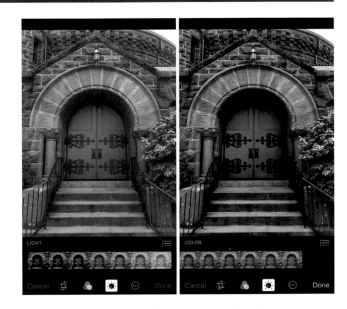

4.1 The Edit section of the Photos app provides some basic, but very capable options for improving your images.

4.3 A before (left) and after (right) view, demonstrating only a few simple adjustments in the Photos app.

4.2 Within the Light, Color, and B&W sections, there are additional options for fine-tuning the adjustments.

Snapseed

If I could only have one processing app on my iPhone, I would probably choose Google Snapseed. It offers a wide range of adjustments, both for overall improvements and for edits that I can apply to specific areas of an image. There are also many options for creative filtering, texture effects, simple portrait retouching, adding lens blur effects, basic text, double exposures, and edge and frame effects. It also has the ability to save the file, or a copy of the file, with edits I can revisit and modify at a later time (**Figure 4.4**).

The incredibly useful Edit Stack feature arranges the different adjustments I make to a photo like layers, or an edit history, and I can go back and readjust my settings, as well as use a mask brush to selectively paint those settings into certain parts of an image (**Figure 4.5**). I can also save my own custom Looks based on edits I've applied to an image, and then quickly apply that same combination of edits to other photos in the future. The custom Looks that I create can also be shared with other people.

Snapseed is a very versatile app that gets better with each update. It's definitely one to have on your iPhone. Oh, and did I mention that it's free?

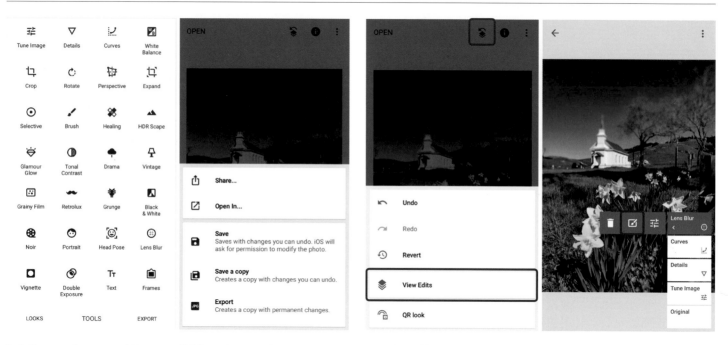

4.4 Snapseed comes with many different ways to adjust or enhance your images, and it includes the ability to save files so you can revisit and modify previous edits, even after the app has been closed.

4.5 The Edit Stack in Snapseed treats your edits like separate layers. You can modify settings across the entire image, or even use a mask brush to paint the edits onto to specific areas of the photo.

Touch Retouch

For minor (and sometimes not-so-minor) retouching, my go-to app is Touch Retouch. It provides an Object Removal tool (**Figure 4.6**) and Quick Repair tool that use content-aware technology to intelligently fill in areas with surrounding detail, as well as a Clone Stamp tool for manual retouching tasks. The Line Removal tool alone is worth the price of admission. It does an excellent job of removing wires and power lines from your otherwise pristine photos (**Figure 4.7**).

This app doesn't offer you the same level of control and finesse that you would have with Adobe Photoshop or a similar computer program, but for an iPhone app, it's very impressive. Understanding the nuances of how the different tools work takes some practice, but overall it's a pretty simple app to use. As with any type of image retouching, whether on a mobile device or on a computer, understanding what can and cannot be easily retouched will help you manage your expectations in terms of what is possible with the app. For some retouching tasks, it may make the most sense to handle them on the computer with Photoshop or a similar program.

4.6 Removing a shadow with the Object Removal tool in Touch Retouch.

PhotoSync

If you need a quick and easy way to transfer images from your iPhone to your computer or to other iOS devices, PhotoSync is one of the best apps for this purpose.

If you are using the iCloud Photo Library, your photos will automatically be transferred over Wi-Fi to the Apple Photos program on your computer, but sometimes it's handy to be able to move photos independently of that program ecosystem.

PhotoSync uses Wi-Fi to connect and move your images via a free companion app installed on your computer (all devices need to be on the same Wi-Fi network). You can also send photos to other nearby mobile devices that have the PhotoSync app installed or to a wide range of cloud-based services, such as Dropbox, Google Drive, and Flickr. You can select individual images or a range of photos. The app even keeps track of which ones have already been transferred using PhotoSync (**Figure 4.8**). PhotoSync is an app I use on a daily basis for my various projects. PhotoSync is available for iOS, Android, Mac, and Windows.

4.7 The Line Removal tool in Touch Retouch required only a few moves of my finger to identify this line and remove it from the photo.

4.8 When selecting images to transfer in PhotoSync, a blue border around a thumbnail indicates a photo that has not been transferred by the app. You can transfer images to computers on the same Wi-Fi network via the free PhotoSync companion app; you can also send images to other mobile devices with PhotoSync or to a variety of cloud-based services.

Instagram

One way to practice your craft is by taking a lot of photos. In addition to making your own photos, you can exercise your creative eye and refine your artistic sensibilities by viewing good images by other photographers. Instagram allows you to create and post your images, as well as search and view photographs from millions of users (**Figure 4.9**).

The app has many useful photo-processing features and one-tap filter effects you can apply, but it really shines as a platform for photo sharing. Even if you are new to photography and aren't big on sharing your own images at the moment, the main reason to have Instagram on your iPhone is that it's a very effective way to view excellent photography and follow some truly incredible artists. As you find other photographers to follow and see whom they follow and what images they like, you can broaden your photographic horizons. Partaking of good, quality images on a daily basis is an excellent way to keep your creative saucepan simmering, even if you find yourself too busy for regular image making with your own iPhone.

4.9 You can find me on Instagram as @sduggan. I hope to cross paths with you there!

Share Your Best Shots on Instagram!

Throughout the *Enthusiast's Guides,* you'll find opportunities to share your best shots with the Instagram community. Follow @EnthusiastsGuides and post your images using the suggested hashtags. You can also search those hashtags to be inspired and see other photographers' shots.

2

KNOW YOUR CAMERA

CHAPTER 2

The key to mastering any tool or process is to move beyond merely familiarizing yourself with it and get to the point where you know it really well. This is true whether we're talking about carpentry, cooking, or photography. In photography, you start with the camera, of course, and, depending on what type of post-processing is required, you may use photo apps or other photo-editing software. For some images, other gear may be involved, such as additional lighting, reflectors, or specialized camera stabilization devices. As advanced as all of that sounds, it's definitely possible to take advantage of such additional gear with your iPhone photography.

But it all begins with the camera. Actually, it all begins with the photographer's eye and the impulse to make a picture, but for the practical purposes of gear you hold in your hands, we'll start with the camera. In this chapter, we'll take a look at the essential things you need to know to move beyond tapping that white shutter button in the iPhone camera app, including recognizing potential exposure issues and actively controlling how the reflected light in a scene is captured in a photograph.

5. KNOW THE BASIC CONTROLS

THE NATIVE CAMERA app in iOS is pretty simple. We'll be taking a detailed look at ways to change the exposure shortly. For those who may be new to the iPhone camera, however, let's start off with a quick look at the basic controls.

Note: This book was written using iOS 11 (11.4 to be exact). If you are using an iPhone with an earlier or later version of iOS, there may be some minor differences in how things are laid out in the camera app or in other functionality that is described.

Opening the Camera from the Lock Screen

When the iPhone is unlocked you can open the camera app via its icon, of course, but there are also ways to access the camera from the lock screen.

On any iPhone running iOS 11 you can go directly to the camera by swiping to the left from the right edge of the screen. This method is the fastest way to get into the native iOS camera app from the lock screen.

On the iPhone 8 and earlier, you can also swipe up from the bottom edge of the screen to show the Control Center, where you'll find the camera icon. On the iPhone X, swipe down on the screen from the top-right corner to open the Control Center, and then tap the camera icon there.

On an iPhone X, hard press on the camera icon on the lock screen to launch the camera app. This shortcut will only work if you have 3D Touch enabled in Settings > General > Accessibility (**Figure 5.1**).

5.1 Knowing how to quickly access the camera app from the lock screen means you can start photographing fast if a picture-worthy situation occurs.

Swipe to the left from the lock screen to open the camera app.

Swipe up from the bottom edge of the screen to open the Control Center.

On an iPhone X, hard press on the camera icon on the lock screen.

Camera Modes

The main camera modes are arranged immediately under the viewfinder or image preview. Swipe left or right anywhere on the screen to choose a different mode. You can also tap the name of a mode to choose it.

Swiping to the left will reveal the photo modes: Photo, Portrait (this will only appear if you have a dual-lens iPhone), Square, and Pano (**Figure 5.2**).

To the left of the camera modes are the shooting modes for Video, Slo-mo, and Time-Lapse. Note that when you are in a photo mode, the shutter button is white, and when you are in a Video mode, it is red (**Figure 5.3**). There are some video-specific preferences that are good to know, and we'll take a look at those later in this chapter.

In the lower-right is a button to switch between the rear-facing camera and the front-facing Facetime (selfie) camera. The button for the front-facing camera is not present with the Pano photo mode, the Slo-mo mode, or the Time-Lapse Video mode. In the lower-left is the thumbnail of the most recent photo or video. Tap this to review the shot and see other recent photos or videos in the Camera Roll.

5.2 Change camera modes by swiping horizontally on their names or anywhere on the touch screen. When in a photo mode, the shutter button is white. Portrait mode is only available on iPhones with dual cameras.

5.3 When in a Video mode, the shutter button is red. Each Video mode has a different white border around the red circle.

Additional Options

Along the top of the screen are settings for the flash, HDR mode, Live Photos, Self Timer, and the Live Filters (**Figure 5.4**). When a feature is on, its icon will be yellow. When you turn Live Filters on (the three gray circles in the upper left of the screen), you can choose from nine filter effects to apply to the live view of the scene (**Figure 5.5**). When a filter is applied, the icon for this feature is in color; when the filter is off, the icon is gray. This is a good indicator to be aware of because if you leave a filter enabled, it will continue to be applied to all your shots the next time you open the camera app. Swipe the filter thumbnails on the bottom of the screen back to the first one (Original) to turn the filters off. The Live Filter effects can be removed from an image in the Edit section of the Photos app.

5.4 Additional shooting options at the top of the touch screen offer control over (from left to right) the flash, HDR, Live Photos, Self Timer, and Live Filters.

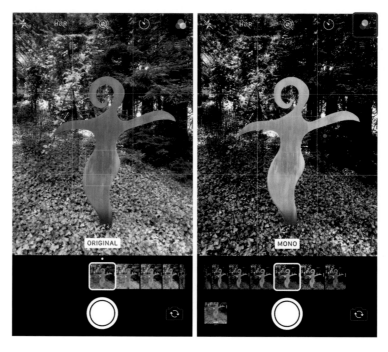

5.5 Live Filters can be applied to the live view of the image as you compose and take your shot. When a filter is applied, the Live Filters icon is in color. Filter effects can always be removed later within the Edit section of the Photos app.

6. UNDERSTAND EXPOSURE TO CONTROL EXPOSURE

AFTER YOU DECIDE what to photograph, and point the camera in that general direction, the first thing to consider as you see the scene on the iPhone's touch screen is exposure. But what is exposure?

Simply put, exposure (in photographic terms) is the result of light reflected from the scene onto the light-sensitive medium (image sensor or film) in the camera. The right amount of exposure to light will result in a "good" exposure that appears to be balanced overall. Not enough exposure will result in an image that is underexposed, or too dark, while too much exposure will lead to a photo that is overexposed, or too light (**Figure 6.1**). Given the interpretive nature of photography, a "good" exposure can certainly be subjective, depending on your own aesthetic or the mood or visual qualities you are trying to convey with the photo.

6.1 Three photos of the same scene, each with a very different exposure: The middle exposure is what the iPhone chose as a "good" exposure (although the highlight detail is still blown out to total white). The other two were adjusted in the camera app to yield darker (left) and lighter (right) exposures.

In severely underexposed images, the shadow detail is dark and blocked up, and in some cases, totally black with no perceptible detail at all. In significantly overexposed photos, the image has a bright and washed-out appearance, and some highlights may be rendered totally white with no hint of the detail. Even in some exposures that are well-balanced overall, bright highlights can still be washed out (**Figures 6.2–6.3**).

To determine the exposure for a shot, camera apps on the iPhone, whether the native iOS camera, or third-party camera apps, all rely on evaluating the light levels in the scene. Sometimes the camera app will do a great job and deliver a well-exposed image, but at other times, the scene may be washed out or too dark. Understanding why this happens is the first strep to knowing how to control the exposure. The key is knowing how your camera "sees," which we'll look at next.

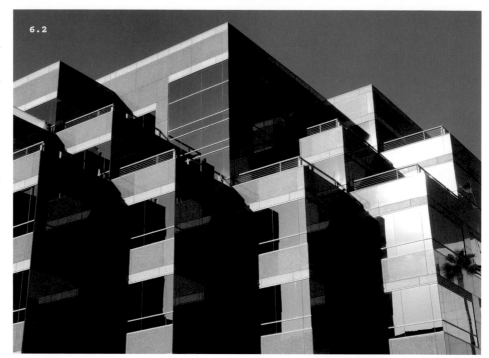

6.2 Bright sun shining on the reflective side of the building causes the highlights to be overexposed with no detail in that part of the image.

6.3 On a rainy day, the highlights on the white stairs at the top of the image are blown out, because the exposure was calculated for the rest of the image, which was darker.

7. UNDERSTANDING HOW THE CAMERA "SEES"

BEFORE WE GET to iPhone-specific camera issues, let's take a short detour to consider how camera light meters work in general and how they come up with their exposure recommendations.

The light meter in your iPhone is not that different from the light meters that have been in cameras for many years. When a digital camera (or any camera with a built-in light meter) "sees" a scene, it provides an exposure recommendation based on the levels of reflected light in the scene. Reflected light is how we see most of the world around us. Reflected light comes from a specific source (the sun, an electric light, a street lamp, light bouncing off the side of a building, etc.) and is reflected off the surfaces we are viewing (a flower, a person, a city street, a landscape, etc.) to our eyes (**Figure 7.1**).

There are some instances when we are viewing direct, transmitted light, such as the sun, the lights of a city at night, or a light bulb in a lamp; and there are times when we see either reflected or direct light that is transmitted through something, such as light travelling through frosted glass or sunlight shining through the leaves of a plant (**Figure 7.2**). However, for the most part we, and the cameras we use, are viewing reflected light.

7.1 In this scene, reflected sunlight coming through windows illuminates a restaurant table. All of the surfaces in the scene are reflecting some amount of light. Lighter objects reflect more light than darker ones.

7.2 This scene contains reflected sunlight (on the forest floor and the trees and grass in the background), direct light (the sun), as well as transmitted light shining through the blades of grass.

Camera light meters measure the brightness of this reflected light and come up with an exposure recommendation for a "good" photo. For the most part, camera light meters do a pretty satisfactory job with exposure recommendations, but it's important to understand that their results are based on simple formulas. Sometimes the resulting exposure is not ideal. Understanding the scenarios where a light meter may be led astray is crucial to mastering your control over the photos you make—with an iPhone or any camera.

At the heart of how camera light meters work is the concept of a brightness value that is equivalent to middle gray, midway between black and white. On a very basic level, most camera light meters are programmed to evaluate a scene and recommend an exposure that averages the reflected light in the scene to a brightness level close to middle gray. For many years now, camera light meters have also analyzed different sections of the scene in the viewfinder, and then combined the separate meter readings for those sections into an exposure recommendation for the overall scene.

7.3 Most of the image in this composition contains snow lit by a bright midday sun, causing the initial exposure to be too dark compared to how the scene really looked.

When a camera light meter "sees" a very bright scene (e.g., a snow or beach scene in bright sunlight), it senses that brightness and wants to underexpose to compensate for it, making the image darker than it should be (**Figure 7.3**). When it evaluates a scene in low light or one with most of the frame comprised of darker subject matter, it's not uncommon for the camera to compensate in the other direction, rendering the image too light and washed out. Understanding how the camera light meter is evaluating different scenes is key to anticipating when it might make an exposure mistake and require you to apply an adjustment.

To see this in action, here is an experiment you can try:

Make sure that the flash in your iPhone camera app is set to off and create three photos of the following objects: a white piece of paper, an object of medium brightness (i.e., a gray sweatshirt), and something that is black or very dark. Fill the frame with the objects so the camera is only "looking" at those brightness levels to determine the exposure. How did your camera do? You can see my results in **Figure 7.4**. With no intervention on my part, the white, gray, and black subjects are all rendered with similar middle-value brightness levels.

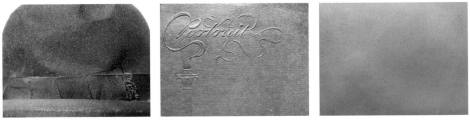

7.4 With the iPhone operating on automatic exposure and with the flash turned off, filling the frame with the three test subjects results in the portrait folder looking correct. The black hat is much too light, however; and the white paper is too dark.

8. ADJUST EXPOSURE TO SUIT THE SCENE

THE CAMERA IN an iPhone is comprised of two very different parts. The hardware includes the lens, the lens-stabilizing features, the image sensor, the flash, and the under-the-hood image processor. The camera app is the software interface for accessing all of this whiz-bang technology for taking and processing the image.

The iPhone comes with its own basic camera app, but you also can purchase many other apps that offer additional controls and functionality not available in the native iOS camera app. In this section we'll concern ourselves with the camera app that comes with your iPhone, particularly how you can set and adjust the basic exposure for a scene.

Set Initial Focus and Exposure

When you compose an image, the camera will automatically select a focus and an exposure based on the scene. The initial exposure the camera gives you is based on how its light meter is evaluating the brightness of the reflected light in the scene. As mentioned in the previous section, darker scenes may appear too light, while bright scenes may appear too dim.

Tap on an area of the scene to set both focus and exposure for that area; a yellow square will appear. This is how you tell the iPhone that you're interested in a specific area of the scene in terms of focus and how the camera should initially set the exposure. If you tap on a lighter area, such as the roof of the snow-covered birdhouse in **Figure 8.1**, that bright area will influence the exposure; notice that areas of the forest in the background are so dark you cannot see much detail in the trees. Also notice that the background is slightly out of focus while

the birdhouse is nice and sharp. Obvious focus differences such as these are typically only noticeable when working with a scene that has a subject that is close to the camera and distant background elements, as in this example.

Tapping on a darker area of the composition will tell the iPhone to determine exposure and focus from that part of the scene. In **Figure 8.2** you can see that the trees are much brighter and the background has sharp focus, while the foreground is slightly out of focus. Since the exposure is being determined by a darker part of the scene, however, the snow on the birdhouse roof is overexposed to total white with no detail.

8.1 Tapping on the roof of the snowy birdhouse on the screen tells the iPhone to focus on that area and to use that level of brightness to set the overall exposure.

8.2 Tapping on the darker trees in the background results in a much lighter scene (with seriously overexposed highlights in the snow) and a different focus point.

Adjust Exposure Separately from Focus

Once you tap on an area to set the initial focus and exposure, you'll see a small sun symbol next the yellow square. When this is visible you can move your finger up and down anywhere on the screen to adjust the exposure, making the scene brighter or darker (**Figure 8.3**). If you have a dual-camera iPhone and the exposure symbol is close to the zoom adjustment, you may inadvertently activate that instead; if this happens, reset the zoom, tap again on the chosen area for the exposure, and drag somewhere else on the screen to adjust the brightness.

With this simple gesture you can dial in just the right amount of exposure based on how you want to capture the scene. This is also useful if you need to set a specific area for the focus, but that area is not ideal for setting overall exposure. These two tools—tapping to set focus and exposure, and dragging up or down to fine-tune the exposure—are powerful for getting the exposure you want, rather than settling for what the camera gives you.

Using Focus and Exposure Lock

The focus and exposure you set using the previous methods will stay applied for a few seconds, but will then reset to what the camera thinks is best. Needless to say, this can be very frustrating if you're taking time finding compositions for the scene, and you have to keep resetting the exposure. To get around this, you can lock the setting by pressing and holding your finger on the area of the scene you are using for focus and exposure (**Figure 8.4**). A small yellow banner will appear indicating that AE/AF Lock is set (AE for auto exposure and AF for auto focus).

Once focus and exposure are locked, you can still adjust the exposure by moving your finger up or down on the screen. The adjusted exposure will stay locked (along with the focus), even if you recompose the scene. It will even stay locked with those settings for multiple photos. If you move the camera to find a different composition, however, just remember that the focus is locked for how you initially set it, and it may not be accurate for your new composition. To turn off AE/AF Lock, just tap somewhere else on the screen.

8.3 Tap on the area you want to use to set the initial focus and exposure, and then drag up or down anywhere on the screen to adjust the exposure separately from the focus.

8.4 AE/AF Lock is a handy away to separate focus from exposure and to set an exposure that will not change, even if you recompose the shot or take multiple photos.

9. USE HDR FOR HIGH-CONTRAST SCENES

EVEN THOUGH THE iOS camera app lets you adjust the exposure (as shown in the previous section), you've probably noticed that there are times when it's hard to arrive at a good balance between the very brightest and darkest parts of the scene. In exposing to get the dark shadows looking the way you want, for example, the highlights may be too overexposed or vice versa (**Figure 9.1**).

The human visual system is very good at being able to see details in scenes with very bright and very dark tones, but cameras and image sensors are less accomplished in that area. They are getting better all the time, but they are still far from what we can perceive with the dynamic duo of our eyes and brain. For certain scenes, especially those shot in bright, contrasty light (where a single exposure cannot capture the full range of tonal detail from the darkest to the brightest tones), you'll need to use the HDR mode.

9.1 Scenes with high contrast can present a challenge for a balanced exposure. The darkest areas often have no discernable detail, and very bright highlights can be overexposed, as is the case with the chimney of this apartment building, which is totally white with no detail.

For scenes that contain a wide range of contrast, you can sometimes get a better exposure by using the iPhone's HDR feature. HDR stands for High Dynamic Range. In a photograph, the dynamic range refers to the range of tonal brightness values from the darkest shadows to the very brightest highlights. With HDR turned on, the iPhone will quickly shoot three exposures of the same scene (it's fast, but it's still a good idea to hold the phone as steady as possible, or stabilize it in some other way if possible). Each exposure is biased towards a different part of the tonal range, so detail in both the dark and bright areas is captured. The three exposures are then combined into an image that contains a wider contrast range than could be captured in a single shot.

In the iOS camera app, tap HDR at the top of the screen (or the left side if you have the camera in a horizontal position). You can set HDR to Off, On, or Auto. With the Auto setting, the iPhone will make the call as to whether a scene might benefit from HDR. When HDR is set to Auto, the HDR letters are white. A yellow HDR banner will appear if HDR will be used for the upcoming shot. When HDR is set to On, the letters are yellow in addition to the HDR banner on the screen (**Figure 9.2**).

In the Camera Roll or All Photos view, you will only see two shots: the "normal" exposure and the combined HDR shot, which will have an HDR badge (**Figure 9.3**). The option of whether or not to preserve the normal shot is found in Settings > Camera (**Figure 9.4**).

The benefits of an HDR exposure with the iOS camera are most noticeable in scenes where the sky in the normal shot is

9.2 The three options for HDR, from top to bottom: Off, HDR set to Auto, and HDR set to On.

9.3 HDR exposures are identified with a badge when viewed in the Camera Roll or All Photos view.

9.4 The normal exposure is saved by default. This can be controlled in the Camera Settings.

overexposed; it will generally look better in terms of detail in the HDR shot (**Figure 9.5**). Scenes that have really bright highlights will usually have better highlight detail in the HDR shot, as can be seen in the reflection on the top of the church tower in **Figure 9.6**. Dark shadow details can also be improved by using HDR (**Figure 9.7**). Keep in mind that the results you get with the HDR mode will vary depending on what area of the scene you've tapped to set the initial exposure. In some cases, you may still end up with very dark shadows or overexposed highlights based on the tonal area the normal shot is being exposed for.

If you've ever used an HDR process with bracketed exposures from digital SLRs, in which the different shots are combined on the computer in dedicated HDR software, the iPhone version may be a bit disappointing. It's really more of modest exposure balancing than a full-on HDR process. There are other apps for iOS that offer more options for both capturing and processing HDR images. We'll take a look at some of those later in the book.

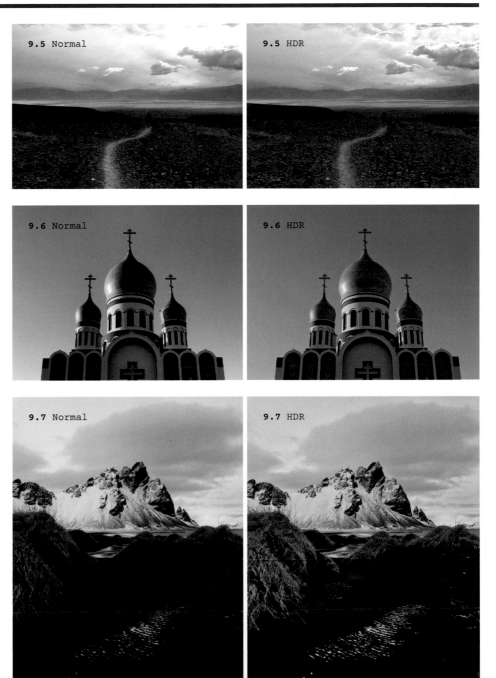

9.5 In this photo taken in Death Valley, the sky in the normal exposure is blown out in the upper-right corner. In the HDR version, the details in the bright clouds are preserved.

9.6 In the HDR exposure, there is much better detail in the bright sunlight reflecting off the tower of the church.

9.7 In this landscape from Iceland, the subtle shadow details are more visible in the HDR shot.

10. TO FLASH OR NOT TO FLASH...

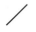

NEXT TO THE HDR setting in the iOS camera app is the flash. Like HDR, this can be set to Off (my preferred setting), On, or Auto. I usually leave the flash set to Off for a couple of reasons. The primary one is that I am not fond of the light it creates. It's okay in situations when there's no other way to take the photo, but as light goes, it's not that interesting. If I can figure out a way to provide illumination some other way, I will (**Figure 10.1**).

The other reason I like to leave it set to Off is that I don't like to be surprised by the flash going off unexpectedly, which can ruin a moment if you're trying to get a natural shot without drawing attention (**Figure 10.2**). If a quiet approach is your aim, be sure to turn the sound off on your iPhone so you can take photos without the shutter sound.

Still, there will be those times when you have to use the flash. Keep in mind that the reach of the flash is not that far. It's good for subjects that are moderately close, but don't expect it to light up anything too far away.

10.1 The same scene photographed with and without flash. I had to make sure the camera was steady for the non-flash shot, but the lighting is more pleasing and natural.

10.2 Quiet moments such as these can be ruined when a bright camera flash disturbs the subject. This is why I leave the flash turned off most of the time.

11. CAPTURE ACTION WITH BURST MODE

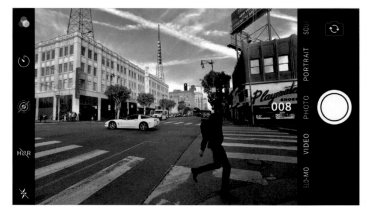

SOMETIMES WHEN TRYING to get a photograph of fast moving subjects such as a dancer, an athlete, or your dog running crazy circles in the living room, it can be tricky to get the timing just right to capture the shot you want. To help you with such scenarios, the iPhone has a cool feature called Burst mode.

Activating Burst mode is as simple as pressing and holding the shutter button. You'll see a number counter quickly flash on the screen telling you how many shots you've taken, and if you have the sound turned on, you'll hear a fast "camera shutter" sound (**Figure 11.1**). If you keep your finger pressed down for a while, you can easily fire off a lot of shots, so just be aware of that number. If you normally have a "slow" shutter-button finger, chances are good that you've already inadvertently run into Burst mode.

Photos taken in Burst mode have their own album so you can easily find them. In that album and in the Camera Roll, the small thumbnails look like a stack of photos. When you open one to see it larger, it will have a label identifying it as a Burst and how many photos it contains. You will only see one photo in the sequence initially. Tap Select under the image (or above the image if the camera is positioned horizontally) to see the entire sequence (**Figure 11.2**).

You can swipe horizontally on the large photos to scroll through them, or you can swipe on the small filmstrip underneath to quickly review the images. This action displays the different photos in a way that looks like a short movie clip. Tap on images to select them as ones to keep, then tap Done. You can choose to keep all of the photos in the Burst, or only the selected favorites. If you keep all of the photos, the selected favorites are added as separate photos to the Camera Roll, and the full Burst sequence is still in the Bursts album. If you choose to keep only the chosen favorites, the Burst sequence is removed (you can still find it in the Recently Deleted album for 29 days, after which it will be permanently deleted from the phone).

11.1 Press and hold the shutter button to activate Burst mode. A number counter will show how many shots are being taken. For this street photography shot, using the Burst mode gave me several different shots of the man in black crossing the street.

Turning a Burst into an Animated GIF

Apart from photographing action, you can also turn Burst sequences into animated GIFs that can be shared to your social media channels. Unfortunately there is no way to do this from within the iOS Photos app, but there are several apps you can use that will do it for you. GIF Toaster and ImgPlay are two GIF-creation apps that I've used, and both are very capable. They allow you to turn photos, videos, Live Photos, and Bursts into animated GIFs; let you control their speed and direction; and specify whether or not the GIF is set to an infinite loop. GIF Toaster provides additional options for cropping, applying filter effects, and adding text or image banners. Both apps allow for easy sharing to standard destinations on your iPhone and on the Web.

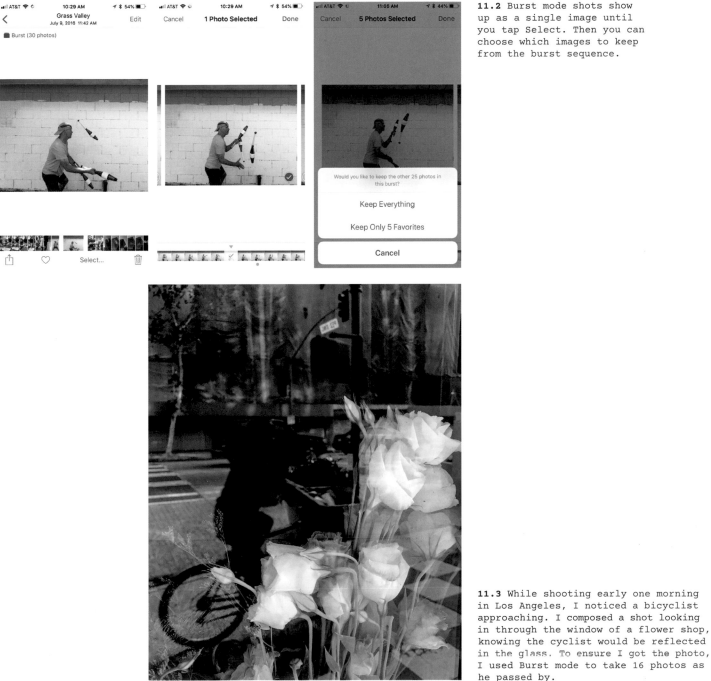

11.2 Burst mode shots show up as a single image until you tap Select. Then you can choose which images to keep from the burst sequence.

11.3 While shooting early one morning in Los Angeles, I noticed a bicyclist approaching. I composed a shot looking in through the window of a flower shop, knowing the cyclist would be reflected in the glass. To ensure I got the photo, I used Burst mode to take 16 photos as he passed by.

12. STRETCH OUT WITH PANORAMAS

SOME SCENES ARE too expansive to fit into the standard rectangular image frame. For those, you can use the iPhone's Panorama mode to capture the wide landscape. With the 12-megapixel camera on the iPhone 6S and later, you can capture panorama images that can contain up to 63 megapixels (**Figure 12.1**).

Horizontal Panoramas
As with most things in the iOS camera app, using Panorama mode is very easy. Select the mode and position your camera in a vertical orientation. An arrow on the left side of the screen indicates which direction to pan the camera when shooting the panorama. If it's more convenient for a particular scene to pan in the other direction, just tap the arrow and it will move to the other side.

Tap the shutter button to begin and start slowly panning in the direction of the arrow. Try to keep the tip of the arrow aligned with the yellow centerline in the pano guide path. You'll see a live view of the pano appearing behind the arrow as you continue to pan across the scene. When you're done, tap the white square to stop the panorama capture (**Figure 12.2**).

Panoramas will be placed in their own album but only if the pano preview extends beyond the halfway point on the screen as

you're shooting it. Shorter panoramas will be in your Camera Roll, not in the panorama album. Shorter panoramas will also not have the panorama badge on the thumbnails.

Vertical Panoramas
Although a horizontal panorama is probably the most common use for this feature,

you can also shoot a vertical panorama by rotating the phone to a horizontal orientation. Instead of panning horizontally, pan vertically to capture a tall, thin image. Vertical panos (some people call them vertoramas) can be an interesting way to capture tall subjects such as trees or buildings (**Figure 12.3**).

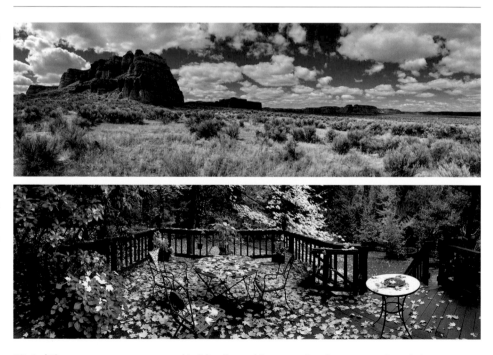

12.1 iPhone panoramas are suitable for wide-open landscapes and quiet scenes close to home.

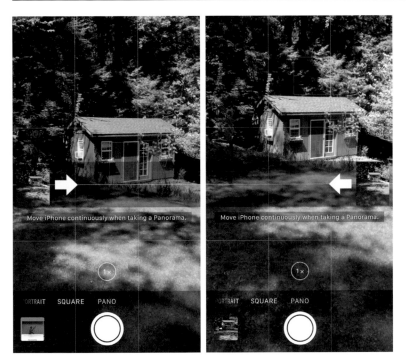

12.2 Hold the phone in a vertical orientation to create a horizontal panorama. Tap on the arrow if you want to pan in a different direction.

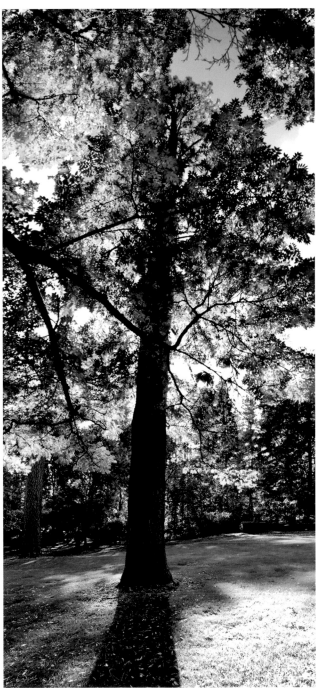

12.3 For shooting vertical panoramas, hold the phone in a horizontal orientation. Look for subjects with a strong vertical presence.

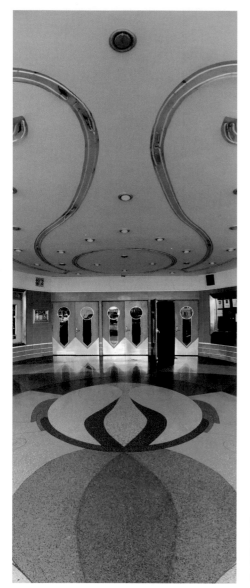

At a certain point, however, be prepared to see some distortion in the image as you arc the phone over your head to capture the highest parts of the subject (**Figure 12.4**).

Look for Foreground-Background Relationships

To spice up your panoramas, look for compositions where you can place a subject closer to the camera on one side and have the rest of the scene as the background. This technique is a preview of some of the things we'll be looking at later in the chapter on composition. The closer, foreground element can be a person or even the closest part of a subject that extends into the background, such as the bridge shown in **Figure 12.5**. Having a closer foreground subject to interact with the background will create a more dynamic composition than a shot where everything is the same distance from the camera.

Play with Motion and Distortion

If a subject moves through the scene as you're shooting a panorama, you could get some crazy results! Since the Pano feature captures slices of the scene as you pan across it, and then blends everything together, the moving subject (a person, a car, your pet cat) is captured in each of those slices as it also passes through the scene. This can create images where the subject in motion is stretched out across the image or is a wild, segmented distortion. It can look very odd and even a bit unsettling, but the results can also be an unexpected and delightful photo serendipity (**Figure 12.6**).

You can also achieve similar results using unconventional camera or panning movements as you shoot the panorama. Try moving the camera in a curving and undulating motion as you pan across a scene (if you go too crazy with your movements the

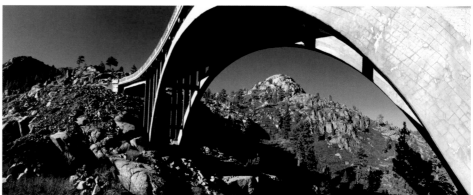

12.4 Not all vertical panoramas need an obvious vertical structure. For this composition of the entrance to an old movie theater, I began by pointing the camera down at the tiled ground in front of me and moved it upward in an arc until I had included the neon lights directly over my head.

12.5 Placing the bridge in the close foreground on the right adds depth to the scene and emphasizes the curved arch of the bridge.

pano will stop because it can't figure out how to stitch the image). The results are hit or miss, but with practice you can get a better sense of what type of motions will work to create an image with just the right amount of interesting distortion (**Figure 12.7**).

Panoramas with obvious distortion are certainly not for everyone, but with a little practice and luck you can end up with quirky (in a good way) images that can be interesting and sometimes quite funny.

You don't have to engage in crazy acrobatics in order to create a panorama with obvious distortion. Any scene in which you are close to a subject that stretches across the entire shot can reveal unexpected distortions (**Figure 12.8**).

12.6 A subject that moves through the scene as you are panning the camera can create strange and delightfully surreal results.

12.7 Moving the iPhone in a curving and undulating motion while panning across the scene in Panorama mode can create results with digital stitching errors that suggest a more abstract interpretation.

12.8 The power line and the white fence in this scene are rendered with an obvious curve, but in the actual location they were not curved the way they appear in the image.

13. PORTRAIT MODE

IF YOU HAVE an iPhone with dual cameras (at the time of this writing that includes the iPhone 7 Plus, 8 Plus, and the iPhone X), the iOS camera app has a Portrait mode. As the name suggests, this is designed for portraiture, but it can be used with other subjects as well. Portrait mode uses the 58mm portrait or telephoto lens to take the photo, but it uses the wide-angle lens to help the camera identify the main subject versus the background. It then creates a depth map to apply real-time blurring to the background.

Blurring the Background with Portrait Mode

With subjects that are clearly distinct from the background, this bit of computational photography works surprisingly well (**Figure 13.1**). For portrait subjects, it creates the type of shallow depth of field that typically can only be achieved in cameras with longer focal length lenses and wider lens apertures (**Figure 13.2**).

For Portrait mode to work, you need to be within 8 feet of your subject. If you're too close or too far away from the subject, you'll see a message telling you this. In low-light

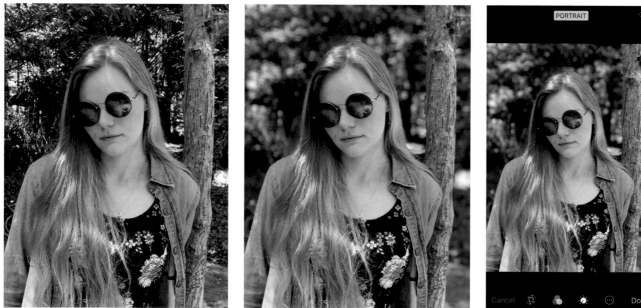

13.1 The same image with and without Portrait mode. The live computational blurring effect works well when there is a clear separation between the subject and the background.

13.2 In iOS 11, the blur can be turned off and on in the Edit section of the Photos app by tapping on the Portrait banner at the top of the screen.

situations, such as at night or in a dim interior setting, you may see a message warning you that more light is required for the photo.

Understand the Limits of Portrait Mode

Since this is an effect that is added to the image, as opposed to actual optical blurring created by a lens, there will be times when you notice errors along the edges of the subject. Understanding what types of subjects and situations are most likely to result in these errors will help you use this feature more effectively (**Figure 13.3–13.5**).

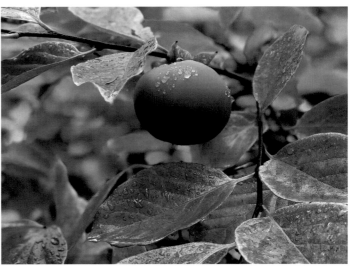

13.3 For a subject with a complex arrangement of near and far elements, the Portrait mode blurring in this photo of a persimmon tree looks pretty good overall. If you look closely, however, you can see minor errors, such as the tip of the leaf closest to the persimmon.

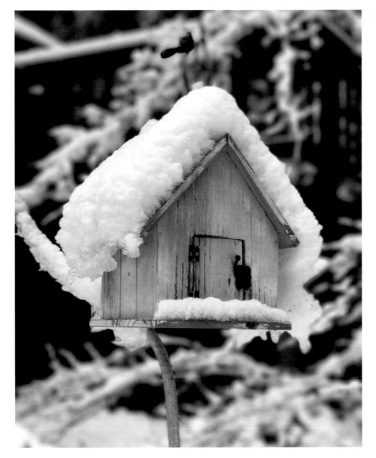

13.4 Portrait mode blurring does a good job simplifying a busy background. The one small error is the hook that the birdhouse is suspended from. If this image had been made with actual optical blurring from a lens, that part would be in focus.

13.5 In this image, Portrait mode has worked well to create a very realistic receding focus from a sharp foreground into a blurry background.

Portrait Lighting Effects

In the iPhone 8Plus and later, you also can access Portrait Lighting effects within Portrait mode. Like the live blurring, these effects are also applied in real time. Tap on the small cube icon to choose from Natural Light (no effect at all), Studio Light, Contour Light, Stage Light, and Stage Light Mono (**Figure 13.6**).

The results depend on the subject you are shooting and how well they are defined from the background. Sometimes the Stage Light effect, which adds a black background, can look a bit unrealistic, but with other subjects it works remarkably well. The more you use this effect, the better sense you will have for what types of scenes and subjects it works with best (**Figure 13.7**)

The Portrait Lighting effects can be turned off and on in the Edit section of the Photos app.

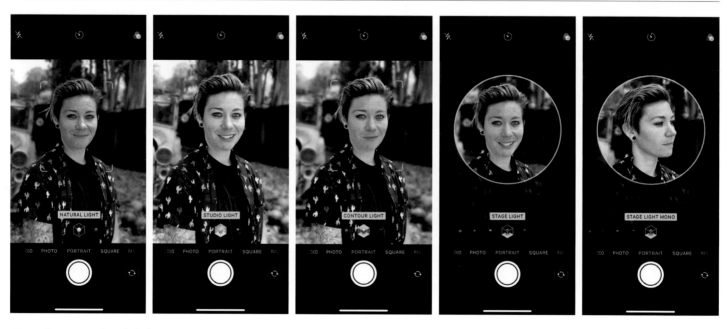

13.6 The Portrait Lighting effects.

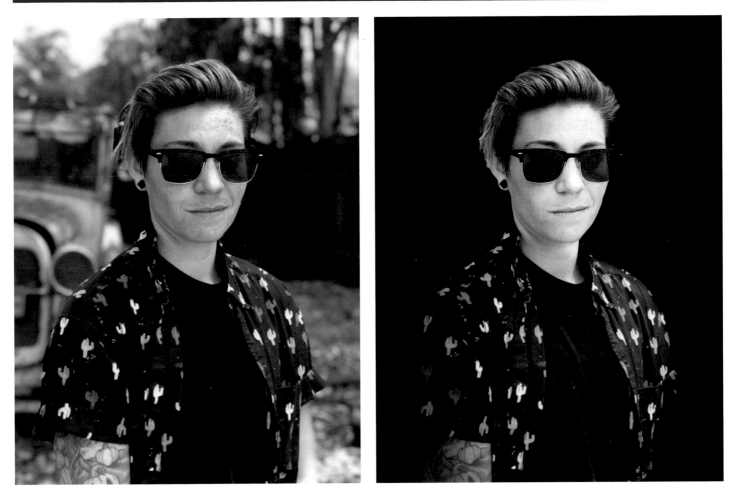

13.7 In this portrait, the Studio Lighting effect (left) is more successful than Stage Light Mono (right), which had difficulty rendering the rough edges of the subject's hair, as well as the light tones of the arm on the right side.

3

COMPOSITION ESSENTIALS

CHAPTER 3

Painters begin with a blank canvas, view the busy and visually-cluttered scene before them, and then choose what to include in their paintings. They control everything in the image and can choose to leave things out of the composition. With photography, we begin with the same real-world scene before us, and must choose what to exclude from the scene to create a visually satisfying composition.

We can reposition very few elements in a scene to create a better arrangement. We can direct a friend to a location with better light or move a still-life subject for a better angle or a simpler background. In most cases, however, the way to change the arrangement of elements in a scene is to frame the scene differently. We can find a new camera angle, use a different lens, change the view with the camera app's digital zoom, or, my preference, move in relation to the subject.

Painters include; photographers exclude. Composition is the conscious act of artful exclusion to arrive at the image you want. The goal of a good composition is to distill a scene to the essential elements needed to portray the subject or tell a story. In this chapter, we'll discuss some essential concepts of photographic composition to help you start seeing potential images in new ways.

14. VERTICAL, HORIZONTAL, OR SQUARE?

ONE OF THE first compositional decisions to make when taking a photo is which basic format, or aspect ratio, to use for the shot. The two primary choices are horizontal and vertical. Many camera apps also offer a choice of other aspect ratios, with the most common additional format being a square. As you're composing the scene, let the subject matter and contents of the scene be your guide (**Figure 14.1**). In most cases you will have a pretty good sense of which format will work best. When in doubt, you can always shoot it in different ways and then decide later which shot you like best.

Shooting Horizontal

Due to how our eyes are positioned on our face, we tend to perceive the world with a horizontal view. Traditional cameras are typically designed in a horizontal format; without consciously rotating the camera to a vertical orientation, this is the most common way to use them. Movies, which we've been watching all of our lives (and which do influence our sense of composition and framing), are presented in a horizontal format. Camera phones throw something new into

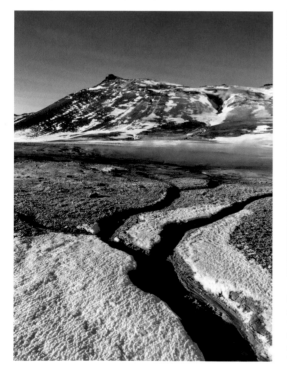

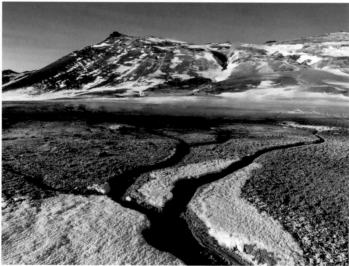

14.1 Many scenes can work well as either horizontal or vertical compositions. In this landscape image, the lines of the water channels fit into a vertical format, but the horizontal format is better suited to showing the landscape, as well as the outer arms of the water channels.

this mix. For most non-camera uses, we tend to hold our phones in a vertical position. Just as rotating a traditional camera to a vertical position requires an extra thought, so too does rotating a camera phone to a horizontal orientation.

The horizontal aspect ratio is a good one to use when the dominant lines in the scene follow a horizontal orientation, such as with a landscape scene or a group photo (**Figures 14.2–14.4**).

14.2 Another term for a horizontal orientation is landscape format, due to the fact that this is an effective way to portray the wide-open vistas often encountered in that genre of photography.

14.3 The horizontal format fits this scene perfectly, showing the three evenly spaced windows and more of the boat than would be possible in a vertical composition.

14.4 The strong horizontal lines in this photo of a small-town movie theater begin with the buildings in the distance. They lead right up to the marquee and the corner building on the left side.

Composing a Vertical Image

The more you photograph, the more you train your eye to see in a photographic way. This includes being able to see when a subject or scene will work best with a vertical presentation. Some scenes are pretty obvious as vertical photos. Look to the elements in the scene for clues. Are there strong vertical lines in the scene, such as trees, tall buildings, or vertical landscape elements (**Figure 14.5**)? Due to the vertical nature of the human form, many portraits also work well when composed in a vertical orientation or portrait aspect ratio (**Figure 14.6**).

Another factor that may influence whether or not you shoot vertical is the end use of the image. Some projects, such as a book cover, magazine page, or vertical poster, might have a specific format. In these cases, you might choose to compose in a vertical orientation, even for scenes that might not "feel" like a good fit for that format (**Figure 14.7**).

Square Format

Even though the iPhone is not limited to capturing images in a square, the square format can sometimes seem like a default format for camera-phone images. In the early days of iPhoneography when Instagram first exploded onto the scene, it limited you to posting only square images. Hipstamatic, another popular iPhone camera and processing app, also offered only square-format

14.5 The strong vertical lines in architectural subjects naturally suggest a vertical composition.

photos for the first few years of its existence.

The only time I shoot in a square format is if I am using an app that limits me to that choice. For nearly all images, even if I can see the possibilities of a square format, I will shoot it as either a horizontal or a vertical and crop it later. This is important because if someone falls in love with an image but they require a rectangular format, turning a square into a rectangle is not going to work without a crop that could compromise the entire composition (see

the sidebar **Cover Your Bases: Shoot Both Ways**).

With equal sides, the square format is ideal for images that have a centered subject or a balanced and symmetrical feel (**Figure 14.8**). It can also work well with patterns, textures, and some instances of leading lines. With certain post-processing edge treatments, the square is also good at evoking the look of vintage photographs.

14.6 Another term for a vertical orientation is portrait format. As the name suggests, a vertical orientation is well suited for portrait subjects. A horizontal format can work well with a portrait if you want to show more of the environment where the image was made.

14.7 This landscape image might not seem like a good fit to be taken in a vertical orientation, but the triangular shape of the dirt road leading into the distance creates a strong vertical shape that visually echoes the similar shape of the two rock cairns. With plenty of room to add text over the sky or the road, this image would work well as a book cover or poster.

14.8 The square format, either photographed that way in a camera app or cropped from a horizontally or vertically oriented photo, works well with many types of subjects and images.

Cover Your Bases: Shoot Both Ways

When I am photographing a scene that I feel will be a strong image, I often shoot it in both a horizontal and a vertical format, even if I am not working on a specific project. Having the photo in both primary formats gives me, and potential editors or photo buyers, more options for how they might want to use the photo (**Figure 14.9**). Also, a good horizontal or vertical shot can be easily cropped to a square format if necessary.

14.9 If the subject is strong and you feel the image offers possibilities for prints or publication, shoot it as both a horizontal and a vertical.

15. LOOK FOR ALTERNATE VIEWS

THERE'S SOMETHING SPECIAL about that first impulse to make a photograph, that initial spark of inspiration when a subject grabs our attention, when we can see the image standing apart from the scene surrounding it. When the "I see a photo" light bulb clicks on, reach for the camera and take that first shot.

If you frame the shot and everything aligns just right, it might turn out to be a really good image. If not, you've gotten that first shot out of your system, and you've opened a door. Step through that door and look closer and deeper to see what other compositional possibilities exist. Ask yourself what other ways you might frame the scene or subject. Can you get closer to the subject? If so, how does that change how it looks within the frame of the viewfinder? How does that change how the subject looks in relation to other elements in the scene? Backgrounds are not the central subject of a photograph, of course, but they can add additional information or visual dynamics to a scene. Move around the main subject and look for new elements that appear in the background (**Figure 15.1**).

Most photos are shot from a standing position with the camera at our approximate eye level. Try to consciously move beyond that default elevation and look for alternate views. How does the scene look if you get down

15.1 Three views of an old theater in downtown Los Angeles: I shot a lot more of this location, but these three, taken in a span of about three minutes, are a good distillation of my photographic interaction with the theater.

closer to the ground? What about placing the camera right on the ground (**Figure 15.2**)? Also try high-angle perspectives by holding the camera above your head and tilting it at a slight downward angle (a selfie stick can help elevate the camera even higher). Is there a nearby staircase or landscape feature you could climb to gain a higher vantage point from which to view the scene?

Finally, if you're moving through a location, whether it's a city street or a trail in the forest, remember to turn around now and then to survey the view behind you. Often, the terrain you've just passed through can look entirely differently when seen with a backward glance.

15.2 A city dog with stylish footwear. Getting down on her level and photographing her from just above the sidewalk resulted in an interesting viewpoint.

16. THE RULE OF THIRDS

AS A GENERAL rule, I'm not that fond of rules when it comes to creativity and art. However, I will concede that there is a rule in composition that can be useful and help you to create more visually interesting photographs. If you've done even the most casual reading on the topic, you've probably heard of it before: the rule of thirds.

Until you learn differently, most beginners tend to compose their images with the subject centered in the viewfinder. While this may be an obvious way to clearly show the subject, in many cases it may not result in the most interesting composition. This is not to say that a centered composition cannot be an effective way to portray a subject; it can, and we'll take a look at that method later in this chapter. But there are many more ways to place a subject within the frame of the viewfinder, and the rule of thirds can help you train your eye to see them.

In the world according to the rule of thirds, the scene is divided into thirds using three vertical and three horizontal lines. The primary compositional principle is that you can create interesting compositions by placing your subject near one of the four intersections of the lines dividing the scene into thirds (**Figure 16.1**). It doesn't have to be positioned right on the intersection—it can just be close.

16.1 The concept of the rule of thirds is based on an imaginary grid that divides the scene into thirds. Placing the subject on or near one of the intersections of a horizontal or vertical line can often result in a composition that is more visually engaging than a centered shot.

In terms of iPhone photography, you may already be somewhat familiar with this compositional concept, even if only on an unconscious level, since many camera apps have viewfinder grid lines that divide the image into thirds (**Figure 16.2**). In most apps, you can turn these off. Often, there are also additional grid overlays for different compositional guides (**Figure 16.3**).

16.2 The rule-of-thirds grid in the native iOS camera app (top) and the Pro Camera app (bottom).

16.3 A menu of different grid choices in the Adobe Lightroom CC mobile app.

17. EXPLORE THE CONSCIOUSLY CENTERED IMAGE

IN A CENTERED image, the subject is placed squarely in the center of the frame. Some traditional cameras encourage this with markings that display a circle in the center of the viewfinder. Because of this, centering the subject is often a default way of framing a shot, rather than a conscious decision based on whether or not this orientation serves the scene and will make a good image.

With some subject matter, consciously using centered framing (as opposed to using it as default) can result in very effective compositions. Centered subjects work well with scenes or locations in which there is natural symmetry, or where you want to

17.1 Basic shapes and forms, such as circles, squares, or triangles, are all natural fits for a more formal, centered composition.

suggest a state of balance. The centered approach often comes across as being traditional or formal, which lends a classic feel to some compositions, particularly when paired with a square image format.

The circular shapes in **Figure 17.1** lend themselves to a centered composition, as well as a square format or crop. The scenes portrayed in **Figure 17.2** are not as obvious for a centered arrangement as the circular shapes in Figure 17.1, but both have strong central elements (the arrow and the man's clasped hands).

17.2 The photos of the city parking lot and the man waiting to cross the street both have strong central elements.

18. CREATE DEPTH WITH FOREGROUND/BACKGROUND ARRANGEMENTS

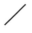

STANDARD PHOTOGRAPHS ARE two-dimensional interpretations of a three-dimensional world. The three dimensions of the scene we experience are flattened out when translated by the camera to a 2-D photo. To counter this, you can add a sense of depth to an image by consciously arranging elements within a photo to draw attention to the distinctly different planes of the foreground, middle ground, and background (**Figure 18.1**).

Creating depth with this approach results in a more dynamic and visually interesting composition (**Figure 18.2**). With some images, such as portraits, layering elements can help tell a story or provide additional information about the subject, including where they live or work. Off-center framing (rule of thirds!) of the main subject is an effective way to emphasize the main, foreground element and still have plenty of room for key middle -ground or background scenery on the other side of the image (**Figure 18.3**). You can also use the Portrait mode of a dual-camera iPhone to further accentuate the differences between the foreground and the background (**Figure 18.4**).

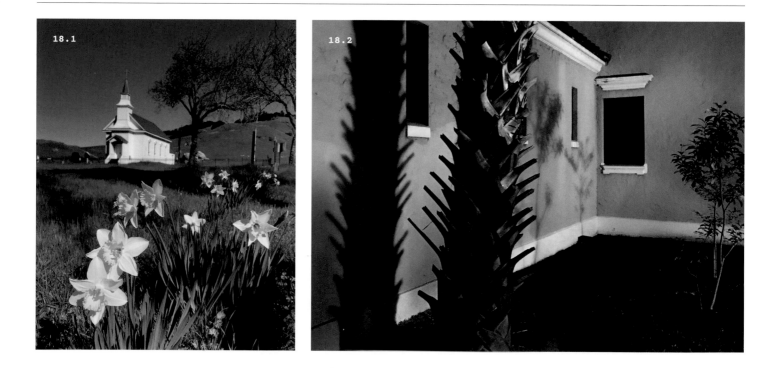

18.1 A roadside view in the foothills of Marin County in California. (I always pull over for a shot when driving by an image-worthy scene.) Because I placed the camera low to the ground, the daffodils in the foreground made a strong contrast to an equally striking background.

18.2 Placing the palm and its shadow in the foreground on the left side of the frame provides a natural lead to the background shadows and window.

18.3 An artist in her studio. Placing the main subject off center creates a space in the frame to show her and her art, and the background details provide further context for the location and subject.

18.4 A forest view on the coast of San Francisco, shot in Portrait mode to blur the background. I further enhanced the effect in the depth map-aware app PortraitCam.

19. CREATE VISUAL PATHS WITH LEADING LINES

WHEN WE LOOK at an image, our eyes enter the frame and then explore the contents of that frame. This may not be apparent to you as you look at a photo, but visual research has shown that our eyes are drawn into a scene by certain elements and can also be guided through an image by areas of contrasts, light and dark tones, or actual lines in a scene.

The name of this compositional technique—leading lines—tells you how you might use it to guide the viewer's gaze through a scene, either to lead to a central element or just provide a nice pathway for the eye to travel (**Figure 19.1**). Common examples of leading lines are paths and walkways, roads and highways, the line of a fence passing through a landscape, power lines drawing you deeper towards a distant horizon, or a stream guiding you through a forest.

Leading lines can also be seen in some areas of brightness against a darker background. Our vision is always drawn to brighter areas in a scene, as well as to areas of contrast. This can create a natural line for the eye to follow, or it can point to the main subject (**Figure 19.2**). In addition to composing a scene to use natural lines as a path for the viewer's eye to follow, you can also create leading lines with localized edits (i.e., image adjustments that only affect part of a photo) to enhance the brightness of a natural line in the scene and make it more pronounced (**Figure 19.3**).

Once you learn to see leading lines in a scene, you'll begin to notice them all the time. Using them is an effective compositional technique that can turn even ordinary scenes into more impactful images.

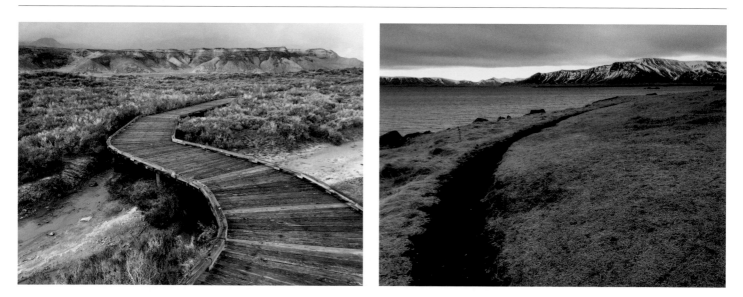

19.1 Trails, walkways, and paths are natural elements to use in compositions to create leading lines.

19.2 The light-colored floor tiles create a line that draws the viewer's eye to the main subject in this image.

19.3 I used selective adjustment tools in Lightroom CC for mobile to brighten the highlights on the curved fence and the walkway surrounding it. I darkened the areas around it to enhance the natural leading lines of the barrier.

Share Your Best Shot with Leading Lines!

Once you've captured a great shot with leading lines, share it with the *Enthusiast's Guide* community! Follow @EnthusiastsGuides and post your image to Instagram using the hashtag *#EGLeadingLines*. Search that hashtag to be inspired and see other photographers' shots, as well.

20. USING THE FRAMES WITHIN A SCENE

ONE OF THE most common compositional techniques involves taking advantage of the concept of the frame within a frame. This refers to elements in a scene that can be used to create a frame that the main subject is seen through. These frames do not need to be strict rectangular constructions (though these create natural frames, they just need to create an opening that can be used to highlight another aspect of the image (**Figure 20.1**).

Frames within frames can be almost anything: openings in tree branches, rock arches, reflections in pools of water, doorways and windows, foreground elements that frame the main subject seen in the middle ground or background (**Figure 20.2**). And they do not need to be overt; some frames within frames are more subtle or suggestive.

Like leading lines, once you become aware of the frame within a frame, you'll begin to notice it everywhere (**Figure 20.3**).

20.1 An outdoor window frame looking onto a pool in the desert and an interior window looking out onto a harbor view. Both create a frame within a frame.

20.2 Pipes at a geothermal power plant in the north of Iceland create a subtle frame for the building and steam cloud in the background. Leading lines have a strong presence in this image.

20.3 Foliage and tree branches can often create a natural and very pleasing frame effect.

21. LIVE ON THE EDGE WITH EDGE COMPOSITIONS

LET'S TAKE A look at a variation of off-center framing by seeing what happens when you place your subject way, way off-center. I refer to this type of framing as "edge" composition, because the subject is placed very close to either the side, top, or bottom edge of the frame (**Figure 21.1**). This placement often feels very wrong as you're setting it up, but with some subjects and scenes it can work well by creating a sense of tension. The tension comes from seeing the main subject, especially if it's a person, so close to the edge, as if they're about to be cut off (and in some cases they may actually be partially cut off). This is about as non-traditional as you can get, but for images where you want to convey a sense of unease or a surreal quality, it can work well (**Figure 21.2**).

Subjects to explore with this approach can include non-traditional portraits with an edgy feel, street photography, cities and the urban environment, night scenes in the city, architecture, abstracts, industrial landscapes, and natural landscape images where an edge element provides additional information or ironic commentary on the scene (**Figures 21.1–21.3**).

21.1 With the angel statue positioned on the edge of this image, this photo has a sense of tension and claustrophobia.

21.2 This photo is all about shapes and bright colors. The use of an edge composition to highlight an elephant that appears to be floating into the scene adds to the playful, surreal quality of the content.

21.3 A highway billboard in a snowy landscape absent of wildlife. Placing the deer on the far side of the photo hints at the shy, reclusive nature of wild animals in this place.

Share Your Best Shot with an Edge Composition!

Once you've captured a great shot with an edge composition, share it with the *Enthusiast's Guide* community! Follow @EnthusiastsGuides and post your image to Instagram using the hashtag *#EGEdgeComposition.* Search that hashtag to be inspired and see other photographers' shots, as well.

22. MOVE THE HORIZON LINE

LANDSCAPE SCENES ALWAYS have a horizon line. While it may not be visible, other types of scenes have an implied horizon line, which you can see in the horizontal lines of windows, doors, floors, and ceilings. Where you choose to place this horizon line within the frame of the image is a conscious choice that can result in very different compositions.

It's common for the horizon line to be centered in the frame. This results in an even division of the top and lower parts of the scene. This may work for some images, but it's a bit boring. You can often get better results by playing around with where you place the horizon.

A landscape image with the horizon placed near the top of the scene lets you focus on the details of the land, while minimizing the impact of the sky. This can be an effective way to photograph a landscape on a day when the sky is dull, washed-out, or otherwise not very interesting (**Figure 22.1**). By giving it a very small section of the frame, it becomes less important and noticeable.

The opposite approach places the horizon line low in the frame, showing only a small amount of the land. This can be an effective way to photograph a scene with an amazing sky that appears over a boring and uninspiring scene down on Earth. Showing a scene with mostly sky can also suggest the vastness of the space that surrounds us (**Figure 22.2**).

Although the very word "horizon" suggests a horizontal placement, not every horizon needs to be positioned as totally level. Just as edge compositions can convey a sense of tension and unease, so, too, can a tilted horizon. A slight tilt may imply that something is a bit off (**Figure 22.3**), while a more exaggerated diagonal slant suggests distortion. Tilted angles can be effective for edge compositions.

22.1 The early-morning sky in Death Valley was void of clouds. Placing the horizon line near the top of the composition minimized the empty area in favor of giving more image area to the interesting textures on the dune.

22.2 Another Death Valley view: Placing the horizon low in the image gives more space to the interesting cloud reaching down from the sky. It also helps make the people appear small and insignificant in the vast landscape.

22.3 The wreck of an old tugboat lends itself to a composition where the camera is purposely tilted to create an askew horizon line.

23. SIMPLIFY WITH NEGATIVE SPACE AND MINIMALISM

PART OF PHOTOGRAPHIC composition involves distilling the scene or subject down to only the essentials needed to tell a story or create an image with an interesting and effective framing. This often involves filling the frame with the subject or at least giving it a prominent place in the composition. But give some consideration to the space around the subject and how that can be used to not only draw attention to the subject, but also to emphasize the subject's place in the greater world around it (**Figure 23.1**).

The visual area that is not the primary subject is often referred to as negative space, particularly if it is empty and uncluttered (**Figure 23.2**). In addition to providing a stage for the main subject, negative space can also become the subject itself. Focusing on large areas of empty or visually uncomplicated space that includes a small and almost inconsequential main element is

23.1 A lone pine tree is dwarfed by the massive slopes of a volcanic cinder cone near Mt. Lassen in northern California. The large areas of negative space emphasize the starkness of the landscape and the size of the cinder cone.

23.2 Moving in for a close view of the top of a parking meter revealed a minimalist composition focused on shapes and bright colors.

a minimalistic approach to composition (**Figure 23.3**). Figure 22.2 in the previous section, in which large expanses of sky occupy most of the scene, can also be placed in this category.

Images that follow this approach can be very effective. We live in a busy and visually full world, so finding scenes where, through the art of composition and careful camera angles, you can remove the clutter and capture a perfectly balanced visual moment can be incredibly satisfying as a photographer (**Figure 23.4**).

23.3 In both of these photos, the play of color and light within the large areas of negative space become the subject of the images.

23.4 Using minimalism and negative space helps distill an image to its bare essentials, resulting in compositions that celebrate simplicity and the subtle details that are often overlooked.

4

LOOKING AT LIGHT

CHAPTER 4

The art critic John Berger once observed that the primary raw materials in photography are light and time. Light illuminates a scene in a particular way, giving shape and form to the elements within the scene. The time refers to how long the camera records that light, which can greatly affect the look of the photo.

When you photograph a scene, you are, in essence, photographing the light that is falling upon the scene. Other elements certainly contribute to a successful photograph, but to create it, you need light. What's more, the character and quality of that light can have a significant influence on the photograph and how it looks.

Some of the most important skills photographers need, no matter what type of camera they use, are the ability to see and understand the light in a scene and to visualize how the camera will interpret it. Knowing how your camera will respond to light, and how different types of light will affect the image, will result in more satisfying and more creative photographs.

24. NOTICING THE QUALITIES OF LIGHT

THE FIRST STEP towards mastering the use of light in your photographs is simply to take note of what the light is doing and how it is affecting the scene or subject you are photographing. This is more an observational skill than a photographic technique, but it is definitely something that will find its way into your photography.

Looking at light and seeing the light is something you can do at any time, even if you don't have a camera with you. With camera phones, however, let's face it—we do have a camera with us most of the time! It's a very useful exercise that will help to train your photographer's eye to notice the subtle details of the world around you. It will train you to understand how the light is illuminating and shaping the elements in a scene.

If you spend the day more or less in the same place, find a spot to observe what the light is doing. Make a point of noticing it—and really seeing it—several times throughout the day. The degree to which the light will change will depend on where you are, the time of year, and the weather (a cloudy, rainy day, for instance, may not provide much variance in the quality of light throughout the day).

Since you probably have your iPhone with you, go ahead and take a photo at various times of the day (**Figure 24.1**). If you're a note-taker, feel free to jot down some written observations. Or, if poetry is more your style, compose a few lines of verse or write a haiku. Have fun with it, but take the time to really see what the light is doing.

You can do this exercise anywhere you

are, even if you're only passing through a location. Make a point to really look at the light and consider the different ways it can transform a scene (the six images in **Figure 24.2** offer a variety of examples). Is it bright and direct, or muted and filtered by clouds? Does the light have a noticeable color? Is it warm or cool? How would you describe the shadows that it creates? Are they dark, hard-edged, and sharply defined? Or soft and indistinct? Does it flatter the faces of people you see?

Think about these questions and observations when looking at images by other photographers. How does the light contribute to the photo? Is it a major player, dominating the scene, or is its role more quiet and subtle? You can learn a lot about light and composition from looking at good photographs.

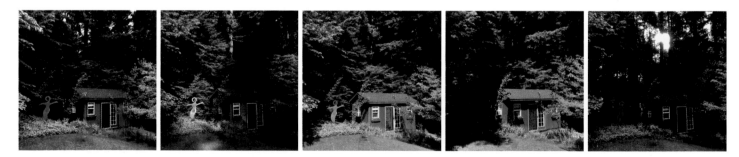

24.1 A view onto the back garden: These photos were taken throughout the day, starting early in the morning and through the late afternoon.

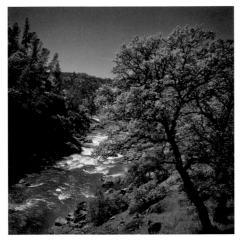

24.2 Bright, direct sunlight on a spring day.

Soft and muted light on a misty morning.

The cool light of a winter scene.

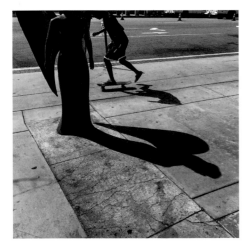

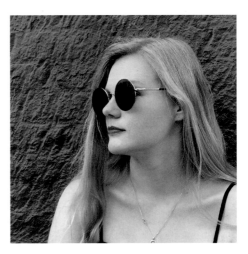

Hard street shadows.

Indistinct shadows in soft interior window light.

Open shade light for a portrait.

25. TYPE OF LIGHT: NATURAL OR ARTIFICIAL

ONE OF THE most basic distinctions when categorizing the light in a scene is whether it is natural or artificial light.

- **Natural light** is light created by a natural source, such as sunlight in all its many forms: direct, diffused, reflected, and filtered (**Figure 25.1**). Even moonlight is just reflected sunlight. Starlight, visible in long, night exposures taken with more advanced cameras, is the light of many distant suns. The light from a fire or candles can also be considered natural light.
- **Artificial ambient light** is a human-made light source that is part of the normal lighting in a scene. This can be any powered light source that happens to be present where you're photographing, such as interior household or office light, streetlights at night, or stage lighting (**Figure 25.2**).
- **Artificial intentional light** is a light source that you provide specifically to add light to the scene. This can include the built-in flash on your iPhone (**Figure 25.3**), additional flashes, or constant light sources you bring to the shoot. Light sources that you use specifically for photography do not have to be expensive and complicated; they can be as simple as moving a small table lamp closer to your subject or having a friend use an iPhone flashlight to throw additional light on a subject.
- **Mixed lighting** refers to a scene where the light comes from different sources. The most common mixed-light images are a blend of natural and artificial light, such as daylight from a window mixing with interior lighting (**Figure 25.4**) or the blue of a twilight sky contrasting with the warm yellows of a streetlight (**Figure 25.5**).

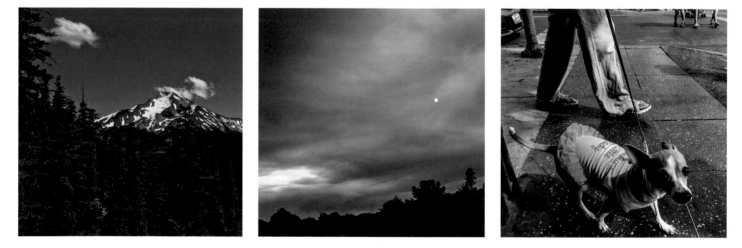

25.1 Natural light from the sun is the most common light source for most photographs. A bright, sunny day in the Oregon Cascades; late afternoon sunlight filtered by smoke from a large wildfire; midday light, direct and reflected from buildings and the street.

25.2 If the scene you're photographing is an interior location without window light or if you're outdoors at night, artificial ambient light (the light that happens to be there) will be the primary illumination.

25.3 The built-in flash on an iPhone is not the best type of light, but sometimes it may be the only light you have.

25.4 Soft window light on a winter afternoon combines with candlelight to illuminate a child's reading lesson.

25.5 In an empty parking lot, the natural blues of twilight mix with the warm colors from a streetlight.

26. THE POSITION OF THE SUN

IF THE SUN is your light source, there's nothing you can do to alter the position of the light that illuminates the scene you're photographing. In some situations you can move the camera, or you may be able move the subject to place them in a more favorable position relative to the light. At the very least, it's important to understand how the position of your primary exterior light source can affect the scene to create very different types of images.

Sunrise and Sunset

The times when the sun first makes an appearance at dawn, or leaves the stage at the end of the day, have long been favorite times for painters and photographers to capture a scene (**Figure 26.1**). One look at the magical colors that transform the sky and landscape at sunrise and sunset and it's easy to understand why. Apart from capturing the beauty of the sky, sunrise and sunset are also good times for exploring simplified compositions using silhouettes, because the sun is low and easy to place behind your subject. When the exposure is made for the sky, the subject will be backlit and appear as a silhouette in the photo (**Figure 26.2**).

26.1 Nature puts on a fine show at the end of the day on the coast of western Iceland.

26.2 With a colorful sunset sky as the backdrop, using silhouettes lets you discover bold and graphic compositions.

Light at a Low Angle

The times just after sunrise and just before sunset are often referred to as the golden hours, due to the warm color of the light (**Figure 26.3**). Early-morning or late-afternoon light can be very dramatic for many subjects. The low angle of the light relative to the horizon (and hence, the subject) creates sharply defined light with long, distinct shadows (**Figure 26.4**).

While light that is low on the horizon can work great for landscapes, it's typically not ideal for portraits. Direct light from a low angle is typically hard and yields images with high contrast. It can also cause the subject to squint, and the high-contrast, bright light will create deep shadows on the lines of the person's face. There can be exceptions to this rule, and for some portraits the look created by hard, low-angled light may work for the story you're trying to tell.

Light at a 45° Angle

Some landscape photographers pack up their camera bags and depart the scene after the sweet light of the early morning hours has passed, but midmorning or midafternoon can be a good time for photography if the magical golden light is not a requirement for your images. In the time between the early morning hours and the middle of the day, as well as the afternoon, the sun is higher in the sky, but not directly overhead. In this position, the sun is at approximately a 45° angle relative to the earth, and can provide good lighting for a variety of subjects (**Figure 26.5**). If the sun is not diffused by clouds, there is still a chance of hard lighting contrast in the image, but because of the angle of view, the contrast is often not as exaggerated as it is when the sun is either very low on the horizon or directly overhead.

26.3 A waterfall bathed in the sweet light of the golden hour.

26.4 Late afternoon sunlight on an autumn day created wonderful long shadows of these costumed performers.

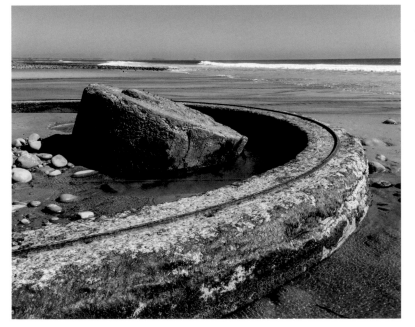

26.5 At mid-morning or mid-afternoon (this may vary depending on the time of year and where you are in the world), the light is not as spectacular as it is earlier or later in the day, but you can still make good photos in it.

Overhead, Midday Light

Many photographers commonly disparage the light during the middle of the day, when the sun is more-or-less directly overhead, as "bad" light. Although it certainly can be challenging to work with, depending on the subject matter, I take a different view of this light. Rather than label it as "bad," I prefer to think of it as different. Good photographs can be made in any type of light. It all depends on the type of image you want to make; and sometimes you don't have control over the time of day when you happen to find yourself in front of a scene that would make an interesting photo. Plenty of excellent photos have been made in what some might classify as "bad" light.

Overhead, midday sunlight is different than the light of the early morning or late afternoon hours. It tends to produce a flatter, less dimensional light that does not define the shape of elements in the scene as well as the more directional light of earlier or later in the day (**Figure 26.6**). In some situations, really bright light washes out colors and produces harsh contrast that is not visually engaging. It is also not ideal for portraits because the overhead light produces hard, dark shadows under the eyes, or across much of the face if the subject is wearing a hat.

For all of its possible drawbacks, midday sun can work well with many types of subjects. The bright light and strong contrast can produce hard shadows for more graphic compositions that can result in very interesting images (**Figure 26.7**). With some subjects, such as with the dogwood blossoms seen in **Figure 26.8**, there can be unexpected benefits. The blossoms were photographed with sun nearly directly overhead, and the downward angle of the light not only made them stand out against the blue sky, but it also provided a bit of backlighting that shines through the petals of the blossoms.

26.6 When the sun is directly overhead, the light is generally not as interesting or nuanced as it is earlier or later in the day. For some scenes, though, it can still result in effective images, such as these memories from a desert road trip, which involved a fair amount of bright overhead sun.

26.7 Midday sunlight can work well for scenes where hard shadows and bright sun create images that lend themselves to a more stark and graphic interpretation of the subject. Black-and-white images can work well with this type of light, especially when colors appear flat and washed out.

26.8 Dogwood blossoms photographed from underneath, with the sun nearly directly overhead.

Early-Evening Twilight

Indirect light from the sun still illuminates a scene even after the sun has gone down (or before it has appeared above the horizon), but in a much softer way. The sky may still have traces of the colors of sunset, or it may be transitioning into the blue hour before full darkness. The light is even and low in contrast, though depending on how long after sunset or before sunrise it is, the light may be dim, which could create a challenge for making a well-exposed image (**Figure 26.9**).

Once the evening twilight period ends, all traces of daylight will be gone, but that doesn't mean that the time for photography has ended. There are still possibilities for making photographs at night, although different techniques and gear may be required. We'll be taking a closer look at night photography with an iPhone in a later section.

26.9 A police station in Iceland at day's end provides an interesting study of architecture at twilight.

27. THE DIRECTION OF THE LIGHT

THE DIRECTION OF the light is similar to the position of the light. While you can't change the position of the sun, you can change your own position (and that of the camera), and sometimes the position of the subject, for a different light direction in your scene. Each direction of light will illuminate different portions of your subject for different results in the overall scene.

- **Frontal Light:** In a scene that is lit from the front, the light is at your back and directly illuminating the front of the subject. This is a common light direction used for many types of photos that results in an image being evenly illuminated (**Figure 27.1**). Large surfaces, such as a light-colored building behind you, can also create frontal lighting by reflecting light onto the subject. However, if the angle of light is low and shining directly into the eyes of your portrait subjects, it may cause them to squint.

- **Angled Side Light:** This is halfway between full frontal and side lighting, with the light positioned roughly 45° from the center of the front of the subject (this refers to the front of the subject in relation to the camera, not the altitude of the light source in the sky). This can result in a very gradual light falloff, which creates a more dimensional effect than the even illumination of frontal light (**Figure 27.2**). It can yield very good results with portrait subjects.

- **Horizontal Side Light:** The light is positioned from the side, at a horizontal angle to the front of the subject. This can result is very dramatic lighting with one side of the scene or subject well lit, while the other side is more in shadow (**Figure 27.3**). With some portrait subjects, however, it may be a bit too dramatic; it will overemphasize the lines on the face and may not be very flattering.

27.1 Frontal light.

27.2 Angled side light.

27.3 Horizontal side light.

- **Backlight:** As the name suggests, backlighting is when the main light source is directly behind your subject. Backlighting can create a very dramatic look, with a clear separation between the subject and the background, as well as edge or rim lighting that highlights the shape of the subject (**Figure 27.4**). Backlighting works well for silhouette subjects and can also be effective with scenes that include partially transparent or translucent subject matter, such as backlit leaves, curtains, or stained glass.

- **Overhead Light:** Light that comes from directly above the subject, such as sunlight in the middle of a cloudless day or a large ceiling light fixture, is typically not what you want to use when making a portrait because it tends to create deep shadows under the eyes and is rarely a flattering type of light. It can be effective for high-contrast street photography and documentary subjects, or for those times when you want a more dramatic and atmospheric character of light (**Figure 27.5**).

27.4 Creating backlighting by shooting into the sun can be particularly effective if you can find an element in the scene, such as the tree in this shot, to block the sun.

27.5 The midday overhead lighting in this photo of a desert mining location works well for the stark and desolate landscape.

28. THE COLOR OF THE LIGHT

ONE OF THE more interesting qualities of light is color. This does not refer to the colors in the scene, but to the actual color of the light. The color of light is based on a variety of factors including the type of the light source, the time of day, the weather and other atmospheric conditions, as well as reflected and transmitted color from elements in the scene. For example, light reflecting off of a colored wall or shining through a colored medium, such as colored glass or fabric, can influence the light's color (**Figure 28.1**).

In addition to the natural color of the light as you find it in the scene, the color of light in the final photo can also be influenced by choosing specific white balance settings in a camera app or by modifying the color balance in post-processing. The color of light can influence a viewer's emotional response to an image, as well as help communicate the story of the scene or suggest a mood (**Figure 28.2**).

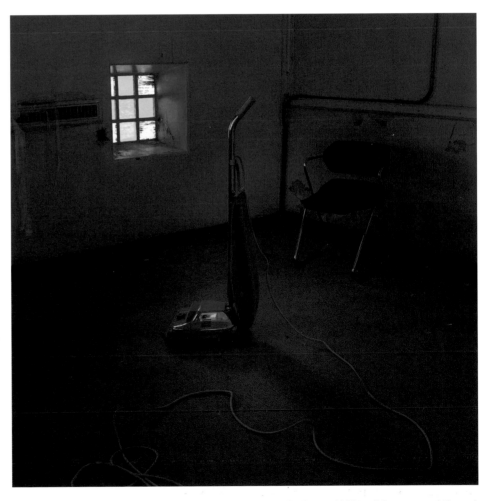

28.1 Afternoon sunlight shining through colored glass fills this room with red light.

28.2 For this photo, a cooler, bluer white balance setting was chosen in a photo-processing app to more strongly suggest the idea of a cold winter evening.

In technical terms, the color of light is specified by color temperature using the Kelvin scale (e.g., 5000K), in which lower numbers indicate warmer colors and higher numbers specify cooler colors. You don't have to worry about the Kelvin scale when shooting with an iPhone, but it's a helpful concept to understand for your photography (**Figure 28.3**).

Let's take a look at some of the different colors of light created by common light sources and conditions.

- **Blue Light:** Natural light in the bluer or cooler end of the spectrum is typically encountered when photographing shortly before sunrise or just after sunset. Blue light is effective for suggesting the cold of winter or to communicate a sense of mystery and unease. Blue light is typically about 10000K to 11000K.
- **Cool Light (Cloudy or Shade):** Sunlight that is filtered by cloudy or overcast skies will typically produce a cooler light, though not as cool or blue as in the time before sunrise or after sunset. Some shaded locations can also result in a much cooler type of light. The cloudy or shade white balance settings in camera apps will try to compensate for cooler light conditions by adding yellow and red to the shot, but sometimes it can be a little too much. The color temperature of light under cloudy skies or in open shade areas is in the range of 7000K to 9000K.
- **Neutral Light:** Sunlight in the middle of the day is usually considered fairly neutral. In fact, back in the days before digital cameras, most color films were balanced to produce a neutral result in midday sunlight. Color temperature, and thus the color of light, can be influenced by several factors, but midday sunlight on a clear day usually falls within 5000K to 6500K.
- **Golden Light:** Golden light is the most cherished type of light for photographers. It typically occurs early in the morning around sunrise, and late in the afternoon before sunset. The warm colors of golden light convey a sense of contentment, and

can be very flattering for portraits. This quality of light doesn't last long, so if you're planning to be at a location to take advantage of it, be ready to work fast once it appears. Golden light is lower on the color temperature scale, around 2500K to 3500K.

- **Common Household Light:** Incandescent light bulbs typically generate a warmer and more yellow light that is around 2500K to 3500K. As the lighting industry evolves, however, more and more household and interior locations may use compact fluorescent bulbs, which are available in a range of color temperatures from warm (2700K) to bright white (4100K) to daylight (5000K to 6500K). Although the auto white balance (AWB) in most camera apps should do a good job correcting for very warm interior light, you can use a tungsten white balance setting to better improve the color balance in the photos (see the next section for more on using white balance in a camera app).

- **Candlelight or Fire Light:** The light from a campfire, fireplace, or candles has a color that is warm and very yellow, around 2000K. These colors will be present in your photo and sometimes they can be very flattering. If the light source is included in the image, this color can convey a sense of coziness.

These are the more common light sources (and their colors) you're likely to encounter. Different types of light color are possible with colored lights found in stage sets, nightclubs, reflections from colored surfaces, or certain atmospheric conditions, such as the orange light created in heavy smoke from wildfires.

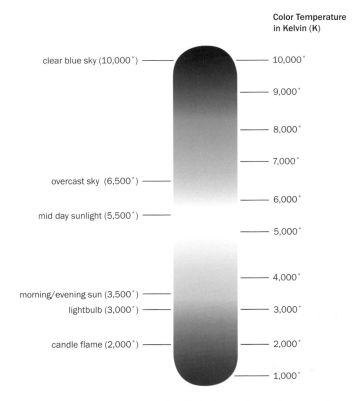

Color Temperature in Kelvin (K)

clear blue sky (10,000°) — 10,000°
— 9,000°
— 8,000°
— 7,000°
overcast sky (6,500°) — 6,000°
mid day sunlight (5,500°) — 5,000°
— 4,000°
morning/evening sun (3,500°) — 3,000°
lightbulb (3,000°) —
candle flame (2,000°) — 2,000°
— 1,000°

28.3 Color temperature on the Kelvin scale refers to the color of light. Lower temperatures produce warmer, more red or yellow light, while higher temperatures yield light with cool colors, like blue.

29. USING WHITE BALANCE TO MODIFY THE COLOR OF LIGHT

THE COLOR OF light in a photo can be manipulated by choosing a white balance setting that will yield a specific effect. Not all camera apps are created equal, however, and some may not offer a way to change the white balance. The native camera app on the iPhone in iOS 11, for instance, does not have a white balance setting. For camera apps that do offer white balance control, this typically comes in the form of presets that are designed to correct for common color characteristics from specific lighting conditions, such as interior tungsten or fluorescent light, or shooting in the shade or under cloudy skies (**Figures 29.1** and **29.2**).

For example, as mentioned earlier, if you're shooting in a shaded area or under heavy, overcast skies, the cloudy or shade white balance presets will inject some warmth into the photo. I would recommend testing this out first, however, since every app is a bit different and sometimes these settings can create a bit too much warmth.

If you want to purposely create a blue look while taking an outdoor shot under more neutral daylight conditions, use a tungsten white balance setting (look for a light bulb icon). Because tungsten lighting is usually very yellow, that white balance setting will add blue to the shot to compensate for the yellow (blue is the color opposite of yellow on the color wheel).

The one drawback to using a white balance setting to alter the color balance in a shot is that you are committing to that look for the photo. Later on if you change your mind and try to correct the color balance, it may not be as easy, depending on the editing app you're using. I would recommend shooting to get a normal color balance for a photo (that is, letting the camera app's auto white balance decide, or by using a white balance preset that is appropriate for the light in the scene), and then adding a more creative or interpretive color-balance effect later.

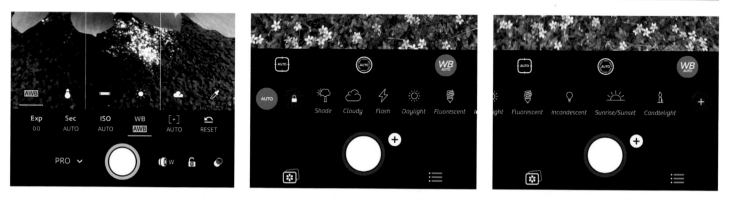

29.1 The white balance presets in the Pro mode of the Adobe Lightroom CC camera. From left to right, AWB (auto white balance), tungsten, fluorescent, daylight, cloudy, and custom.

29.2 The Camera+ 2 app offers more white balance presets based on common types of light.

30. SIMPLE WAYS TO ADD LIGHT TO A SCENE

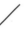

FOR MOST IMAGES, you will probably use the existing ambient light that is present in the scene, whether it's natural or artificial. If that isn't enough light for your shot, adding a little extra light of your own may help to make a better image, either by filling in some shadows to create a better overall exposure or by adding a highlight in an important area. Let's consider a few simple ways to bring additional light to a photo.

- **Use the built-in flash.** The flash on an iPhone is not very bright and will only work if the subject is reasonably close to you (e.g., a group of friends at a party). If possible, see if there are other ways to get the shot without it, such as by moving closer to another light source, such as a lamp. If the built-in flash is the only additional light available to you, in some dark locations there may be no way to take a photo without it.

- **Use the built-in flash to supplement daylight.** In conditions with plenty of light where the flash would not normally go off, the built-in flash can add a little extra light to create more even illumination. It can fill in shadows under the eyes or even create a nice catch light in the eyes (**Figure 30.1**). This is useful especially is situations where the main subject is backlit.

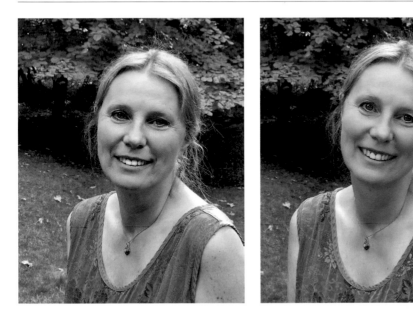

30.1 In the photo on the left, the flash was set to Auto and did not fire. In the image on the right, the flash was set to On. Not only does the flash help to lighten shadows under the eyes, but it also creates a warmer and more pleasing color balance.

- **Look for reflection possibilities.** If you're in an area where there are buildings or other reasonably large structures (even some cars can work), keep your eyes open for a light-colored surface to reflect the ambient light in the scene. Reflected light opens up a lot of possibilities for moving beyond direct sunlight to illuminate your subject.

- **Use photo reflectors.** Photo reflectors come in a variety of sizes and some models are collapsible and can be easily carried in a small camera bag or purse. These are especially useful for portraits and can reflect sunlight or any other bright light source (**Figure 30.2**).

- **Place household lamps creatively.** If you find yourself in an interior location with lamps that can be safely and easily moved, consider placing them in locations where you want to make your photo. Sometimes the extra light you need may already be there, but it requires repositioning.

- **Use a second (or third) iPhone.** Sometimes, all a photo needs is a little extra light. Perhaps a highlight or a little backlight to create more separation between the subject and the background. In some situations, using the flashlight feature on another iPhone can kick in just the right amount of additional illumination. Because you'll be photographing with your own iPhone, you'll have to enlist the assistance of a friend as a V.A.L (voice-activated light stand) and direct them to shine the flashlight just where you want it (**Figure 30.3**). For some photos in dark locations, you can also use an iPhone in the hands of your subject to cast a soft light onto their face (**Figure 30.4**).

- **Use flashlights or small LED photo lights.** For night situations or times when you need more light than a reflector or the built-in flash can produce, consider flashlights or small LED lights to add some additional illumination. For illuminating larger areas or subjects that are far away, photo lights like the Lume Cube can create a lot of very bright illumination. You can read more about this in the section on night photography in chapter 5.

30.2 Many photo reflectors are collapsible and easily transportable. They can provide a nice way of using reflective light on a nearby subject.

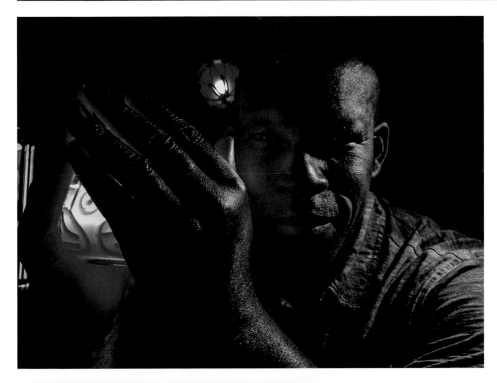

30.3 This portrait, taken in a darkened tiki bar, uses the ambient lights in the bar with candlelight filtered by red glass and an iPhone flashlight held by a friend to create a highlight on the side of the man's face and shoulder.

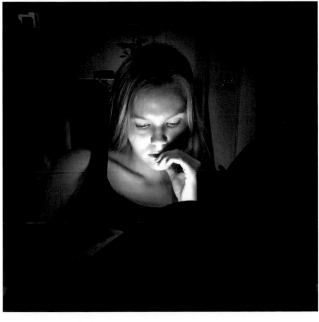

30.4 An iPhone held in the hands of the subject creates soft illumination on her face.

5

CREATIVE
EXPLORATIONS

CHAPTER 5

There is no single ingredient that goes into creative photography, but rather, there is the creative application of many different techniques, concepts, chance encounters, and sometimes, happy accidents. Once you are well versed in the technical capabilities of the iPhone camera or other camera apps you may be using, and have a good grasp on the essential concepts of composition, an understanding of how light affects an image, and how to control your exposure, you're ready for some visual explorations.

The type of photography that moves and interests you will influence what directions your creative meanderings take you. It's also important to explore beyond those interests now and then. These explorations can be self-assignments that let you practice a new type of photography, or they might be exercises in learning how to use a new technique to capture images in a different way.

In this chapter, we'll take a look at a range of different photographic styles, scenarios, and genres to explore the application of composition, working with light, and controlling exposure. We'll also consider additional techniques and image-making approaches to expand the possibilities for iPhone image capture.

31. LANDSCAPE PHOTOGRAPHY

THE LANDSCAPE AS subject has an important place in the history in photography. Landscape images can often be challenging due to the the sheer vastness of a scene and the wide variance of light you're likely to encounter depending on the season, the time of day, and the weather.

It's easy to do quick snapshots with an iPhone, and sometimes that's all you may have time for. But if you do have the luxury of time to indulge in your visual explorations, take advantage of it to move beyond the grab shot. The landscape offers many possibilities for beautiful and interesting images. Consider how some of the composition and lighting concepts we explored in earlier chapters can be applied to your landscape photography.

Find Foreground/Background Relationships

One of the challenges of landscape photography is that your subject can appear distant. This tends to minimize the impact of a vast and impressive scene, especially when photographed with the typical wide-angle lens of an iPhone (**Figure 31.1**). One of the realities of a wide-angle perspective is that it tends to make far-away scenes and elements look even farther away in the photograph. The smaller size of the image when viewed in apps on the phone, like Instagram, is another factor that can make images of a grand landscape seem a bit underwhelming.

When you're composing a landscape photo, look around to see if there are any foreground elements that can be worked into the composition. Placing elements in the foreground not only creates more visual depth in the scene, it can also provide additional contextual details. Consider the different views in **Figure 31.2** of Vestrahorn in southeast

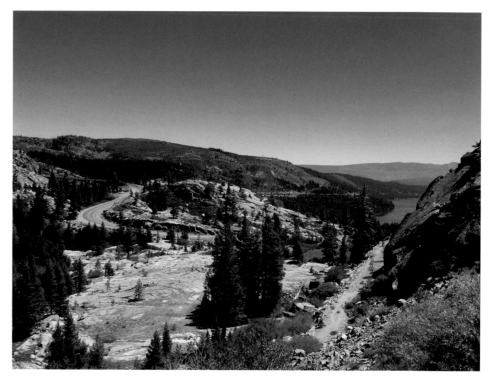

31.1 The wide-angle view of an iPhone lens can often make a grand vista appear distant and underwhelming.

Iceland. The first image only shows the ocean in the foreground, but using the dunes of black sand and contrasting yellow grasses gives additional information about the location and makes for a more interesting photo. Even when the storm front moved in and the mountain vanished behind a veil of clouds, the foreground elements help anchor the image.

Explore Alternate Horizons

The horizon, the point where the defined forms of terra firma intersect with the ever-changing tapestry of the sky, is an important part of many landscape images. How you choose to place the horizon line can result in very different images of the same location (**Figures 31.3** and **31.4**). It's a worthwhile exploration, even if nothing comes of the images with views that run counter to your initial instincts for how to compose a scene. If you're photographing for projects (or potential future projects) where type will be added to a photo, creative horizon placement can be important in opening up room for lettering and logo elements to be added without interfering with the main image.

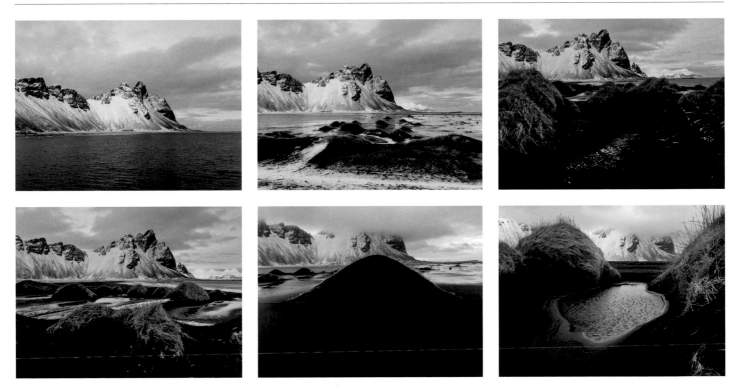

31.2 One benefit of working a location to find new compositions is that you find new compositions! These images of Vestrahorn in Iceland are presented in the order they were taken. My exploration of the location led to different combinations of foreground and background elements.

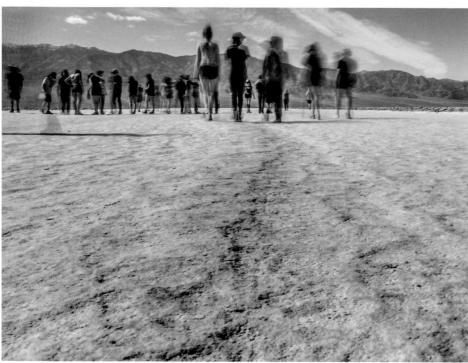

31.3 Creative placement of the horizon line can dramatically change a photograph and the location it portrays. In this view of Death Valley, the lowest point in the continental U.S., the low angle emphasizes the hard surface of the salt flats (motion blur courtesy of the Slow Shutter Cam app).

31.4 Using alternate horizon placements can be useful for photos that have text or other graphics added to them, such as those used for posters or book covers.

Work with the Light You Have

As mentioned in an earlier chapter, all photography is a record of the light falling upon the scene. A photo is a light drawing; a rendering of how the light was moving through and illuminating a scene or location. Landscape photography is very dependent on the light. In some situations, you may be traveling through a location but you don't have time to stay for the really good light in the early morning, late in the afternoon, and in the early evening. It may not be the light that you want, and it may not be illuminating the scene in a way that you like, but look on it as a challenge. Try to find interesting images, even in less-than-ideal light. You might surprise yourself and take photos that are really intriguing. In such cases, I am sometimes reminded of the classic Crosby, Stills, Nash & Young tune, "Love the One You're With," and adapt the lyrics to be about the light I encounter in the moment: "If the light's not what you want, work the light you have."

Plan Ahead for the Good Light

If your schedule allows for the luxury of planning to shoot at a certain point in the day for specific light, working with the light doesn't necessarily meaning settling for what you first encounter. Advance research into the location where you'll be and what times of day are best for specific types of light will allow you to maximize your image-making time by arriving on location before the light you want to shoot in appears so you have time to set up and

be ready. Apps like PhotoPills and The Photographer's Ephemeris let you see the position and angle of the of the sun at your intended shooting location for different times of the day and year (**Figure 31.5**). You can also look up a specific date in the future so you can plan your trip to coincide with the best chance at getting the type of light you want.

Use HDR to Capture More Tonal Detail

In many landscape situations, there can be a wide range of contrast between the darker areas of the land and the brighter areas of the sky. Take advantage of the iPhone's built-in HDR capability in the native camera app to record a more balanced exposure with better detail in both the darker and brighter areas (**Figure 31.6**). For best results with HDR, keep the camera as still as possible when taking the shot, because the app is actually taking two or three photos. You can also brace the camera against a stable, non-moving surface or use a tripod.

Other camera apps also offer HDR. One of my favorites is the camera in the Lightroom CC for mobile app, because it allows me to capture raw HDR files in the DNG (digital negative) format (**Figure 31.7**). Having an HDR file that is also a raw DNG allows for more flexibility when fine-tuning the image with the Develop controls in the Lightroom CC for mobile app, or in Lightroom on my computer. We'll take a look at shooting in raw on an iPhone in more detail in chapter 7.

31.5 PhotoPills (left) and The Photographer's Ephemeris (right) are photography-planning apps that let you see exactly where the sun, moon, or stars will be on a certain date and time in relation to the location where you will be shooting.

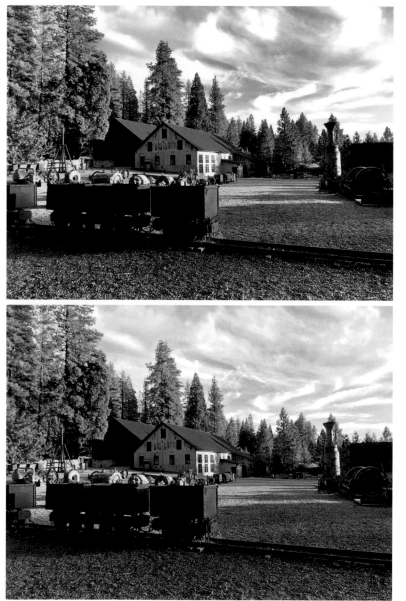

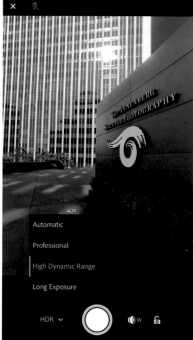

31.6 Sometimes highlights can be overexposed, especially if the camera is metering for the darker tones in the scene. You can see this in the blown highlights in the clouds and on the building (top). Shooting with an HDR feature can result in a photo that has a more balanced tonal range with better detail in the shadow and highlight areas (bottom).

31.7 The Lightroom CC for mobile app has an HDR mode that allows you to capture images in the Digital Negative (DNG) raw format. This gives you greater post-processing possibilities so you can get the photo looking just the way you want.

32. PICTURING THE CITY

CITIES ARE GREAT locations for photography, and they are especially well suited as subjects for the on-the-go nature of iPhone photography. Whether your subject is the architecture, the people on the street, abstract compositions, or the many fascinating details and textures, there are always interesting photo possibilities in the city.

The City as Landscape

Cities are just another type of landscape (the term "cityscape" applies to this). Images that show the city on a large scale, such as those that feature skylines, bridges, or views from afar that show the expanse of a city, are still representing the landscape of the area (**Figures 32.1 and 32.2**). In these types of images, composition and the view you choose for the scene are important, but your images are dependent on light and weather to help create a striking view. Photo-planning apps like The Photographer's Ephemeris and PhotoPills are very useful for finding good overviews of a city and knowing in advance how the sunlight is likely to be hitting your scene at a certain date and time.

Design with Lines, Shapes, and Patterns

The architectural elements in cities are perfect subjects for exploring the world of lines, shapes, and patterns (**Figures 32.3–32.5**). Keep your eyes open for interesting arrangements as you move through the city. Sometimes, just walking half a block can create new relationships between structures or reveal a new element for composition. Some compositions may suggest a more abstract approach, while others can reveal a sense of history when an older structure is included with modern and contemporary buildings. The taller buildings in many cities also modify the light, adding new elements to a scene through the contrast of light and shadow, or reflections from the glass and steel surfaces of nearby structures.

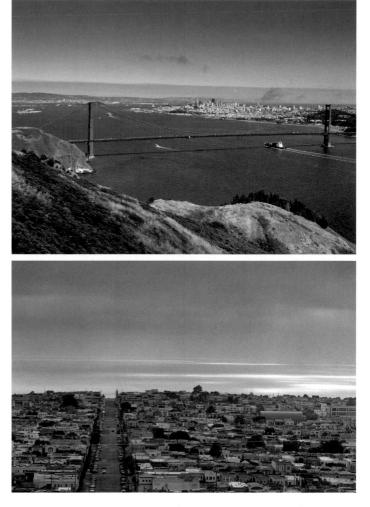

32.1 When seen from afar, from a vantage point that encompasses a wide view, cityscape images have a lot in common with landscape images.

32.2 Even some views from deep within urban locations can evoke the idea of landscape. The avenues between tall buildings, such as this image of Wall Street in New York City, are referred to as canyons—and for good reason.

32.3 Early evening summer sunlight creates reflections of the sky and surrounding structures in the windows of two buildings in San Francisco.

32.4 Suspended tramlines break up the grid of windows on the sunlit building in the background.

32.5 A silhouette of the Brooklyn Bridge just before sunrise highlights the shapes and patterns in the image.

Reflections of the City

The presence of so much glass and polished steel in city environments means there are many opportunities for finding interesting reflected views (**Figures 32.6** and **32.7**). You can also find opportunities for reflections in still water, whether from a reflecting pool or a puddle on the street.

There are other aspects of city photography that can be explored, including focusing your view on the people you see or shooting the city after dark. Those are two of my favorite ways to photograph in cities, and there are many image possibilities waiting to be discovered. We will discuss both of these options in the sections about night photography and street photography.

32.6 A curved corner window creates distorted reflections in San Francisco.

32.7 A New York scene reflected in the glass of an old door also creates a frame-within-a-frame image.

Share Your Best Cityscape!

Once you've captured a great cityscape, share it with the *Enthusiast's Guide* community! Follow @EnthusiastsGuides and post your image to Instagram using the hashtag *#EGcityscape*. Search that hashtag to be inspired and see other photographers' shots, as well.

33. STREET PHOTOGRAPHY

THERE IS OFTEN some overlap between subjects or genres in photography. Such is the case with street photography, which typically refers to unplanned, chance encounters and life-as-it-happens moments of people captured in public spaces (**Figure 33.1**). This is not to say that there has to be people in the shot; sometimes an image in this genre can show the visual mood and textures of a location.

The name of the genre is useful because it instantly conveys to most people a certain style and subject matter, but it's also a bit confining—though the street is certainly a common location for this type of photography, not all "street photography" is made on the street. You can find subjects within this genre wherever you find people in a public venue, such as in museums (one of my favorite places for this type of photography), airports, or even at the beach (**Figure 33.2**).

33.1 Catwoman and Zorro cut through the crowd. The crush of tourists, costumed characters, cops, fortune tellers, street vendors, and locals make the Hollywood Boulevard Walk of Fame a great location for photography. I've been working on a street photography project there for over two years.

33.2 Street photography can be made on the street, but also in such places as museums, waiting to board a plane in an airport, parks, and beaches.

Identify Good Locations

What classifies as a "good" location for street photography depends on the type of photos you want to make in terms of the activities that people are engaged in. One thing to look for, however, are locations where there is a high concentration of people: busy city streets, state or county fairs, small town street fairs, parades, museums, airports, and concerts. Being in the midst of, or on the edge of, large groups of people will give you plenty of subject matter to choose from (**Figure 33.3**). And, as just another person in the crowd with a cell phone, you'll blend in more than if you were photographing with a large camera and a big lens.

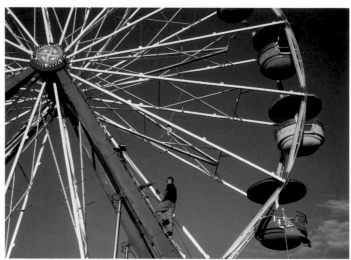

33.3 Locations with a lot of people are often good places for street photography because you have a higher likelihood of seeing an interesting scene.

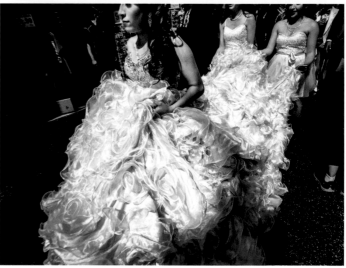

Find a Shot and Wait for Something to Happen

One technique that can be very successful with street photography is to identify a location that looks intriguing—it has good light or interesting circumstances—and hang out there for a while to see if anything good happens (photographically speaking). How long you may have to wait depends on the time of day and how much activity there is in that area. Sometimes the wait is worth it, and sometimes not. But it's a good strategy that can really pay off.

The whimsical image in **Figure 33.4** is a good example of how using this technique can capture interesting moments. I was visiting the Los Angeles County Museum of Art on a (rare) wet and stormy day. People in the rain are always interesting to photograph—there's the added visual elements of umbrellas, wet streets, and reflections. After purchasing my ticket, I waited under the covered entrance area and watched people interacting with the rain and the over 200 vintage street lamps in artist Chris Burden's *Urban Light* installation. I did not have long to wait long before a woman approached, skipping delightedly through the rain. As I watched, and began taking pictures, her skipping became more elaborate and she began jumping back and forth.

Anticipate the Moment

The best wildlife photographers recommend that knowing the habits and routines of the animals you're photographing can be very useful in recognizing situations that might yield a good shot. Anticipating the possibilities for a shot and being ready for them means you're prepared to shoot when the action occurs. The same principle can also be applied to street photography. If you anticipate that certain conditions or activities may result in interesting moments, you're already more likely to get a good shot because you're ready for it.

In capturing the fleeting moment in **Figure 33.5**, I noticed the woman with two small dogs halfway up the block stopping to have a short conversation. I knew she was headed my way so I squatted down and began photographing one of the Walk of Fame stars in front of me as I waited for her and the dogs to enter the frame. Once they did, I took several photos until she exited the composition. Getting down low brought the dogs closer to the camera, making for a more dynamic composition than if I had shot the image from standing height.

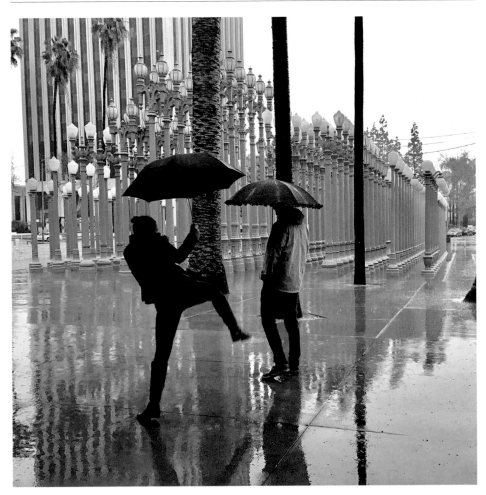

33.4 While waiting for an interesting moment to occur in a good composition, I saw this woman skipping and jumping happily in the rain.

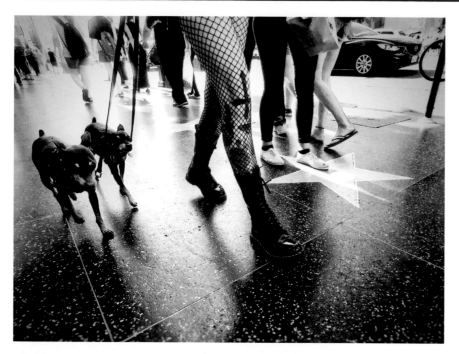

33.5 Knowing this woman and her dogs would pass by my position, I composed a shot and waited for them to enter the frame.

Be Ready for the Unexpected

Learning to anticipate the moment is an excellent strategy for street photography, but you also have to be ready for the unexpected. You may have only seconds to compose and take the shot when you see a photographic moment materialize (**Figure 33.6**). When I am actively on the prowl for street-photography images, I have the camera app open on my phone, even if the phone is at my side. This allows me to react quickly if I see the possibility for making an image. The downside to this approach is that it drains your battery faster because the video display of the camera app is on most of the time. To offset battery drain, I always have one or two external battery packs with me so I can keep the phone powered during my street photography excursions.

33.6 A woman reaches up to touch "Marilyn Monroe's" blonde wig. My camera app was already open and I was able to quickly compose and take a photo of this interesting gesture. I used a Moment 18mm wide-angle lens, which allowed me to include more in the frame even though I was quite close to the women when I took the shot.

Street Photography: Black and White or Color?

All but one of the street photography examples in this section are black and white. There is a strong tradition of using black-and-white photography in this genre, but that doesn't mean that street photography can't also be interpreted in color. The approach you use will be influenced by your own personal aesthetic, as well as by the color dynamics of the scene you're photographing. In some scenes the color is an important element, and the photos would not be as effective in black and white (**Figure 33.7**).

33.7 Each of these images works better in color, either for showcasing the bright and bold tones of a county fair or for the contrast of the woman's blue shorts peeking out from the photo booth.

34. NIGHT PHOTOGRAPHY

AS WE SAW earlier in the book, photography is all about capturing reflected light in a scene to make an image. The challenge of night photography, especially with the smaller image sensors in phone cameras, is that there is much less light to work with. But less light, even significantly less light, does not mean you cannot make good images. It just means you have to be a bit more mindful of the scenes you photograph, how you stabilize the camera, and in some cases, use specialized apps to get the most out of photographing the world after dark.

The main limitation that smartphones have with night photography is the very small image sensor required by the form factor, which tends to produce images with more noise. As we discussed earlier, the size of the lens aperture can also affect night or low-light photography. Aperture controls how much light passes through the lens, which can influence the length of the shutter speed; speeds that are too slow can cause a lack of sharpness or blurring due to camera motion.

34.1 Tripods are not the only way to stabilize an iPhone for low-light photography. For this photo, I stabilized my iPhone on the top of a newspaper box.

Stabilize the Camera

Because low-light or night photography typically requires slower shutter speeds to gather enough light for a "good" exposure, finding a way to stabilize the camera during the exposure is critical if you want an image with good focus and no motion blur.

- **Brace the Camera.** Find a stable surface (a wall, table, ledge, car roof, friend's shoulder) and brace the camera against it to keep it as still as possible during the exposure (**Figure 34.1**).
- **Use a Tripod.** This is the classic way to stabilize a camera. Tripods are available in a wide range of sizes, from compact models that will easily fit in a coat pocket to bendable tripods that can be mounted in difficult locations to selfie stick/tripod combos (**Figure 34.2**). In most cases you'll also need to acquire special mounting hardware to attach the iPhone to the tripod (**Figure 34.3**).

Keeping the camera still during the exposure records the non-moving elements of the scene in focus, and can render moving subjects with blur as they move through the scene (**Figure 34.4**). We'll be looking at this technique in more detail in the next section.

34.2 Tripods for your iPhone come in a variety of sizes and capabilities, from compact models to tripods with bendable legs (such as the Gorillapod) to selfie sticks with short tripod legs hidden in the handle (such as this one pictured from Yoozon).

34.3 If you want to use your iPhone on a regular tripod, you'll need an adapter to attach it. The MeFoto Sidekick 360°Plus is one model that easily fits my larger iPhone and offers both vertical and horizontal positioning. The flat base also lets you use it without a tripod to stabilize the camera on a surface such as a table.

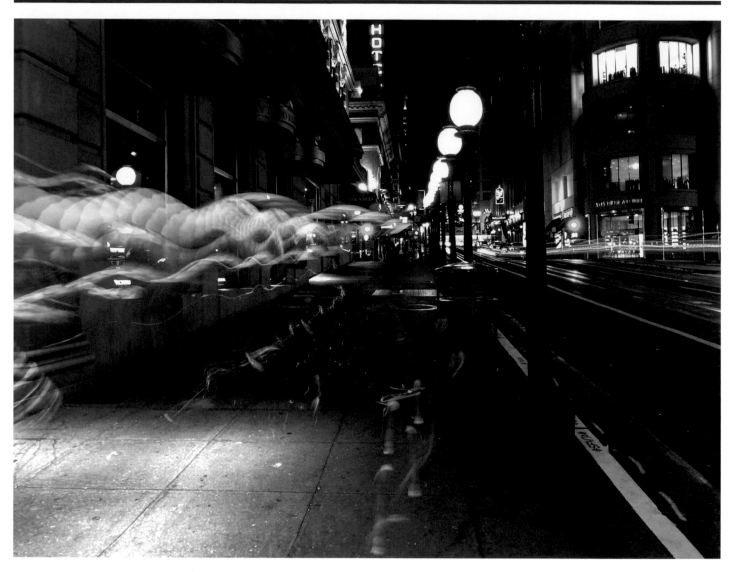

34.4 One of the pleasures of long-exposure photography is being able to experiment with motion blur. Stay tuned for a deeper dive into that topic.

Twilight and the Blue Hour

The best time to begin your night photography explorations is well before dark. You want to be ready to go in the early evening—at twilight (**Figure 34.5**) (plus, showing up early means you might get a chance to shoot a late afternoon or sunset). Twilight is also known as the "blue hour": the time when the sky takes on a lovely shade of blue that gradually darkens as the evening transitions into the dark of night (**Figure 34.6**). The primary advantage of shooting at twilight is that there is still some light in the sky, which adds color and more obvious visual separation between the sky and the scene below it.

34.5 Just before twilight in San Francisco: This is a handheld shot made with the native iOS camera. The lens blur and partial black-and-white effect were applied in Snapseed.

34.6 Twilight and the blue hour are excellent times to begin your exploration into night photography.

Share Your Best Blue-Hour Shot!

Once you've captured a great blue-hour shot, share it with the *Enthusiast's Guide* community! Follow @EnthusiastsGuides and post your image to Instagram using the hashtag *#EGbluehour*. Search that hashtag to be inspired and see other photographers' shots, as well.

Follow the Light

Some of the most challenging types of night photography with a phone camera are scenes in very dark environments with little or no artificial light, such as out in the countryside. In these very dark locations, the native camera app on iOS is not suitable to make a clear shot, even if you have the phone on a tripod. You'll have to explore other apps that are designed for longer exposures and darker environments (we'll explore some of those a bit later).

In many nocturnal scenarios, however, especially in towns or cities where artificial light is a part of the nightscape, you can create very interesting night scenes with the existing light. The illumination created by such artificial sources as streetlights, business signs, and car headlights, helps add shape and form to the scene, defining it and making it more recognizable. Even if the resulting shot has stark shadows and bright highlights, the added light reveals the contour of the location (**Figure 34.7**). In some scenes, a very minimal contour may be all you need (**Figure 34.8**). The ambient light also allows a better chance of getting a sharp photo while handholding the iPhone (although stabilization against your body or some other surface is still recommended for the sharpest shot).

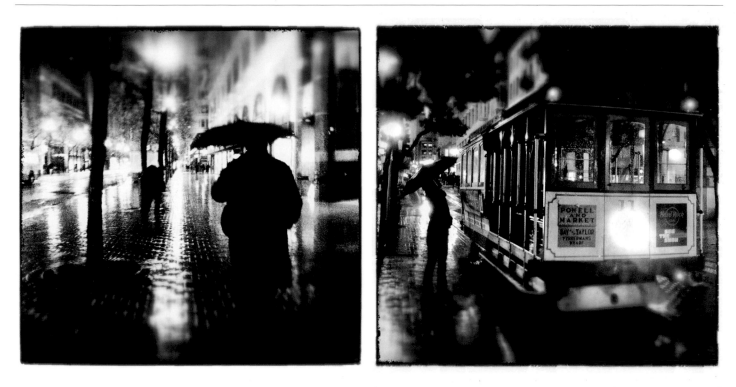

34.7 Two handheld shots from a rainy night walk in San Francisco. The slight soft quality from a radial-blur effect added in Snapseed adds to the mysterious, film-noir mood of the images.

34.8 Even a very small amount of light can be enough to add shape and context to the dark scene before the lens. In these examples, the thin sliver of light defines the shape of the fountain, and light from the window and nearby streetlights illuminates the building.

Use Night-Photography Apps

Because low-light or night photography typically requires slower shutter speeds to gather enough light for a clear image, there are specialized apps better suited than the native iOS camera for capturing night scenes.

- **Average Cam Pro.** This is an excellent app for taking long night exposures with minimal noise. If conditions are right, you can even reveal the beauty of a starry sky over a silhouetted landscape. You can configure the app to take many exposures (up to 128) of a scene (**Figure 34.9**). These are averaged together to create an image with more brightness and less noise than would be possible with a single exposure (**Figure 34.10**). Working with an app that blends that many exposures means you must have the iPhone immobilized on a tripod. Any motion in the scene will be rendered as a blur. This effect can look very intriguing, but not if you're looking for a crisp shot.

- **NightCap Pro.** This app offers several modes and features designed to produce better night photos, including modes for Long Exposure, Light Trails, Stars, Star Trails, Meteors, and even the International Space Station (**Figure 34.11**). It also offers support for the Apple Watch, allowing you to control many of the app's features from that device.

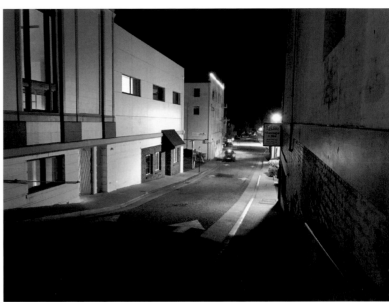

34.9 The settings screen for Average Cam Pro configured to average 32 shots together.

34.10 An average of 16 separate exposures created with Average Cam Pro. The ambient light is from streetlights, interior lights, and the tail lights of a passing car.

34.11 This image (left) is a 10-second exposure made with NightCap Pro using the Stars Mode (above).

Add Your Own Light

One of the most challenging types of night photography with phone cameras is when there isn't enough light to illuminate the forms in the scene. These situations may call for you to add your own light sources. You can also add lights to open up the darkest areas of the scene. I'm not referring to the onboard flash in the camera app, which has very little reach, but to small external LED lights, such as the Lume Cube (**Figure 34.12**). With 10 levels of brightness up to 1500 lumens, the Lume Cube can really light up a large area at night (plus it's waterproof down to 100 feet). In **Figure 34.13**, taken with the native iOS camera app, the Lume Cube revealed the details along a forest path at night. It's not just for illuminating large areas; it also works for smaller locations. In **Figure 34.14** the artwork is well lit, but everything around it is very dark. A Lume Cube at low power helped open up the dark shadows to show more details of the stairwell, which gave more context to the location.

A device such as the Lume Cube represents a very flexible way of bringing your own light to a nocturnal scene. It offers enough brightness to light a large and somewhat distant location. But you can also use ordinary flashlights and other battery-powered lights. Sometimes you can find unexpected compositions with these types of lights, such as in **Figure 34.15**, which I took while walking the dogs one night.

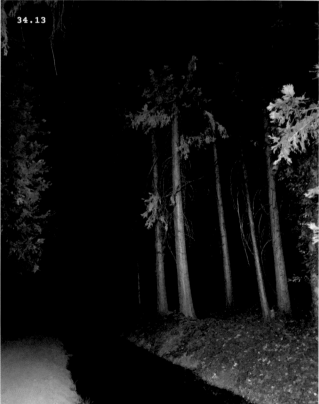

34.12 A Lume Cube has ten levels of brightness up to 1500 lumens, has slave flash functionality, and is waterproof down to 100 feet.

34.13 Lighting up a dark forest path with a single Lume Cube.

34.14 A Lume Cube held in one hand helped to slightly lighten and open up the left side of the photo, which was mostly black.

34.15 A wispy sapling illuminated by a small flashlight.

35. LONG EXPOSURES AND MOTION BLUR

WE'VE ALREADY TOUCHED on using longer exposures, or multiple averaged exposures, for night photography. One aspect of longer exposures is that any motion in the scene will be blurred, which can create some very interesting results. The native iOS camera doesn't offer a slow shutter speed mode (the maximum exposure time is ¼ of a second, and speeds that slow are only used in very dim conditions). However, it does have a way to create a long-exposure effect from the 3-second clip created as a Live Photo. The Live Photo feature is turned on by tapping the concentric circles at the top of the iOS camera app. It records 1.5 seconds before and after the still photo. When you press on the image in the Camera Roll, it plays back with sound, giving you a short glimpse of the live action that was present when you took the photo.

Long Exposure Effects with Live Photos

Stabilize the camera as much as possible, and make sure that Live Photo capture is enabled (look for the yellow circles at the top center or left side of the iOS camera). Find a subject with moving elements that you want to be blurred. A fountain, river, or waves at the beach works well for this feature. Fast motion, such as cars, bicycles, or even people walking at a brisk pace won't work with this effect—subjects with fast-motion speeds won't result in anything recognizable in the final image (**Figure 35.1**).

After taking the shot, review it in the Photos app. Swipe up to reveal the Live Photos effects you can apply (**Figure 35.2**): Live (the default), Loop, which creates a continuously looping short video, Bounce, which is a video that plays forward, then "bounces" backwards, continually repeating the cycle (similar to the Boomerang feature in Instagram), and Long Exposure, which averages the entire Live Photo exposure into one shot. Choose an effect and it will be applied. You can always choose another effect or reset to the default Live Photos view. With the right subject, the Long Exposure effect

35.1 The red taillights of a car passed through this scene during the Live Photo, but the car's speed was too fast for it to register in the Long Exposure effect.

35.2 The effects choices for Live Photos.

created from a Live Photo can create a pretty good visual approximation for an actual long exposure (**Figure 35.3**).

Apps for Motion Blur

If you want to explore the world of motion blur, you'll have to use apps that are specifically designed for this purpose. Here are some of my favorites:

- **Slow Shutter Cam.** This app is not a true long-exposure app; rather, it takes multiple shots over a specified period of time and blends them together (**Figure 35.4**). Slow Shutter Cam has three capture modes: Motion Blur, Light Trail, and Low Light (**Figure 35.5**). Each mode has controls for adjusting the time of the exposure and the ISO. Specific modes also have controls for Blur Strength, Light Sensitivity, and Noise Reduction.

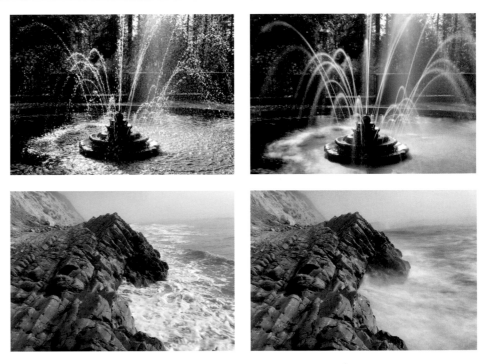

35.3 The Long Exposure effect for Live Photos works very well with moving water, as can be seen in these images of a fountain and waves breaking on the rocks.

35.4 A bus pulls up outside a bookstore in San Francisco. I did not have a tripod with me for this shot, but managed to brace the iPhone for an exposure time of one second.

35.5 Tap the gear icon to reveal the capture settings for Slow Shutter Cam.

Because of the way this app captures images, you are not limited to shooting at night. You can use it in bright, daytime conditions when actual long exposures would result in photos that are drastically overexposed (**Figure 35.6**). Another cool aspect of this app is that you can watch the motion blurs build up in real time. Tap the shutter button to stop the exposure when you like the level of blur, or let it go until the end of the chosen shutter speed. One of the things I like about Slow Shutter Cam is that I can also use it to create interesting effects by "painting" with the light in the scene. This approach involves purposely moving the camera in specific ways to create light trails and motion blur, such as the triptych in (**Figure 35.7**). For these images of the neon lights near the exterior box office of a movie theater (seen in Figure 35.5), I moved the camera in curving motions to make designs from the brightly colored lights.

- **Adobe Lightroom CC for mobile.** The camera in this versatile image-processing and image-organization app has a Long Exposure mode. This mode works similarly to Slow Shutter Cam in that it takes many photos to blend together into an image in which the motion is blurred (**Figure 35.8**). The only control in this app is a slider that lets you set the duration of the shot (**Figure 35.9**).

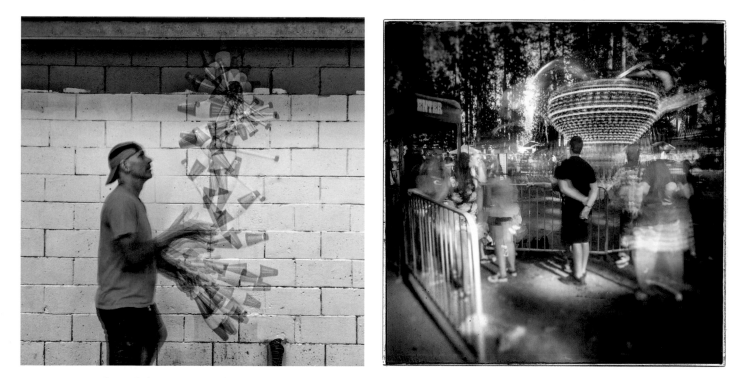

35.6 Two examples of images taken in bright daylight conditions with a slow shutter speed. The juggler exposure was taken with the iPhone was on a tripod. The fair photo was further processed with a sight radial blur and a vintage effect in Snapseed.

35.7 The lights were stationary in this scene, but moving the iPhone in a curving motion during a 2-second exposure created interesting and colorful abstract designs.

35.8 A 2.5-second image made with the Long Exposure mode in the Adobe Lightroom CC for mobile app.

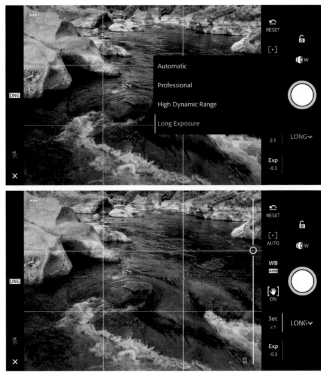

35.9 The controls for Long Exposure mode in Adobe Lightroom CC for mobile.

- **NightCap Pro.** As with Slow Shutter Cam, the Light Trails mode in NightCap Pro lets you see the blur of your moving subject build up in real time. Tap the shutter button to stop the exposure. Even though this visual effect is transitory, it adds an interesting element to the experience of making the image (**Figure 35.10**).

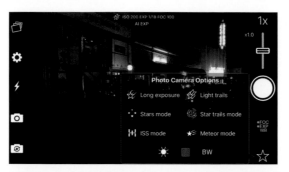

35.10 Nightcap Pro has a special mode for Light Trails that can be used either at night or during the day. It also has other night-oriented photography modes.

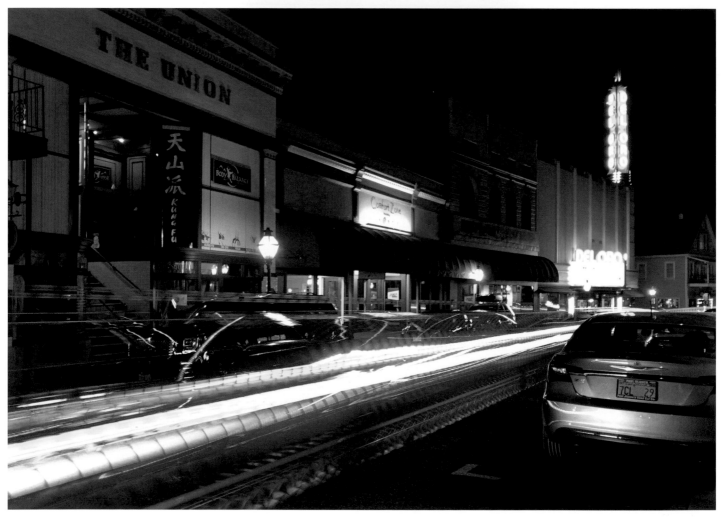

36. CLOSE-UP AND MACRO PHOTOGRAPHY

ANY TIME YOU focus (pun intended!) on one particular area of photography, you discover new ways of seeing. The same is true for close-up or macro photography. The great thing about exploring the close-up world with the iPhone is that you can get started without buying any new lens attachments.

The close-focusing capabilities of the iPhone camera's built-in lens are very good.

Consider the images taken with an iPhone 7 Plus in **Figure 36.1**: The lens was about 3.5 inches from the leaves. The soft blurring of the background occurs with the iPhone when you are very close to an object. A tripod was used for this shot, not for slow shutter considerations, but because it was more comfortable in composing this low-angle shot. In **Figure 36.2** you can see I was able to get good focus at as close as 2.75 inches.

36.1 By placing the leaves close to the lens (3.5 inches away) and positioning them on one side, I opened space on the right side of the image to include the large oak in the background.

Get Closer with Add-on Lenses

If you want to bring the subject even closer, or explore very small items as subjects, then you'll need to invest in an accessory lens that attaches to your iPhone. There is a variety of close-up or macro lenses available, ranging from simple clip-on lenses to lenses that fit into a bayonet mount on a special mounting plate or case designed for the lens. Be warned: Not all types of lens-mounting systems work with all types of iPhone cases.

- **Moment Lenses.** My favorite accessory lenses for the iPhone are made by Moment. These lenses feature excellent glass optics and a proprietary mounting system that works with a metal plate you attach to the iPhone (included with the lens). You can also purchase an accessory case that has the mount included, which is how I like to use these lenses (**Figure 36.3**).

In addition to excellent wide-angle, telephoto, and fisheye lenses, Moment offers a 10X Macro lens that lets you get very close to your subject. Additionally, the white translucent hood not only provides a quick focusing aide (when it touches a surface, the subject is in focus), it also lets you temporarily corral insects under the lens so you can get a shot before they scurry away (**Figure 36.4**).

36.4 The translucent hood/focusing aid on the Moment 10X Macro lens prevents a fast-moving centipede from escaping the photo shoot.

36.3 Moment has a variety of accessory lenses with a bayonet mount that attach to the iPhone via a metal adhesive plate that comes with each lens, or with an accessory case that has the mounting ring as part of the case design.

- **Olloclip Lenses.** As their name implies, Olloclip lenses simply clip onto the existing lens of your iPhone (**Figure 36.5**). They offer accessory lenses in a variety of configurations, with a single clip-on attachment typically containing two or three different lenses. Their macro kits are available in different configurations, and there is a version that comes with three macro lenses in magnification strengths of 7X, 14X, and 21X (**Figure 36.6**). Olloclip lens kits are also available with lenses that offer telephoto, wide-angle, or fisheye, and some of these kits also include a single macro lens.

Simplify the Background

With some types of macro photography, there may be distractions in the background. Even though it will be out of focus, there still may be bright highlights that draw the viewer's eye from the main subject. An easy way to simplify the background and create a studio-style look is to place a piece of black art board or foamcore behind the subject (**Figure 36.7**). Because your view is a close-up, the background material does not have to be very large to fill the frame behind your subject. The backdrop card does not to have to be black, of course; feel free to explore other colors as they suit your creative purpose.

36.5 An Olloclip lens attachment with three macro lenses: 7X, 14X, and 21X. The 14X lens (pictured with a translucent hood/focus aide) unscrews to reveal a 7X lens underneath.

Focusing with Macro Lenses

Focusing with accessory close-up lenses is usually accomplished by moving the camera closer to the subject until you get a sharp focus. The depth of field is generally very shallow with these lenses, and a tripod or some other form of camera stabilization is useful to keep the focus consistent between shots (Figure 36.5 shows the iPhone mounted onto a small tripod). If you are on the go and don't have a tripod with you, try shooting a burst of several photos; that way you have the chance of getting a few shots in good focus.

36.6 The first image shows a coin (approximately 1 inch or 25.5mm in diameter) as large as it could be captured in focus with the standard iPhone lens. The subsequent images show it photographed with Olloclip macro lenses at 7X, 14X, and 21X magnification.

36.7 A black card or piece of foamcore can be very useful in creating a background free of distractions in a close-up photo.

37. PORTRAITS AND PEOPLE PHOTOGRAPHY

PEOPLE ARE ONE of the most common subjects for mobile photography. It's both fun and meaningful to photograph our family and friends. For the purposes of this discussion, a portrait is a photo where the subject is aware they are being photographed and may be an active participant in the process. This sets it apart from more candid or street photography.

For the best portraits, pay careful attention to the lighting and the location where you are shooting.

The Normal Lens versus the Telephoto or Portrait Lens

The standard lens on an iPhone is a moderately wide-angle lens. Higher end iPhone models since the 7 Plus also have a second camera with a moderate telephoto or portrait lens. If you have an iPhone with a portrait lens, or if you have an accessory portrait or telephoto lens, consider using that for portraits. Typically lenses with a portrait or moderate telephoto focal length (50mm–65mm) create a more flattering view of the face than the iPhone's standard wide-angle lens (**Figure 37.1**).

If all you have is a wide-angle lens, try not to get too close because this tends to add a slight distortion to the facial features. Wide-angle lenses are great for showing more of the subject or for showing more of the scene around the subject, but they are not ideal for a close-up view of a person's face.

Portrait Mode to Blur the Background

If you have a dual-camera iPhone, don't forget the Portrait mode. This mode automatically uses the moderate telephoto or portrait lens to capture the subject and uses the wide-angle lens to separate the foreground from the background. It then creates a depth map that applies live, real-time computational background blurring. This effect creates a more classic portrait look, like you might expect from a digital SLR camera (**Figure 37.2**).

The Portrait mode isn't perfect and there may be some subjects and background combinations in which the edges between the blurred areas and the in-focus areas are not perfect, but in many scenarios the results are very impressive. We'll explore other ways you can take advantage of the Portrait mode depth map for creative processing later in this section and in the section on double exposure and compositing.

37.1 The standard wide-angle lens on the iPhone (left) is typically not as flattering for portraits as a moderate telephoto or portrait lens (right).

37.2 If you have a dual-camera iPhone, you can use Portrait mode to create computer-generated background blurring. This works best when the subject is 5 to 8 feet away and has good tonal separation from the background.

Find Open Shade for More Flattering Light

If you're outside and want to make a portrait, look for areas of open shade. This diffused light is more flattering for portraits than harsh, bright sunlight. In sunny conditions, people often squint, and there can be bright highlights on foreheads and dark shadows from facial features. Open shade offers a softer and more even quality of light (**Figure 37.3**).

This is not to say that you cannot make interesting portraits in hard, high-contrast light. This quality of light will create bright highlights and deep shadows, and can work well with high-contrast black-and-white treatments, where a classically flattering look is not the objective.

Take Advantage of Window Light

Window light, especially, softer, indirect light, has long been used in portraiture because it is flattering and versatile. A classic portrait setup utilizes soft winter light from a north-facing window. If the light comes through a thin curtain or drape, the material will help soften the light. You can modify the placement of curtains that block the light to create the specific lighting look for your intended portrait (**Figure 37.4**). Window light doesn't always have to come from a window; any small opening that directs light onto your subject will work. Consider the image in **Figure 37.5**, in which a narrow opening in the side of an abandoned snow shed in the Sierras created beautiful portrait lighting.

37.3 Open shade, or the lighting found on an overcast day, always creates more flattering light for portraits than bright, harsh sunlight.

37.4 Photographers have long favored indirect window light as flattering for portraits. In this portrait, there is also another window creating a nice backlight effect on the woman's hair.

37.5 Light coming through a narrow opening in a dark mountain tunnel provided unexpected, almost studio-quality light.

Simplify the Background

A busy, cluttered background contains visual distractions, especially when photographed with the standard wide-angle camera-phone lens. When you make up your mind to create a portrait, try to find a location where the background is simple, with fewer details to distract the eye (**Figure 37.6**). Locations with a background that is dark and far away from your subject work very well, as seen in Figure 37.5. You may be able to take advantage of a black (or white) cloth that can be arranged behind your subject. Consider the color of your subject's skin and clothing, and pick a background color and tone that will make their face the most prominent element in the image. For some portraits, you might also consider leaving in certain background elements that reveal a little bit about them, who they are, and what they do (**Figure 37.7**).

Environmental Portraits

The goal of environmental portraits is to show a person in the environment where they live, work, or play. This type of portrait usually includes details that tell a story about the person's relationship to that location.

The iPhone's standard wide-angle lens is often the preferred choice for environmental portraits because you can include more of the subject's surroundings. Consider placing the person off to one side of the frame, allowing you the rest of the composition for the location. Environmental portraits are often used in documentary photography because they effectively tell a visual story about the subject (**Figure 37.8**).

Not all environmental portraits have to be taken with the wide view; some subjects and the work they do may lend themselves to a more close-up approach.

37.6 These portraits were made in the same location. In the first photo, the background contains distracting elements. Moving a few feet and shooting a slightly different angle created a more simplified background that does not detract from the subject.

37.7 Working some background elements and details into a portrait can add context by revealing something about the subject, such as this image of an author in his study.

37.8 A ceramics artist working on her sculptures. Placing the subject on one side of a horizontally oriented composition left plenty of room in the image to also show her artwork and her studio.

Using Depth Maps for Creative Portrait Editing

The PortraitCam app by Brain Fever Media lets you take the basic background-blurring effect that shooting in Portrait mode provides and then customize the blur in a variety of ways (you can also shoot directly from the PortraitCam app). You can adjust the amount of blurring and even change the shape of the blurred highlight points in the background. There are spin blur controls, color-fringing effects, and a variety of other available adjustments (**Figure 37.9**). You can use the depth map created by Portrait mode as a mask, or you can apply a blurring effect using more traditional radial, linear gradient, or landscape (tilt-shift) masks. You can also use a wide choice of lens-flare effects and color filters to top off your image with some final visual seasoning. You can even take a photo that was not shot in Portrait mode and, through face and edge detection, create and edit a mask to separate the foreground subject from the background and apply the same blurring effects that you would with a camera-generated depth map (**Figure 37.10**).

37.9 PortraitCam provides many ways to modify and customize the blurring effect created by a depth map for photos taken in Portrait mode.

37.10 The Face Detection feature in PortraitCam offers good edge detection that can help to create a depth map, even for images that were not photographed in Portrait mode with a dual-camera iPhone.

38. FOOD PHOTOGRAPHY

DID PEOPLE TAKE as many pictures of their food before there were camera phones? I think not. The ease of camera-phone photography combined with being able to instantly share your photos to family and friends led to the rise of "this is the meal I'm about to enjoy" photography. If you're like me, you may occasionally roll your eyes when you see a fellow diner taking a snapshot of their food in a restaurant. But, I've done it, too! Sometimes the arrangement of delicious meal on a plate is so visually pleasing that you feel compelled to document it, especially if food and fine dining are your passions. Whatever moves you to make an image, here are a few tips for taking better photos of food.

- **Remove Distractions.** For the classic overhead shot looking down at the plate, make sure there are no distractions in the edges of the frame (parts of silverware, the edge of napkin, etc.) that don't need to be in the photo (**Figure 38.1**).

38.1 A simple overhead study of just the appetizer plate, with all other table elements removed.

- **Include Design Elements.** Having a clean area surrounding the plate is one approach, but look around the table and see if there are other elements you might add to the composition. Perhaps the silverware is particularly interesting (or you can position it in an interesting way, as seen with the candle reflection on the knife in **Figure 38.2**), or maybe you can arrange colorful placemats or napkins to add bold and vibrant shapes and colors to the image. Moving beyond the classically centered arrangement will make space for other elements.
- **Explore Different Angles.** The downward view of the plated food is common because it's natural to point your iPhone lens down at the plate and take a quick snapshot. But, as with any type of photography, once you've taken that first shot, see if you can find other angles and ways of framing the subject that may be more interesting and dynamic (**Figure 38.3**). Even the overhead view can be livened up with creative framing that only includes part of the plate (**Figure 38.4**). The more you look, the more you'll see.

38.2 After the first shot, further exploration revealed an interesting reflection on the blade of the knife and an arrangement of shapes and diagonal lines that was visually engaging.

38.3 Treat the food as you would any other subject and look for different camera angles or ways to position the plate. The more you work with a subject, the more refined your framing becomes. The second image has more depth and gives a better view of the food.

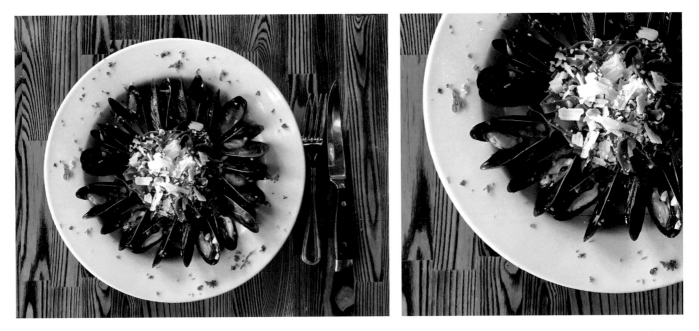

38.4 Even the basic downward view can be made more interesting with tighter framing that shows only a portion of the plate. The circular plate in this shot works particularly well with this approach.

- **Take Advantage of the Light.** Whatever you photograph, always be thinking of how the light affects the scene and how you might modify it to create a better image. When days are longer, you can plan a restaurant visit in the early evening to take advantage of window light. In **Figure 38.5**, I used a small plate as reflector to bounce fill light onto the shadowed side of the scene (you can see the results of this impromptu reflector in **Figure 38.6**). A large window at the front of the restaurant let in plenty of natural daylight for the table.

- **Include Some of the Background.** Food photography is not just about the food. The place where you're enjoying a fine meal might be a big part of the story. Look for ways to photograph the food while also working in some of the surroundings. This could be as simple as an angled view that shows the plate (or part of a plate), the red-and-white-checkered tablecloth, the salt and pepper, the fresh bread and balsamic vinegar, or a fireplace in the background (**Figure 38.7**).

38.5 If there is a lot of natural light, try use a light-colored plate or napkin as a reflector.

38.6 Lit only by window light, the first image has darker shadows on one side. A small white plate was used as a reflector to add fill light, as seen in the second image.

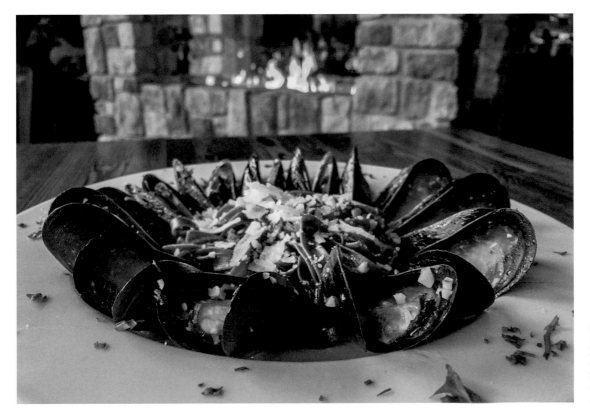

38.7 An interesting background can add a lot to a food photograph: It shows location, establishes a mood, and maybe adds a splash of color.

- **Head into the Kitchen.** Of course, not all food photography is centered on the meal. Photographing the ingredients as they are being prepared is also an effective way to find interesting and colorful subject matter (**Figure 38.8**). This is easy when you're in your home or at the home of a friend, and if you know a restaurant owner, you might be able to arrange a cool photo shoot. Ripe vegetables being sliced and diced on the cutting board offer texture, color, and shapes that can be arranged and photographed in a variety of ways.

Dealing with Low Light

If the light levels are low, you have to find creative ways to bring more illumination to the scene. One way to brighten the scene is to have a companion use another phone to add more light (**Figure 38.9**). The color balance of this illumination is typically cool. You can also use a secondary light in various positions; this approach is preferable to the iPhone's built-in flash, which will reflect back at the camera. Play around with the placement of the candles on the table to brighten the image in a more natural way, as seen earlier in Figure 38.2. I've even asked for an extra candle if I needed more light!

38.8 The Portrait mode on an iPhone 7 Plus provided pleasing background blurring in this image.

38.9 In darker situations, the glow from another mobile phone can add enough light to make a photo.

39. DOUBLE EXPOSURES AND COMPOSITES

WHEN TWO OR more photos are blended together the result is referred to as a double-exposure effect or a composite image. There are many photo apps available for the iPhone that make this type of image blending easy.

Double-Exposure Blending

Back in those thrilling days when cameras used film and not pixels, a double exposure was created when a frame of film that had already been exposed with one image was exposed again with another scene. On some cameras this was an intentional operation, but on cheap cameras it was usually accidental; if you forgot to advance the film after taking a shot, you would get an unplanned double (and sometimes triple) exposure (**Figure 39.1**).

In apps that offer a double-exposure effect, you are typically working with photos that are already on your Camera Roll. The blending is achieved through blending modes. If you have ever worked in a program like Adobe Photoshop or Photoshop Elements, you may already be familiar with blend modes. The key to using them effectively with your iPhone photos is understanding how they affect the tonal values of black, white, and gray.

39.1 A film double exposure made in a plastic Holga camera.

Both very dark and very light colors can be controlled through certain blend modes to be rendered invisible in the final image (or partially visible with some transparency), allowing the details of a second photo to appear in the empty space. Consider the two source photos in **Figure 39.2**: I added circular shapes containing white, middle gray, and black to the winter scene. In Figures **39.3–39.5** you can see how these two images are combined when specific blend modes are applied to the top layer of the winter scene (I used the Adobe Photoshop Mix app for this blend mode example).

- **Hiding White or Light Areas.** The Darken and Multiply blending modes will completely hide white areas and partially hide lighter areas with tonal values less than total white. Anything darker than the underlying image will be visible in the composite or double exposure (**Figure 39.3**).
- **Hiding Black or Dark Areas.** The Lighten and Screen blending modes will completely hide black areas and partially hide darker areas with higher tonal values than total black. Anything lighter than the underlying image will be visible in the composite or double exposure (**Figure 39.4**).
- **Hiding Middle Gray.** If there are tones in the image that are close to middle gray in brightness, the blending modes of Overlay and Soft Light will conceal those image tones (**Figure 39.5**).

If you position your subject against a black or very dark background, you can use the Screen blending mode to hide that dark area. Then the double-exposure or composite image can come through in that space. Lighter areas in both photos will visible. Conversely, if you photograph a subject against a white or very light background, you can use the Multiply blending mode to hide or diminish the bright areas.

39.2 Circular shapes containing white, black and middle gray tones have been added to the snowy scene to illustrate how different blend modes treat light, dark, and middle-value tones.

39.3 The Darken and Multiply blending modes will hide white areas and partially conceal lighter areas, depending on their brightness level.

39.4 The Lighten and Screen blending modes will hide black areas and partially conceal darker areas, depending on their brightness level.

39.5 The blending modes of Overlay and Soft Light will not show areas that are middle gray in brightness and will add more contrast to the blended image areas.

In-Camera Double Exposures with Hipstamatic

You have the most control over double exposures when you choose from images that you have already taken (and some, perhaps that you photographed just for this purpose). Hipstamatic is an app that channels the analog plastic or vintage camera experience not only in how it captures photos, but also in the presentation of the app itself, which has a variety of different interfaces that resemble those of old cameras.

Its double-exposure mode is very interesting. It replicates (in digital form) the experience of not advancing the film (either accidentally or on purpose), creating a double exposure of two images (**Figure 39.6**). As with an actual film camera, you have to shoot the images consecutively to create the double exposure; you cannot load in images from your Camera Roll. This offers an entirely different way to be creative with double exposures, because you have to react in the moment and think ahead about how to create an interesting blended composite with two images shot in sequence. Note that the only control you have over how the two shots are blended is what you choose to photograph and the arrangement of light and dark areas in each scene.

In the classic "plastic-camera" look of Hipstamatic, turn on the double-exposure switch in the upper left until it shows the yellow double-exposure icon, then take the first shot. The switch will move to a halfway point, indicating you can take the second photo. **Figure 39.7** shows these two stages of a double exposure. The first shot is of an old camera in my office, and the second shot is a view of the trees outside my office door. Once the second exposure has been made, the two exposures are blended together. Light areas that receive more exposure in either image will be dominant and more visible over the darker areas in either scene (**Figure 39.8**). Once you understand this basic principle, you can compose shots with some idea of how the light areas will be visible in the darker parts of a second exposure.

39.6 A Hipstamatic "in-camera" double exposure (as opposed to images combined after the fact in post-processing) made from two consecutive shots of a bronze sculpture and a butterfly in a display case.

Share Your Best Double Exposure!

Once you've created a great double exposure, share it with the *Enthusiast's Guide* community! Follow @EnthusiastsGuides and post your image to Instagram using the hashtag *#EGdoubleexposure*. Search that hashtag to be inspired and see other photographers' shots, as well.

39.7 The two stages of a double-exposure shot. For the first shot, the switch in the upper-left corner is turned on, showing the entire double-exposure icon. For the second shot, the switch has moved to a halfway point. Tap the picture button in the lower right to review the blended image. The images seen in the camera interface above are in the live view through the "viewfinder"; not photos that have already been taken.

39.8 The result of the Hipstamatic double-exposure process shown in Figure 39.7.

Isolate Objects with a Simple Background

Double-exposure blending relies on tonal values for combining images rather than specific selection of a particular object in a photo. Fortunately, there are apps that have smart brush and smart selection tools that make it easy to isolate an object from its background.

To make this post-production task easier, it helps to photograph objects that you want to use in a collage or photo composite against a background of a contrasting tonal value (i.e., lighter or darker than the subject) or color. When photographing subjects outside, you have to work with the background in the scene. Sometimes this can be challenging, but

at other times you might get lucky, as I did in **Figure 39.9**. For smaller to medium-sized objects where you have more control, the use of a black or white background can create the tonal separation that will come in handy in a compositing app (**Figure 39.10**).

39.9 The dark area of the doorway in the first photo made it relatively easy to create a double-exposure blend with the photo of the mountain tunnel. I used the Lighten blending mode and a few brush strokes of a very simple masking effect in the Union app combine the two images.

39.10 Simple setups for photographing a light object on a dark background and a dark object against a light background. I use poster board or foamcore for the background.

Apps for Double Exposures and Photo Composites

There are many different apps that offer features and functionality designed for creating blended or composite images. Here are some of the ones that I use on a regular basis to create my own iPhone composites:

- **Snapseed (Google).** This is more of an all-purpose, jack-of-all-trades photo app (and definitely one you should have!), but it does have a Double Exposure tool that is easy to use and provides a good introduction to simple image blending. It only has five blending modes, but three of those are Darken, Lighten, and Overlay, which work well for many images (**Figure 39.11**). With creative use of the masking provided in the Edit Stack feature of Snapseed, you can even apply masking to control which parts of an image are visible.

- **Union (Pixite).** This is an excellent app that I use when my compositing needs do not extend beyond two layers. This app provides the ability to apply basic tonal and color adjustments to a background image, as well as add a foreground layer (which you can adjust with the same tools) that can be controlled with a variety of very useful layer masking tools (**Figure 39.12**). You can edit a layer mask with brush tools and create a layer mask based on a radial or linear gradients, or common shapes. You can even use another photo as a layer mask and use a magic wand tool to create a mask based on color or tonal values in the foreground image. Layered projects can be saved with the layers and masks preserved so you can re-open them in the future and continue working on them. Pixite also offers a lot of other cool apps for adding design, graphic, and 3D elements to your photos.

39.11 The light feather was photographed against a black background, making it easy to blend it into the desert landscape with the Lighten blending mode in Snapseed's Double Exposure feature.

39.12 The Union app lets you place a foreground layer over a background image, combine them with blending modes, and fine-tune the composite with very useful masking tools. You can see the finished composite in Figure 39.9.

- **Adobe Photoshop Mix.** I use Adobe Photoshop Mix to explore images that require more than two layers of compositing. It has many useful features, including smart brush selections and masking (**Figure 39.13**). This app, available for iPhones and iPads, keeps getting better, and for intricate composite projects, it provides the tools and functionality I need. Plus, if you have an Adobe Creative Cloud subscription (the Photography Plan, which includes the full desktop versions of Photoshop, Lightroom, and all the mobile apps, plus an Adobe Portfolio site, is $9.99 per month), you can send a mobile Photoshop Mix file to Photoshop on your desktop, and it will be waiting for you (Wi-Fi permitting), layers, blending modes, and layer masks intact, when you get home.

This short list is a good place to start if you want to explore making double exposures and composites with your iPhone. For more tutorials on iPhone composites, check out my website at seanduggan.com.

Depth Maps for Replacing Backgrounds

As you recall from chapter 2, a depth map is created when an image is taken using the Portrait mode on a dual-camera iPhone. The photo is made with the portrait or telephoto lens, but the camera uses the view from the wide-angle lens to create a depth map that separates the foreground subject from the background.

Ever since Apple opened up the depth-map API to other app developers in iOS 11, there has been a range of new apps that leverage

39.13 Adobe Photoshop Mix offers the ability to use multiple layers, blending modes, content-aware selection and masking tools, and other essential image-adjustment capabilities.

this aspect of the photo and offer cool effects. Here are a few apps I've used that allow you to access the depth map for interesting effects:

- **Focos (Xiaodong Wang).** This app lets you create photographs with a depth map. You can also use it to apply a variety of effects with the depth mask, as well as apply simple edits to the mask itself. Unlike Portrait mode in the iOS camera, which only allows the background to be blurred, the camera in Focos lets you blur either the background or the foreground by tapping on the area you want to be in focus. As with PortraitCam, you can adjust the amount of blur and reshape the highlight points, as well as apply a variety of different "lens" presets. The real power of Focos is in its ability to use the depth map to apply a wide variety of image adjustments, including replacing the background (**Figure 39.14**). You can either import a new image for the background or export a version of the image where the background is replaced by black (and remember what we can do with a black background using the Screen blending mode!). You can also save a transparent PNG file (**Figure 39.15**), which can be imported as a new layer into another compositing app, such as Adobe Photoshop Mix or Union.

39.14 The original mountain lion statue showing some of the Focos controls for modifying the character of the blurred area, as well as options to use the depth map to apply a wide range of effects, including replacing the background, saving it with a black background, and saving it with a transparent background.

39.15 The mountain lion statue with a new background added in the Focos app, exported with a black background, and exported with a transparent background. Either the black or transparent background versions could be added as a layer in another compositing app.

- **DepthCam (Brain Fever Media).** This app is focused on visualizing the depth map with the DepthCam camera before you take the shot, as well as editing it after the fact and saving copies of both the image and the edited depth map, or just the depth map (**Figure 39.16**). It does not offer the creative enhancements that PortraitCam or Focos do, but it does provide several interesting ways to visualize the depth information in the image, including grayscale and color wireframe views, grayscale and color views, and 3D maps. Those who know their way around Photoshop can open the depth map and use it as a grayscale layer mask for adjustments or for a composite image. In some apps, such as Union, you can use a photo as a layer mask. By loading the saved depth map as a mask, you can apply it to your compositing projects (**Figure 39.17**).

39.16 The DepthCam app lets you see a preview of a rough depth map before you take the photo, providing confirmation of the depth information in the image. You can also modify the depth map and then re-save the image and the depth map, or just the depth map itself.

39.17 For this image, an edited depth map from the photo of the forest was saved from DepthCam as a separate image file. It was then applied as a mask to a foreground layer in the Union app.

40. EXPLORING EVERY DAY

THE PURPOSE OF this chapter (and, indeed, the whole book) is not to cover every possible type or genre of photography you might pursue with your iPhone, but to provide an overview of important technical skills and conceptual approaches you can use to control how your images look. With every photograph you make, you will learn something that will eventually find its way into other images and photographic situations you encounter. Even the mistakes are valuable! In fact, it's likely that you'll learn more from the shots that don't work out than you will from the immediately successful shots.

Understanding and using proven photographic composition and lighting techniques will allow you to use the very capable iPhone camera and image-processing platform to create the types of photographs that move you, intrigue you, and excite you. A key component of making such images is to never stop exploring, looking, or seeing. A camera is a passport to see the world in new ways, to notice things that you might ordinarily pass by, and to engage with other people and situations on a new level.

40.1 This is a cropped section from a larger panorama made with an iPhone 6. The full-size image is 24 megapixels and could easily be printed 36 inches wide.

6

CAPTURING MOTION
WITH VIDEO

CHAPTER 6

In addition to a camera that creates still images, the iPhone also has excellent video capabilities for capturing motion in different ways. In addition to regular video, you can also capture slow motion and super slow motion, as well as record time-lapse videos that compress a long period of time into a short clip of less than a minute.

Because your camera phone is with you most of the time, this allows you to capture photographs of all the unexpected moments that catch your eye. The excellent video capabilities of the iPhone mean you can do the same thing with sound and motion.

41. CHOOSE A VIDEO ORIENTATION

THE FIRST THING to decide when shooting video is how to hold the camera: Vertically or horizontally?

For most uses, the iPhone is commonly held in a vertical position. The classic presentation of film and video, however, is in a horizontal orientation. Vertical video is more common these days, especially for formats such as Instagram Stories, and is often the default camera position for non-photographers (**Figure 41.1**). It's certainly easier to hold the camera that way if something unexpected starts happening, but a horizontal video is a more natural fit for how we are used to seeing the world on video. Plus, it presents a larger image when viewed on a computer display, TV, or iPhone in a horizontal position (**Figure 41.2**).

No matter what format you choose for your videos, make sure to have the iPhone positioned this way *before you start recording*. The position of the iPhone at the start of the video determines how it is displayed (horizontal or vertical) throughout the entire video. Rotating the iPhone into a different position while recording will result in a video that is flipped on its side.

41.1 Vertical video is common for non-photographers, or people wanting to fit the video to a specific publishing platform, such as Instagram Stories, but it's not ideal for showing horizontal subjects, such as landscapes, or for easily combining with other clips that have been recorded in a horizontal orientation.

41.2 If you want your videos to have more of a cinematic look, hold the iPhone in a horizontal (landscape) orientation while recording.

Easily Rotate Video with Google Photos

A common video mistake with camera phones is to start recording in a vertical position and then change to a horizontal orientation mid-recording. This will result in a video that starts vertical, and then gets flipped on its side, while still being presented in a vertical format. As of this writing, the video-editing controls in iOS (more on that later) are very basic and do not include a way to rotate a video that was changed mid-recording to a different orientation. Fortunately, the free app Google Photos does provide a way to do this.

When viewing a video in Google Photos, tap the icon showing the three sliders to enter the Edit mode, and then tap Rotate (**Figure 41.3**). Next, use the Trim markers at either end of the timeline to trim off the part of the clip that was recorded in a vertical position (**Figure 41.4**). Tap Save in the upper-right corner of the screen. The trimmed, rotated clip will be saved as a copy to your Camera Roll.

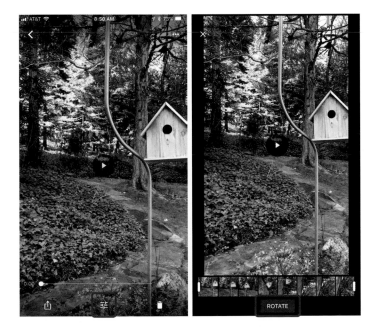

41.3 When viewing a video in Google Photos, tap the icon showing the three sliders to enter Edit mode. Then tap Rotate.

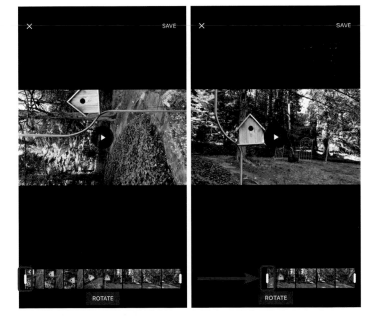

41.4 Use the Trim markers at either end of the timeline to trim off the part of the clip that was recorded in a vertical position.

42. RECORD A VIDEO

AS WITH A still photo, you can tap on the screen to set the initial focus and exposure, as well as use the AE/AF Lock feature mentioned earlier in the book. Press the red button to start recording. You'll see a timer at the top of the viewfinder showing how much you've recorded. As long as the AE/AF Lock is not being used, the focus will automatically shift to focus on the subject in the center of the frame. As you move through a scene while filming with the camera, the iPhone does a remarkably good job of adjusting the focus. If you need to manually set the focus while shooting video, tap the screen on the part of the scene you want to focus on (this will also set the exposure for that area, so you might see a quick shift in the overall brightness of the scene on the display).

The small white button will take a still frame while recording video. At 3412 x 1920 pixels (on a 12 mp iPhone), the size of this still grab is smaller than the default 4032 x 3024 size of a regular still photo, but still a good deal larger than the 1920 x 1080 dimension of the video.

To stop recording, just tap the red square. In the Photos app, you can find videos in their own album, as well as in the Camera Roll. Before we get to viewing videos and the simple edits you can apply to them, let's take a look at some settings that influence how the video is captured (**Figure 42.1**).

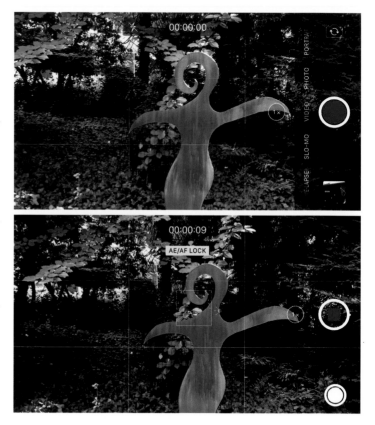

42.1 Video mode, as it looks before and during a recording. Note that AE/AF Lock is turned on in the recording view. Tap the white button to save a frame as a still photo (this option is also present in the Slo-mo video mode).

43. UNDERSTAND THE VIDEO SETTINGS

YOU CAN ACCESS the video preferences in iOS 11 by opening the Settings and scrolling down until you find the Camera settings (**Figure 43.1**). In earlier versions of iOS the camera and photo settings are grouped together.

- **Preserve Settings:** This is very useful if you want the camera app to always open into video mode, so you can be ready to record at a moment's notice. There's not a specific setting for this, but you can set

the camera to open up to the last camera mode you used (**Figure 43.2**).

- **Record Video:** In this setting you can choose the default frame rate (frames per second, or fps) for video. The default is 30 fps at 1080p resolution (1920 x 1080 pixels). In the example shown in **Figure 43.3**, I have mine set to 60 fps because I had recently been shooting falling water in a stream and I wanted a slightly faster frame rate so the movement of the

water would not appear jumpy.

If you want the maximum video quality (in terms of size), you can shoot in 4K, which refers to the fact that this size is approximately 4,000 pixels wide. This is an increase from just over 2 million pixels at 1080p to 8.2 million pixels for 4K. A chart on this screen will show how much storage space is required for one minute of video at the different frame rates and resolutions.

43.1 Choose the Camera settings to access options for recording video.

43.2 When Preserve Settings is enabled, the camera will automatically apply the last-used camera mode when you open the app.

43.3 In the Record Video settings, you can choose the frame rate (fps) and the resolution (pixel dimension) of the video. To render fast motion a bit smoother, try recording at 60 fps.

- **Lock Camera:** On iPhones with dual cameras, there's a Lock Camera setting that prevents switching between the 28- and 56-millimeter lenses while you're recording. This is useful if you don't want to accidentally switch lenses in the middle of shooting a clip.
- **Formats:** In this section you can choose between the High Efficiency setting, which is the newer HEVC or H.265 video format, or Most Compatible, which is the more common H.264 video format (**Figure 43.4**). If you're viewing your video primarily on your iPhone or iPad, or you have a Mac running the High Sierra operating system or later, then the High Efficiency setting

is fine. But if you need to work with your iPhone videos on a Mac that is not running High Sierra, or use them in other programs that may not yet recognize the newer HEVC/H.265 video codec, then choosing the Most Compatible setting may be the best choice until your other video-editing programs are updated to support the new format. There are also conversion utility programs, such as HandBrake, that can convert HEVC/H.265 video into H.264. Choosing Most Compatible will also apply the setting to still images, and the camera will use the JPEG format instead of the newer HEIF/HEIC image format.

43.4 The camera capture format settings apply to both still photos and videos.

44. REVIEW AND TRIM A VIDEO

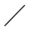

WHEN YOU PRESS the Play button to view a video, the rest of the screen goes black, which is a nice presentation background. If the video was taken in landscape orientation, rotate the phone to horizontal so the video can fill the entire screen. Tap on the screen to access the timeline under the video and a Pause button in the upper-right corner (or under the video if the iPhone is in a vertical position). You can swipe on the timeline to quickly scrub through the video if you want to skip to a specific part (**Figure 44.1**).

Tap Edit in the upper right of the screen to access the video editing options (**Figure 44.2**). In iOS 11, the only edit you can apply is trimming the video to set new in and out points. This is very common since the few seconds at the beginning and end of a video are often things that you want to cut.

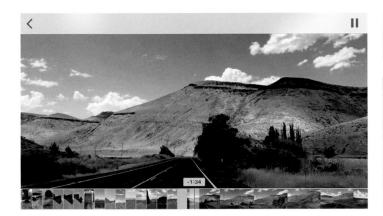

44.1 Tap the screen after a video starts playing to access the Pause button and the timeline, which you can use to scrub through the video to quickly move around in the clip.

44.2 When a video is paused, you can access the Edit screen to trim the video.

Drag on the white arrow on either side of the timeline to set a new in or our point. If you keep your finger on the timeline and pause, the timeline will expand to a closer view of the sequence, which makes it easier to apply your trims to just the right spot. When you tap Done, you can either cancel or save the trimmed version as a new clip (**Figure 44.3**). This new edited version of the clip will be added as the most recent item in the Camera Roll or All Photos view, but in the Videos album (as well as in the Moments view) it will appear next to the original clip, which will be ordered chronologically by date.

If you're in the Edit screen for a video and you tap the More button (three dots in a circle), it will show you other apps on your iPhone or iPad where you can send the video for further edits (**Figure 44.4**). You'll probably see iMovie there, since that is an Apple app. If you tap the More button here, it will show you all the apps installed on your device that can work with the iOS Extensions feature, and you can turn them on to have them available in the video's Edit screen. An app has to be specifically programmed to take advantage of the iOS Extensions feature in order to show up in this list.

44.3 In the Edit screen, drag on the arrows at the start or end of the timeline to apply a trim and specify new in and out points for the video. The Photos app will save this as a new clip, preserving the original.

44.4 Tap the More button to see additional video apps installed on your iPhone that are programmed to work as an Extension of the Photos app.

45. CAPTURE AND EDIT A SLOW-MOTION VIDEO

FILMING IN SLOW motion is definitely one of the coolest things you can do with the video capabilities on your iPhone. There's something fascinating and, at times, mesmerizing, about seeing moving subjects rendered in slow motion. Anything that moves is a potential subject: the dog running in the backyard, kids on a trampoline, falling snow, bubbles rising through water, a fountain in the afternoon sun, or a hummingbird coming in for a landing (**Figure 45.1**). Even the most ordinary scene can become magical when filmed in the slow-motion (Slo-mo) mode. Showing the wonders of slow-motion video is a bit hard to do in a printed book, of course, but you can do a search on YouTube to see a variety of subjects rendered in slow motion to give you some ideas.

Slo-mo Under the Hood: How It Works

If you recall from the previous section on video, there are different frame rates (the number of frames per second, or fps) you can use to shoot. The default for the iPhone, and many digital video recorders, is 30 fps. The Slo-mo features offers two high-speed frame rates: 120 fps and 240 fps. When video shot at those higher frame rates is played back at the normal rate of 30 fps, the action appears dramatically slowed down.

45.1 So many subjects can look cool when filmed in slow motion.

While we're on the subject of Slo-mo under the hood, let's take a look at the preference settings, which control the frame rate of the Slo-mo feature. As with the video settings, you can find these controls in Settings > Camera > Record Slo-mo. The choices you see will depend on which iPhone you have. The iPhone 8 and iPhone X allow for 1080p recording at both 120 and 240 fps, while the iPhone 7 and 6 series limit 240 fps recording to 720p (**Figure 45.2**). Bullet points under these settings tell you how much storage space is required for a minute of Slo-mo video using each setting.

Filming and Editing in the Slo-mo Mode

Apart from selecting the Slo-mo shooting mode, filming in Slo-mo is just like shooting a regular video: swipe and tap on the modes to find and select Slo-mo, then tap the red button to start recording and tap the red square to stop (**Figure 45.3**). The white button lets you take a still frame while shooting (it will be the same pixel dimension as the video).

Slo-mo videos can be found in their own album or ordered chronologically in the Camera Roll or All Photos view. When you review a Slo-mo video, it will begin at normal speed and then transition to slow motion after the start. Towards the end of the clip, it will switch back to normal speed again. You can change where the Slo-mo effect begins and ends by pausing the video and tapping on Edit in the upper-right corner.

The in and out points can be edited the same way as with regular videos. Above the timeline is a line of small marks showing the playback speed of the video.

45.2 The Slo-mo size and frame-rate settings.

45.3 The camera app in Slo-mo mode.

Marks that are close together are regular speed, and those that are farther apart are slow motion (**Figure 45.4**). You can drag on the playback speed marks to arrange these as you like to control when the slow motion playback begins and ends.

Slo-mo Playback on a Computer

Your Slo-mo videos will always play the slow-motion speed fine on your iPhone, but whether or not the playback speed is correct when you transfer the file to your computer depends on the media player or other program you're using to view the clips. If you're using a Mac running OS High Sierra or later, and viewing the video in the Quicktime player or in the Apple Photos program, the slow-motion speed will play just as it did on your iPhone.

If you are using the High Efficiency format (HEVC/H.265) mentioned earlier in the section on Camera Settings, other media players may not recognize that format yet. This should be less of an issue as media players are updated to support the newer format. If you want the iPhone to transfer files in the most compatible format, open Settings > Photos, find the setting for Transfer to Mac or PC, and set this to Automatic (**Figure 45.5**).

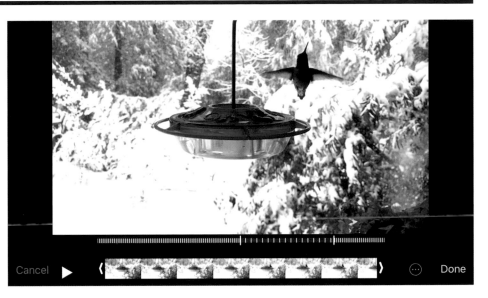

45.4 The small marks above the timeline indicate the playback speed for a Slo-mo video. Sections that are closer together are normal speed. Slo-mo starts when the marks are spaced farther apart. Drag on this to control where the slow-motion speed begins and ends.

45.5 In Settings > Photos you can have iOS automatically convert photos and videos to the most compatible format for transferring the files to a Mac or PC computer.

46. SHOOT A TIME-LAPSE VIDEO

SLOW MOTION EXTENDS our perception of time, making motion appear much slower than normal. Time-lapse, on the other hand, does just the opposite: it compresses time and allows you to record a video that presents the passage of time at a much faster rate than normal. The Time-lapse mode is great for recording changes that occur over a long period of time, such as clouds moving over the landscape, traffic rushing by on the freeway, or capturing a clip that compresses a long car trip into less than a minute (**Figure 46.1**).

Shooting a time-lapse video on the iPhone is just like shooting any other video. It's a one-button operation: start and stop. There are no other settings or controls (**Figure 46.2**). That can be a positive if you like to keep things easy and simple, or a negative if you prefer more hands-on control over how the time-lapse is captured. (If you crave more control over the process, there are other time-lapse apps, such as Lapse It, that offer you more options.)

An essential ingredient for many time-lapse movies is that the camera be immobilized on a tripod or stabilized in some other way to ensure that it does not move while the time-lapse is being recorded (**Figure 46.3**). This may not always be necessary if you are recording while moving through a scene, and in that case you can mount it to a bike, or on the dashboard of your car. Another useful accessory for time-lapse recording is an external battery pack. If the time-lapse will span a long period of time, having extra battery power can be essential.

Choose a location or scene where there is movement that can be recorded over a long period of time. In terms of how long to shoot, a minimum of about 10 to 15 minutes is a good place to start. You can have longer real-time durations of course, including ones that last several hours. You have no way of setting a specific frame rate or desired length for the video. The app selects the frame rate based on the real-time duration of the clip, but this calculation is not made until after the time-lapse is shot.

46.1 Passing clouds and city traffic are both great subjects to record as a time-lapse video.

For example, a recording with a duration of 10 minutes results in a video with an approximate frame rate of 2 fps, and a length of about 20 seconds. As the real-time duration increases, fewer frames are used in the final result, resulting in videos of a similar length (between 20 to 50 seconds) where the action seems even faster.

Time-lapse videos are automatically placed in their own album in the Photos app.

Beyond the iOS Video Capabilities

In this chapter, we have covered the functionality and capabilities of the Video modes in the native iOS camera app. In a world of excellent iPhone apps, however, there are always other possibilities to consider. Here are a few ideas for other video-specific iOS apps that you can install on your iPhone or iPad if you want to check out additional features and functionality. There are many more iOS video apps, of course, but this list is a good place to start your video-app explorations.

- **FiLMiC Pro.** If you want a full-featured video-recording app, look no further than FiLMiC Pro. This app offers full manual control over focus, exposure, white balance, frame rate, and audio settings.
- **Adobe Premiere Clip.** This is a free video-editing app that has more editing options than the native iOS Photos app. You can arrange multiple clips in any order you like, trim clips, apply a color look to the entire project, and add music from the iTunes music library.
- **Enlight Videoleap.** This app offers the same basic timeline-based clip-sequencing function as Adobe Premiere Clip, but also has blending modes, simple video masking, filter effects, and the ability to add a layer over your video (a still image or another video clip), The free version of this app offers a good set of functions, but you can only unlock all the features by purchasing a monthly or yearly subscription.

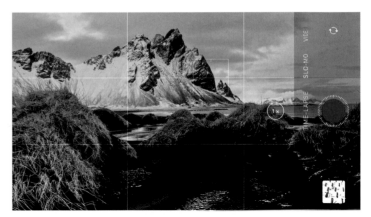

46.2 Time-lapse on an iPhone is a one-button operation.

46.3 For best results, use a tripod or find some other way to immobilize the phone when recording a time-lapse video. In this example, I was shooting dual time-lapse sequences: one with the normal wide-angle lens (left) and one using the 56mm telephoto or portrait lens (right). The iPhone on the left is attached to an external battery pack.

INSIGHTS ON
PROCESSING

CHAPTER 7

One of the great things about the iPhone is that you have a camera and a very capable image-processing studio all in one. Thanks to the incredible number and variety of iOS photo apps, the adjustments you can apply to your photos right on the phone can range from quick and simple to very sophisticated.

In the world of apps, the landscape can change frequently as new apps and updates arrive. Rather than getting too detailed with which sliders and buttons to use in specific apps, I want to concentrate on the bigger picture as it relates to image processing. Understanding the important ingredients of a photograph and how to work with those elements will allow you to become more comfortable using a variety of different apps, no matter what visual style you prefer.

As we explore how to use image fundamentals such as brightness, contrast, color saturation, and temperature to improve a photo, I will cover both the image-editing features in the built-in Photos app, as well as some other photo apps I regularly use. The focus will be on understanding core concepts, the essential editing you can apply to your photos, and some of the other effects you can create. Let's get started!

47. LOOK AT THE IMAGE

BEFORE YOU START editing a photo, take a few moments to study it and ask yourself some basic questions about its appearance.

Overall, how does it look? Is it so dark that some details are hard to see? Or is it so bright that it is washed out? Are the highlights blown out to total white? What is the quality of the contrast (the difference between the bright and dark areas)? Is the contrast flat and dull, or hard and sharp? What about the color quality of the image? Is it warm or cool? Are the colors a bit drab or more brightly saturated? With practice, this quick evaluation will take only a few seconds and can help you to find a path through the adjustment forest, no matter which app you use (**Figure 47.1**).

Now that you are more aware of the process of examining the basic tonal and color qualities of an image, think about how your photo might be interpreted. Can adjustments evoke a mood or support a story? Does the image need to be edited to appear similar to other photos in a series? Some of these visualizations may be considered as part of the intent of the photo, but some ideas may not occur to you until you're working on the file. It's okay to let the image be your guide.

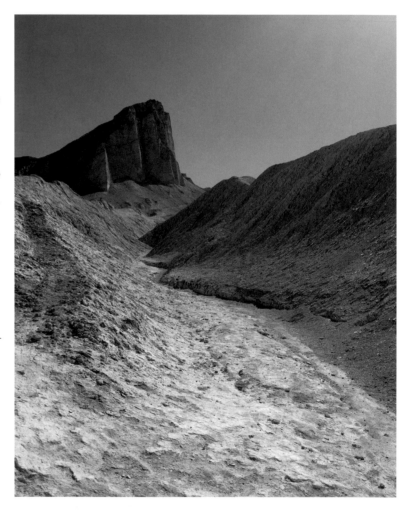

47.1 A view of Manly Beacon in Death Valley National Park. Overall the exposure looks good, and there are no drastically overexposed highlights, or underexposed shadows. However, the contrast seems a bit flat and dull.

48. WORKING WITH THE TONAL RANGE

AT A VERY fundamental level, a photograph is created of brightness tones from the darkest, black shadows at one end of the spectrum to brighter values and total white at the other end. This is commonly referred to as the tonal range. There are color considerations as well; in some images, color plays a prominent role—but the true foundation of any photograph is the tonal range. In some photo apps and desktop imaging programs, this is represented as a bar graph known as a histogram. A histogram's shape often resembles a mountain, which is fitting: it reminds me of how the famous naturalist and mountain explorer John Muir described California's Sierra Nevada range: The Range of Light (**Figure 48.1**).

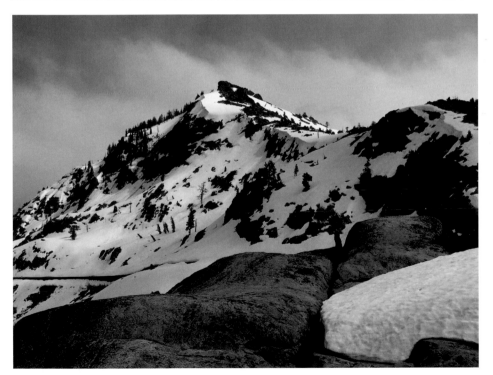

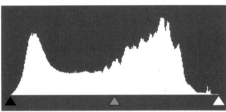

48.1 A photo of Donner Peak in California's Sierra Nevada. The histogram shows the distribution of image pixels along the tonal range from black to white.

The common controls you have for manipulating the range of light in your photos are Brightness (sometimes called Exposure), Contrast, Highlights, and Shadows. Some apps may also offer controls for the black and white points. Many apps, including the built-in Photos app, group these controls into a section called Light.

Tonal Edits in the Photos App

To access the image-editing tools in Photos, tap on Edit when viewing an image. Along the bottom (or right side, if you're holding the phone horizontally) are buttons for Cropping, Filters, Adjustments, and the Extensions where you can send an image from Photos to other apps for additional editing. In the top-right corner is a magic wand icon that applies an auto adjustment, which can be a good place to start if you're new to image adjustments (**Figure 48.2**).

Tap the icon that looks like a small dial to reveal the three adjustment groups: Light, Color, and B&W. Tapping Light will reveal a small slider of thumbnails you can use to brighten or darken the photo (**Figure 48.3**). There's more to this slider adjustment under the hood. To see more options, tap the menu icon to the side of the thumbnail slider. This will list the specific adjustments made by moving the thumbnail slider (**Figure 48.4**). In addition to adjustments targeting a specific area in the tonal range, there is also a slider for Brilliance, which is a mix of both brightness and contrast.

Tap a control to make modifications. Swipe horizontally on the slider to make changes to that aspect of the image, and swipe vertically on the adjustment scale to switch to the next adjustment. Press and hold on the image to see the original (**Figure 48.5**).

The best way to learn is to explore and observe. This is true for any app. Move the sliders in either direction and notice how they affect the image, as well as the regions they target. Depending on the app you're using, some adjustments are more heavy-handed than others. For instance, the Exposure adjustment in the Photos app produces a much more exaggerated and clunky result than using the Brightness slider, which allows for more subtle adjustments (**Figure 48.6**).

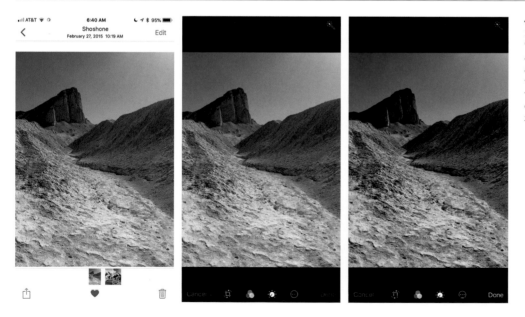

48.2 In the Photos app, tap on Edit to open the editing controls. The magic wand icon will apply an auto adjustment. If an auto adjustment is applied, this icon will be yellow. In this example, the auto adjustment has slightly darkened the image and also increased the contrast.

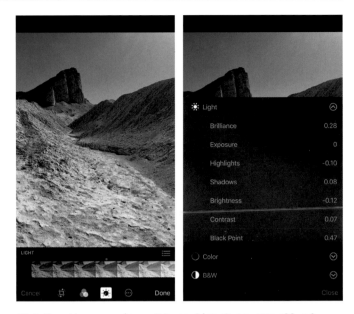

48.3 Tap the small dial icon to reveal the three editing groups: Light, Color, and B&W (black and white). Choosing one will reveal a slider comprised of variations of the image.

48.4 Tap the menu icon (three lines) to see all of the adjustments within one of the adjustment groups. A small change to the Light slider reveals that several adjustments are actually being applied.

48.5 Once you select a parameter to adjust (in this case, Shadows) move the slider until you get the effect you want. Swipe vertically on this adjustment scale to move to the next parameter.

48.6 The Exposure adjustment is more extreme than the Brightness adjustment. Compare how similar adjustments of the slider affect the image.

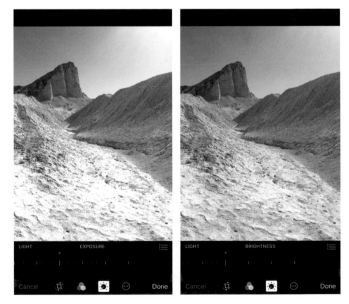

Tonal Edits in Other Apps

You will find the same basic tonal adjustments, with slight variations now and then, in many other photo apps. **Figure** 48.7 shows some of the tonal adjustments for Instagram, Snapseed, and Lightroom CC for mobile. Keep in mind that each app will have its own recipe at work under the hood, so you have to play around to get a sense of each app's adjustment range.

The Hard Truth About Tonal Clipping

With some photos, you may run into bright highlights that are totally white, with no discernible detail. Or, a photo may have dark shadow areas without detail because the area appears totally black. In each of these scenarios, the shadow and highlight details can be described as being *clipped*. This means that either no detail was captured in the original photo, or that the image was edited and adjustments were applied that created shadow or highlight clipping.

Unfortunately, once a tonal value has suffered irreversible clipping, there is no way to bring those tonal details back. The most likely cause of shadow or highlight clipping is from a poor exposure in the camera. This is why it's a good idea to notice the exposure as you're taking the shot to ensure that bright highlight details are not washed out or important shadow details are not rendered as black. You can adjust the exposure on the iPhone's screen to get a better result, or you might need to shoot in an HDR mode if you find yourself in high-contrast lighting. Another way to give yourself more leeway in terms of adjusting tonal values in high contrast scenes is to use an app that will capture a raw image. We'll cover that later in this chapter.

48.7 Some of the tonal adjustment options in the editing tools in Instagram (there are more beyond the ones that show on a single screen), the Tune Image controls in Snapseed, and the Light adjustments in Adobe Lightroom CC for mobile (sliders for Whites and Blacks are under the Shadows slider).

49. THE IMPORTANCE OF CONTRAST

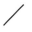

ONE OF THE most important aspects of making a photograph look its best is contrast. A single adjustment to this characteristic can make a huge difference in the image. Contrast is the difference between the bright and dark tones in the image. If the difference is pronounced and significant, the photo has high contrast. Darks are darker and light tones are brighter. If the difference between the lights and the darks is more subdued, the image has moderate or low contrast (**Figure 49.1**).

The human visual system favors contrast. It makes things easy to see and creates separation between elements, such as subject and background. "Flat," "dull," "bland," and "muddy" are some of the terms used to describe low contrast in photos. There are certainly times when a low-contrast approach may be a good choice for a photo, if it serves other aspects of the image, such as story or mood. The important thing is to understand how contrast between the elements in the image affects the final photograph. Fine-tuning and shaping the contrast of your image helps you better express the scene or subject by creating a mood, an integral part of an image's style. It's a very important tool for optimizing the look of a photo.

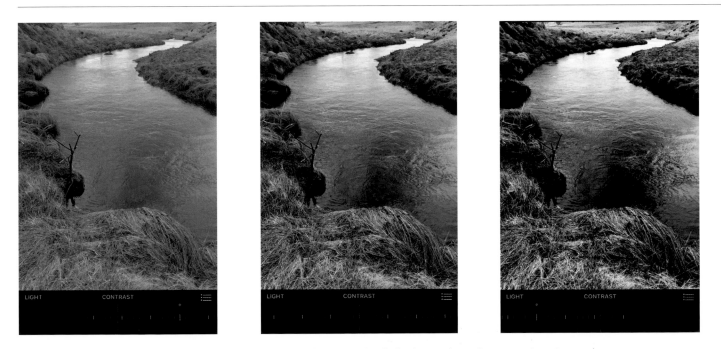

49.1 The image in the middle was captured by the iPhone. The left image is a lower-contrast version, and the right image is a higher-contrast version.

Tonal Edits to Modify Contrast

Nearly every photo app I've ever used that offers basic image adjustments has a slider for contrast. This is pretty easy to understand and use: move it one way for more contrast; move it the other way for less contrast. This is likely to be the primary way you adjust contrast with your photos. Let's take a look at some other ways that contrast can be modified.

Adjusting the Black and White Points

Tones in a photo go from black to white with a range of gray values in between. There are color values, too, but right now we are focusing on luminance, or brightness.

A typical contrast slider will adjust highlight and shadow values at the same time. In processing apps that let you adjust the black and white points, you can modify those key tonal areas separately, allowing for a more custom contrast adjustment (for instance, you might need to adjust the black point more than the white point).

Two things that can result in a flat, low-contrast image are the lack of a pure black or white point (**Figure 49.2**). Adjusting the black and white point will set that basic level of contrast (**Figure 49.3**) and you can then adjust Brightness or Exposure (similar terms used in various apps for an overall brightness adjustment) while preserving those values for the blacks and whites.

The Editing Adjustments in the Photos app in iOS offer a control to adjust the black point, but not the white point. The closest adjustment is the Highlights (**Figure 49.4**).

In Snapseed, there is no option to adjust the white or black point in the Tune Image controls (**Figure 49.5**), but there is a way to do it in the Curves adjustment. We'll look at Curves in more detail later.

As you saw in Figure 49.3, in Adobe Lightroom CC for mobile, the develop options do provide a way to adjust the black and white points separately from other parts of the tonal range (**Figure 49.6**).

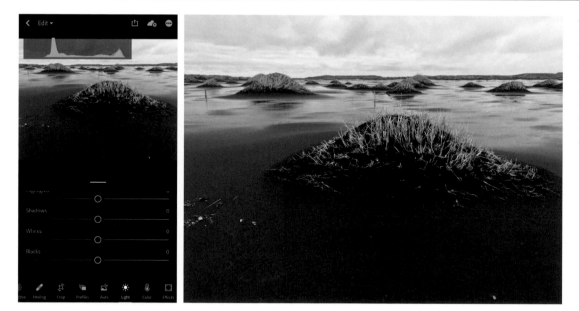

49.2 The histogram for this photo, seen near the top of the preview in the Adobe Lightroom CC app, shows the lack of a true black or white point (look for the empty gaps on either side of the histogram shape). This causes low contrast overall.

49.3 Adjusting the black point and the white point results in more pleasing overall contrast (notice how the histogram differs from the one in Figure 49.2). Further adjustments allowed me to adjust the midtones (exposure), as well as the highlights, and shadows to arrive at the final version of the image.

49.4 The editing tools in the Photos app in iOS 11.

49.5 The Tune Image controls in Snapseed.

49.6 Some of the editing tools in Adobe Lightroom CC for mobile.

Many apps don't provide a way to see when a dark shadow detail is being forced to total black (or, to channel a popular film franchise, forced to the dark side), so you should be cautious with adjusting the black point on images where the contrast is already strong. The same is true for adjusting the white point. If highlights are bright but there is still good detail (like the textures in bright clouds), then there is probably no need to adjust the white point. Adjusting the black and the white point is best used on images with clearly no black or white values in the original iPhone capture.

Some apps, such as Adobe Lightroom CC and Snapseed offer a small histogram that you can use to see if shadow or highlight values are being clipped (**Figure 49.7**).

49.7 If you look at these histograms from Adobe Lightroom CC for mobile and Snapseed, you can see how the histogram shapes in the second version of each photo appears to be cut off on the left. This indicates that shadow values are being clipped.

Fine-tune Contrast with Curves

Some apps have a Curves feature (**Figure 49.8**). This is definitely a different animal than a simple contrast slider, but under the hood, the same type of adjustment is taking place. With Curves, you get a lot more control over which parts of the tonal range are affected by contrast adjustments.

The basic curve graphic shows a square grid with a diagonal line running from the lower-left corner (black point) to the upper-right corner (white point). The diagonal line represents the tonal scale of the original image (or the version of the image you are adjusting). The very middle of this line is the midpoint between black and white. Adjusting

the upper part of the curve above the original diagonal line and adjusting the lower part of the curve below the diagonal line will result in an increase in contrast. The highlights are made brighter and the shadows are made darker. Such a curve is often referred to as an S-curve (**Figure 49.9**).

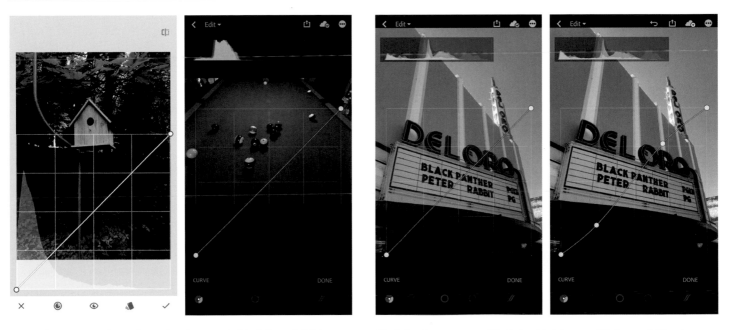

49.8 The Curves interface in Snapseed (left) and Adobe Lightroom CC for mobile (right). Both Lightroom and Snapseed let you use the curve for the overall image as well as the three individual color components of red, green, and blue that make up an RGB image. Snapseed also offers several curve presets.

49.9 An S-curve applied in Lightroom CC for mobile to increase contrast.

When adjusting a curve, try to keep it smooth without any dramatic shifts—avoiding what I call "dangerous curves." The steeper a curve is, the more contrast you will add to the photo. When the top or bottom sections of a curve hit the "ceiling" or the "floor" of the grid, you are forcing highlights to pure white and shadows to pure black (**Figure 49.10**). Curves with abrupt horizontal shelves will also create problematic results in the image (**Figure 49.11**).

Developing an understanding for Curves adjustments in apps on your iPhone or iPad is great practice for using desktop-based imaging programs such as Adobe Lightroom and Adobe Photoshop, where Curves is a main feature for adjusting the tonal range.

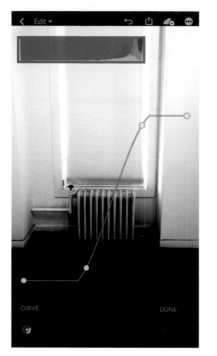

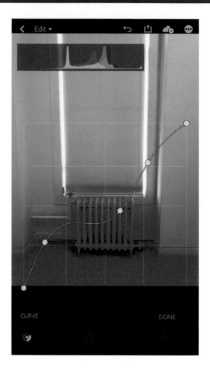

49.10 Dangerous Curve #1: In this curve, the highlight section is hitting the ceiling, causing those tones to be clipped to total white, and the lower section is flattening out on the floor of the curve grid, causing darker values to become a total black.

49.11 Dangerous Curve #2: A shelf is created when a diagonal section of the curve is adjusted to become more horizontal, causing what used to be different tonal values to be more similar, or in some cases, the same value. This results in the flat gray tones you can see in the floor of this photo.

WE STARTED OUR conversation on image processing with a look at the tonal range, the brightness or luminance components of a photograph, and how those can be modified with exposure, brightness, contrast, and black point and white point adjustments. Now let's consider changes we can make to the color characteristics of a photo.

Color Balance/Color Temperature

In photographs, the overall color of an image is frequently described by where it falls on the color temperature spectrum. In simple terms, this can be easily expressed by describing the color balance as cool or warm (**Figures 50.1–50.2**). This characteristic is commonly adjusted using the white balance controls of Temperature (blue-yellow) and sometimes Tint (green-magenta). Many camera apps also have white balance controls that let you control color balance when photographing a scene. Depending on the app you're using, other color filter effects may be available to shift the color balance for creative effect.

50.1 The color balance in this photo is very warm due to the warm, yellow light from the lamp and other light in the room.

50.2 This photo was made just before sunrise and the color balance is more on the cool side.

In the Photos app on iOS, the Color Adjustments let you modify the image with the slider of thumbnail images, or tap on the menu to reveal separate controls for Saturation, Contrast, and Cast (**Figure 50.3**). Saturation is fairly self-explanatory; it's a basic adjustment. Contrast is very interesting, however, because it applies only to areas in the image where there is color contrast. If an area is already devoid of color (e.g., the dark gray asphalt of a desert road), then no contrast adjustment is applied to that part of the photo. Cast is the adjustment that controls the color temperature, or the balance between the cool or warm quality of the color in the image.

HSL—Hue, Saturation, and Lightness

Another very common way to describe color uses three terms that you will find in many image-editing apps: **hue**, the general "flavor" of a color, or where it occurs on the color wheel (i.e., red, blue, yellow, etc.); **saturation**, which refers to the intensity or purity of the color (highly saturated color is bright and punchy while lower saturated colors are more muted and pastel); and **lightness**, or luminance, which is the brightness value of a color.

- **Hue** controls will shift colors to another location on the color wheel (e.g., turning a bright orange red to a pink red). Depending on the app you use, this can be done to all the colors in a photo, or to specific colors. When applied to a specific color it can be an excellent way to fine-tune the character of a specific color (**Figure 50.4**).
- **Saturation** controls let you either saturate the colors to increase their vibrancy and intensity, or desaturate them to remove color (**Figure 50.5**). Be careful when increasing saturation; if you do it too much the result can look very unnatural and overdone.
- **Lightness** (also referred to as luminance) controls manipulate the brightness of a specific color. **Figure 50.6** shows the blues in the sky getting darker and lighter.

The exact ways in which you can alter the color properties of hue, saturation, and lightness will vary depending on the app you are using. Nearly every app that offers basic adjustments will provide a way to adjust color saturation and color balance, but you may only find controls for overall hue adjustments, or specific color hue modifications, in more full-featured or specialized photo apps. Other apps, such as Mextures, allow you to apply

50.3 The Color controls in the Photos app (iOS 11).

50.4 Adjusting the Hue of the color red in Adobe Lightroom CC for mobile.

color looks, filters, and style treatments that affect the entire photo instead of individual colors (**Figure 50.7**).

When making any adjustments to an image, ask yourself if they serve the photograph. Are they corrective in some way, compensating for a deficiency in the original exposure? Or are they more interpretive, changing the "performance" of the image (harkening back to Ansel Adams) to evoke a mood or support the story you want to tell? Image adjustments with a definite idea or purpose behind them will always be more effective than an image that has been altered by randomly moving sliders in a variety of apps.

50.5 Adjusting the overall Saturation in the iOS 11 Photos app: As shot (left), low saturation (middle), and high saturation (right). The version with increased saturation is a bit over the top when viewed on a screen.

50.6 Adjusting the Luminance of the blues in Adobe Lightroom CC for mobile.

50.7 Applying a gradient as color style treatment in Mextures.

51. GLOBAL VERSUS LOCAL ADJUSTMENTS

IN MOST APPS, the tonal adjustments (brightness, contrast, shadows, highlights, etc.) and the color modifications (color balance, hue, saturation, lightness) you apply to a photo are usually applied globally (affecting the entire image). With some apps, you can also apply these adjustments locally, or to a selective area of the photo. This gives you a great deal of control over sculpting the light and shadow of the image to portray the scene as you envision it—either re-creating it as you saw it or taking the image in an entirely different direction.

Selective or local adjustments can be as basic as adding a simple vignette effect to darken the outer edges of a photo and draw attention to the center subject (**Figure 51.1**). With some apps, however, you have the luxury of "painting with light" or shadow, if that's what the photo calls for. I also like to think of being a post-production lighting designer who, instead of creating the lighting for a stage play, is lighting the "set" of a photograph (**Figure 51.2**).

Earlier I mentioned that the human visual system favors contrast. It also favors light, particularly light that's noticeable because it is set off from the rest of the image by contrast. When we look at a photograph, as with a scene in the real world, we see the light areas first. Adding selective adjustments to your photo gives you another creative tool for enhancing the tonal map of the image to take advantage of this tendency of the human eye. You can strategically guide the viewer's eye along a specific path in the photo (**Figure 51.3**).

51.1 A simple vignette effect added in Snapseed does a lot to enhance this photo, shot with Portrait mode in the iOS camera app.

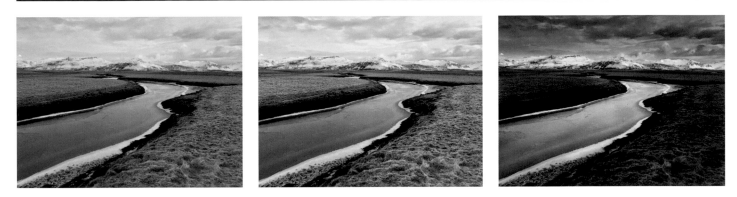

51.2 Three views of a photo showing the original shot (left), a version with overall adjustments (middle), and a version where selective local edits have been added in Lightroom CC for mobile to lighten the river and distant mountains, as well as darken the sky and surrounding fields (right).

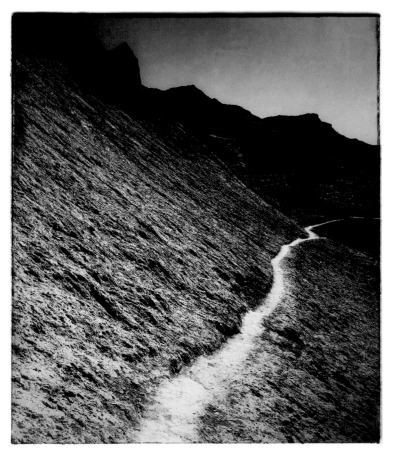

51.3 This image has been modified with selective adjustments to enhance the brightness of the path and darken other areas, providing a line for the viewer's eye to follow.

Selective or local editing functionality is not available in the iPhone Photos app, but is an option in some photo apps such as Snapseed, Adobe Lightroom CC for mobile, and others. The most common ways to apply selective, local adjustments in iOS apps is using a brush tool, a linear gradient (i.e. a gradient that spans a straight line), or a radial gradient (**Figures 51.4–51.6**). Some apps may also have tools that let you target specific color and tonal values for applying adjustments. As is typical with apps, there is no one way this functionality is implemented and you have to figure out the "dance steps" for each app.

51.4 With Snapseed's Edit Stack feature you can revisit the different adjustments you've made to a photo and change their settings, or you can use a masking feature to brush in changes in specific places (in the third image, the red overlay shows the areas where a darkening adjustment has been painted).

51.5 The Selective Adjustments in Adobe Lightroom CC for mobile let you use an adjustment brush and radial and linear gradients to apply modifications to specific areas of the image. The red overlay in the third image shows where the adjustment will be visible.

51.6 Snapseed also has a Selective tool that lets you target specific color or tonal values in an image. The range can be adjusted using a two-finger gesture to expand or reduce the affected area (shown in red in the first image). You can then adjust the brightness, contrast, saturation, or structure on the selected area.

52. EXPLORE A BLACK-AND-WHITE VIEW

BLACK-AND-WHITE PHOTOS OFTEN suggest a classic feel, but this visual interpretation is much more than just a vintage look to apply to a photo. By removing the distractions of color, you can focus more on the interplay between light and shadow. The monochromatic approach can be very effective for a range of subject matter (**Figure 52.1**). A black-and-white treatment can be applied in many apps in basic and nuanced ways. There are also apps that specialize entirely in black-and-white looks.

In terms of applying a black-and-white treatment to a photo in an iOS app, the most important thing to understand is that the different colors in a scene can be translated into gray values of different brightness. This allows you a lot of flexibility for how a color image is translated into black and white (**Figure 52.2**).

The black-and-white adjustment in the iOS Photos app has the familiar slider on the thumbnail images. As you move this back and forth, notice how certain colors (blue sky, a red car, green trees) are rendered into lighter or darker tones of gray. Tapping the menu button reveals four additional controls for fine-tuning the black-and-white effect: Intensity, Neutrals, Tone, and Grain.

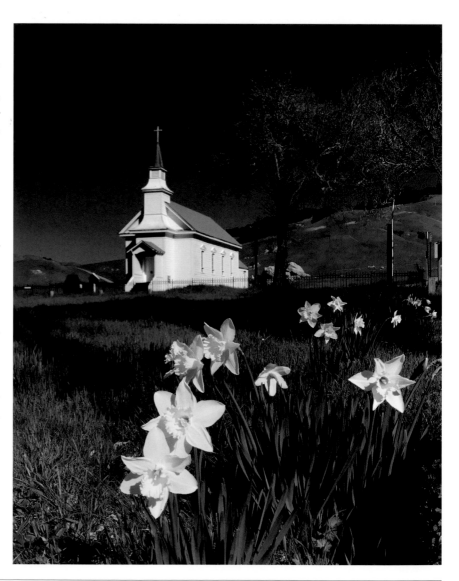

52.1 Black-and-white is a look that can be very effective in many genres of photography.

52.2 The iOS Photos app has a basic black-and-white tool. Swipe on the thumbnail slider to see the colors in the photo interpreted in different ways. Tap the menu button for additional options.

Other apps give you more clearly presented color-based controls for affecting the look of the black-and-white conversion of the photo. Snapseed provides a color filter button that lets you "filter" the black-and-white treatment through five colors: red, orange, yellow, green, and blue. When using a given filter, that color, or colors close to it, will be represented by lighter tones of gray. You can see this in **Figure 52.3.** With an orange filter applied to the photo, the red car and yellow lights are represented by lighter tones; the blue building is rendered darker. There are other presets in Snapseed's black-and-white tool with different tonal and contrast looks, as well as adjustments for brightness, contrast, and grain.

In the more full-featured Adobe Lightroom CC for mobile, after opening the Color controls and tapping on Black-and-White to apply the initial conversion, you can tap on the Mix button to apply separate color filters to create eight different black-and-white interpretations. There is also a very useful targeted adjustment tool that lets you tap on an area of the photo and then drag up or down to adjust the grayscale brightness of that area.

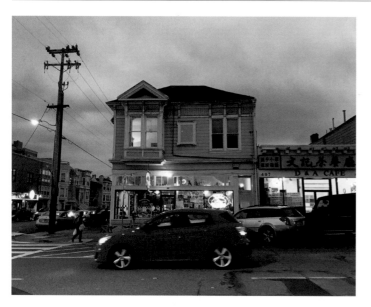

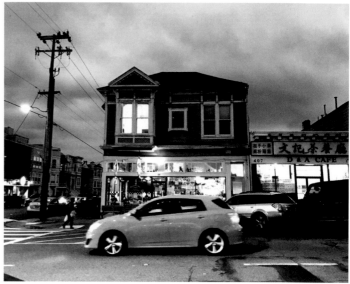

52.3 The black-and-white tool in Snapseed offers color filters that translate a given color range to a lighter tone of gray in black-and-white photos.

52.4 Adobe Lightroom CC for mobile offers even more color filters for fine-tuning the black-and-white mix, plus a targeted adjustment tool for on-image adjustments. All changes are not permanent and are synced to the image in other locations of the Lightroom ecosystem. The app also has a good selection of black-and-white profiles that you can apply to your photo.

Fine-tuning Back-and-White Photos with Contrast

There are two types of contrast in photographs: tonal contrast, the difference between lights and darks; and color contrast, which is created by different colors playing against each other in the scene. When color is removed from an image, you lose color contrast, and the result can look a bit flat. Revisiting contrast is always a good idea after converting an image to black and white. Some apps may point you in this direction with an easy black-and-white preset that automatically applies a contrast boost.

53. BLURRING EFFECTS

WE'VE DISCUSSED MANY of the essential processing concepts: adjusting the tonal range, the contrast, the color in a photo, applying changes either globally or locally, and creating a black-and-white interpretation of the image. For the rest of this chapter, we'll take a brief look at some of the photo processing effects in the very broad category of "everything else." First up is blurring effects.

As discussed in chapter 5, the primary way to achieve a blurred background at the time you make the photo is to use the Portrait mode on an iPhone with dual cameras and lenses. There are many apps that also offer blurring effects you can apply to an image. Here's a rundown of the types of blurring tools and filters that might cross your path.

- **Radial Blur:** The blur is applied around a circular or spherical shape that you can adjust using a two-finger gesture. In addition to changing the amount of the blurring, some apps also let you adjust the transition area where the focused part of the photo gradually becomes more blurred. Radial blurring is the most basic type of blurring effect and can be found in many apps, including Snapseed, as seen in **Figure 53.1**.

- **Tilt Shift or Gradient Blur:** This type of blurring is applied along a straight line. Tilt shift is a digital version of the blurring that can be created using the tilt and shift movements of a view camera—hence the name. It creates a blur with a band of in-focus area with blurring on either side. This can be arranged horizontally, vertically, or diagonally. A simple gradient blur affects one part of the image and transitions to non-blurred area along the straight line of a gradient (**Figure 53.2**).

53.1 Radial blurs add an interesting visual element to a photo, and for some subjects, they can help to guide the viewer's eye and simplify a cluttered background.

53.2 A tilt shift or gradient blur applies the blurring effect along a straight line. When used with photos taken from a high vantage point looking down on a subject, such as a city street, it can create a "toy landscape" effect.

One thing to keep in mind is that a blurring effect in post-processing is blur applied on top of the existing image; it's not a blur designed to emulate the look of shallow depth of field. There are apps, such as AfterFocus, that let you define specific areas for user-applied background blurring (**Figure 53.3**).

Blurring with Depth Map-Aware Apps

Beginning with iOS 11, Apple allowed third-party app developers access to the depth maps that are created using the Portrait mode on dual-camera iPhones. The depth map is what Portrait mode uses to achieve its live computational blurring effect. This depth map is saved with the file and the effect can be turned off or on in the Edit section of the Photos app. Once other app developers gained access to this, some very interesting new apps began to appear on the scene that let you further manipulate and customize the blurring effect that is controlled by the depth map.

PortraitCam lets you alter the amount of blurring that is affected by the depth map. It's also a very capable blurring app for images that don't have a depth map. You can customize the shape and rotation of the highlight aperture shapes, and even add a spin effect to the blur (**Figure 53.4**). For images that were not photographed with a depth map, you can use edge-aware masking tools to create your own masks for what should be blurred areas, and also apply standard effects such as radial, gradient, and landscape gradient blurs.

Focos is a camera app that lets you choose whether the foreground or background is in focus (**Figure 53.5**). It also offers a blur-editing app with similar blur features to PortraitCam. One of the most useful ways Focos lets you use depth maps is to allow you to apply them as a mask through which other adjustments are made. For example, if you want to darken only the background of a photo, you could achieve this with the depth map alteration capabilities of Focos. This, and many other adjustments, is easily done with the options in this app.

53.3 AfterFocus has edge-aware masking tools that let you define a specific background area in the photo to which blurring can be applied. The believability of this type of blurring depends on how distinct the edges of the foreground subject are.

53.4 PortraitCam offers not only blurring effects that take advantage of an existing depth map in the photo, but also other blur masks such as radial, gradient, and landscape.

53.5 Focos lets you use a Portrait Mode-created depth map to specify whether the foreground or background is in focus. You can also use it to apply a variety of useful and interesting effects.

54. TEXTURES, EDGE EFFECTS, AND BORDERS

TEXTURES, CREATIVE BORDERS, and edge effects have been a mainstay in iOS photo apps for several years. Early trends were photo apps that created an aged, distressed, damaged, or vintage look, which is still a popular style today (**Figure 54.1** and **54.2**).

One potential drawback to some textures is that, because they are used by a lot of people, they may be very recognizable. In Snapseed, for instance, the Grunge filter offers five different textures you can use (**Figure 54.3**). The problem is that they are all very distinct with easily identifiable patterns that make them easy to spot in other photos. You can rotate them and modify the strength of the texture, but the fact that they are so recognizable makes them less appealing to me, so when I do use the Grunge tool, I tend to apply textures with a light touch or not at all.

Another thing to keep in mind about using textures is that you should always apply them towards the end of the editing process, especially if a blur is also being applied. If you apply a texture first and then a blur effect after that, the texture will also be blurred, which doesn't make sense. Real blurring happens in the camera, or later in a darkroom when an image is printed. Textures and edge effects come from things such as film edges, the paper a photo was printed on, or damage and deterioration that the photo may have endured over the years. In an iPhone processing workflow, the texture effect should always comes after other effects, like blur (**Figure 54.4**).

54.1 Vintage Scene is an excellent app with a wide range of edge effects, paper textures, and tools for fading and damage that can be applied and customized in a variety of ways. You can also save your own presets from the combinations you come up with.

54.2 Tintype by Hipstamatic was inspired by the tintype film pack for the Hipstamatic camera app. The stand-alone app provides more controls for creating a very satisfying tintype effect.

54.3 The Grunge tool in Snapseed offers nearly 1,500 styles that can be customized in a variety of ways, including the addition of textures. This image also has an edge/frame effect added in Snapseed.

54.4 In order to mimic how a texture would affect a photographic print in real life, first apply the blurring effect, and then apply the texture. In this case, the blurring was applied in Snapseed and multiple texture effects were applied in Mextures.

55. DIPTYCHS, TRIPTYCHS, AND MIRRORED IMAGES

WE'RE USED TO seeing photographs presented both as single, stand-alone images, and also in groups, albums, or series. A diptych or a triptych lets you present a single image that is an arrangement of two or three photos. Diptychs and triptychs are not meant to look like a photo collage, but are simply photos that are presented in two or three portions next to each other as a unit. This allows for a new way to present a subject beyond a single image, as well as offers the possibility for some interesting visual associations.

Diptychs and triptychs can be arranged from very different photos that all have something in common, such as the shape of the main subject, as seen in **Figure 55.1**. Or, one photo may provide an ironic commentary on the other image, as seen in **Figure 55.2**. You can also use this format to create a segmented portrait of a person or place. Diptychs can even be inspired by seeing the two photos in proximity to each other in the Camera Roll, as in **Figure 55.3**; I did not take these photos with a diptych in mind, but later noticed their similarities as I scrolled through the Camera Roll.

55.1 A diptych based on the similar circular shapes of a bicycle tire and an old electric heater.

55.2 Diptychs can be used to express irony or present a humorous pairing of photos. Signs in Iceland's glacier lagoon gift shop café warn visitors not to venture out onto the ice—but some tourists always tempt fate!

55.3 These photos were taken on the same afternoon, but I didn't see the possibility for a diptych until I saw them near each other in my Camera Roll.

There are many apps that let you create layouts of multiple photos, with the diptychs or triptychs being two of the more basic layouts available. Some of the images in this section were made with the Diptic app, which offers a lot of layouts and features, including the ability to control the color and size of the borders between the photos (**Figure 55.4**).

A mirrored image is a diptych where the same photo is used for both sides, with one side flipped to create a "reflection" of the other photo. In most mirrored images, the borders between the photos are turned off to create a seamless blend between the two halves of the photo. Mirrored images are fun and easy! And sometimes the results can be a bit of a surprise (**Figure 55.5**). Mirrored images work well with natural scenes and forms, as well as with architectural subject matter, as seen in **Figure 55.6**, which shows a single photo of a museum mirrored in two ways. And once you create a mirrored image, you can open it up and mirror it again and again to create intricate kaleidoscopic results (**Figure 55.7**).

You can use the Diptic app for creating image mirrors, but I also like to use MRRW, which is an add-on purchase for the SKRWT app. This app offers additional features and controls, such as automatic edge alignment, that make it much easier to explore the reflective or mirrored possibilities an image may have (**Figure 55.8**).

55.4 The Diptic app is a good place to start if you want to explore the creative possibilities of diptychs. It also offers basic layouts for presenting several images.

55.5 While on a walk, I found the wing of a Stellar's jay on a forest path—a stark, yet colorful reminder of the circle of life in the woods. It created a variety of interesting mirrored images.

55.6 Making mirrored images from a single photo of the DeYoung Museum in San Francisco yielded results that suggest a futuristic location in a science-fiction movie.

55.7 The Golden Gate Bridge and a building in downtown San Francisco, each mirrored multiple times to explore a kaleidoscopic interpretation.

55.8 SKRWT is a perspective-correction app that also includes MRRW, which is one of the best mirroring apps I've found.

56. COLLAGES AND PHOTO COMPOSITES

MANY APPS THAT let you combine photos together to create blended collages and photo composites. (If you're interested in a simple layout collage where different photos are grouped together, check out Diptic). A blended collage can be as simple as one photo overlaid on another image with a mode that blends them together in a creative way, perhaps reminiscent of a double exposure from the film-photography days (**Figure 56.1**). Or it can be more intricate, where two or more photos are edited and arranged together to look like a realistic image of a fantastical scene (**Figure 56.2**). Some collage styles may also contain elements that are more typical to graphic illustration and poster design.

The easiest way to explore photo collage is by using the simple overlay features that are available in some apps. In chapter 5, I covered the capabilities of Snapseed, Union, and Adobe Photoshop Mix for creating

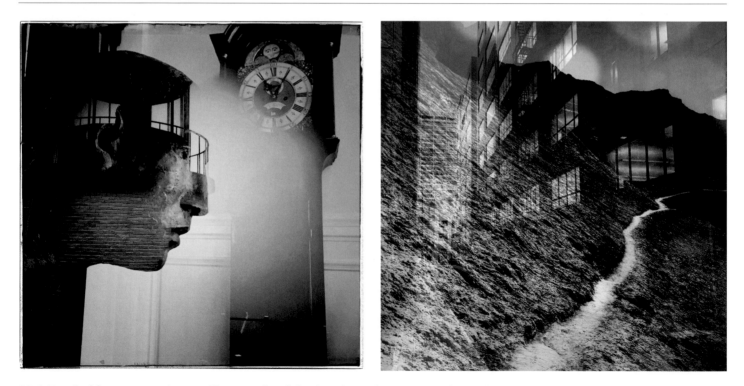

56.1 Two double-exposure type collages made with the Diana Photos app using a feature that randomly chooses images from your phone to create a blended collage, as is the case with these examples. The only downside to this app is that (at the time of this writing) it limits the saved collage to only 1536 x 1536 pixels.

blended images in the section on photographing for double exposures and composites. If you are interested in this type of image making, definitely refer to that section for information on those apps. Here are a few other apps that I often use for this type of image making:

- **Matter:** This is made by the developers of the Union app. It lets you add a wide variety of 3D shapes to your images that you can rotate and position as needed. You can also change the surface quality to be translucent, matte, or to reflect the image you are placing it in. You can even export a video where that shape and its shadow are slowly rotating in your photo. I like to use it to create interesting shapes and structures that I add to composites that I then work on in other collage or compositing apps (**Figure 56.3**).

- **Circular:** This app offers a deluxe take on the basic "tiny planets" effect. Beyond "planetizing" your photo or creating a tunnel effect, Circular also offers a variety of additional ways to enhance and transform the basic effect, including adding new skies, sky elements, center elements, and filter effects. The fantastical scene in **Figure 56.4** was made on a cross-country flight in Circular and Adobe Photoshop Mix.

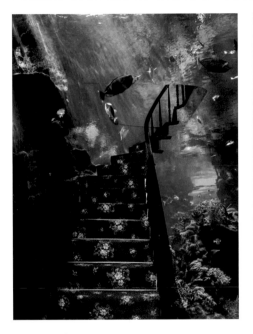

56.2 Under the Sea, a composite of two images made with the Image Blender app.

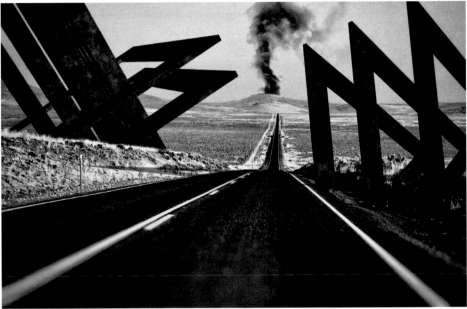

56.3 Channeling a dystopian road-trip movie. The geometric structures were added in the Matter app, and the smoke on the horizon was added in the Union app.

56.4 Creating composites is a fun way to pass the time on a cross-country flight. This image was made using a variety of apps, including Circular for the basic "tiny planets" effect, as well as the addition of the center planet and the cloud. The interior clock was added in Adobe Photoshop Mix. The edge effect was added in Snapseed.

- **LensLight and LensFlare:** These apps are made by the developers of PortraitCam, DepthCam, and Circular. They let you add a wide range of light effects to your images, including lens and light flares, sun shapes, and other lighting treatments. Sometimes they can add a nice final touch to spice up a collage or composite image, as in **Figure 56.5**, which was created from a basic image mirror made in Diptic. The new forest background was added in the Union app. The sunflare from LensLight worked with the actual lighting in the background photo of the forest path.

Collages and photo composites are a fun way to play with images on your iPhone or iPad. There is an aspect of experimentation and discovery in these explorations that can be very rewarding. To learn more about creating collage and composite images on iPhones and iPads, see my website at seanduggan.com.

56.5 This began as a simple mirrored image created in Diptic. Then I added a forest path between the curved-tree "gate." The sunflare created with the LensLight app was a nice final touch.

Share Your Best Composite Shot!

Once you've created a great composite shot, share it with the *Enthusiast's Guide* community! Follow @EnthusiastsGuides and post your image to Instagram using the hashtag *#EGcomposite.* Search that hashtag to be inspired and see other photographers' shots, as well.

ONE ASPECT OF iPhone photography that flies under the radar, especially if you're new to photography and digital image processing in particular, is the ability to shoot in raw. This is not a feature that is available in the iOS camera app, but it is something that is offered by other camera apps. Before we go any further, let me explain what a raw file is, and why you might want to consider it for some of your iPhone photography.

When a digital camera captures the reflected light in a scene to make a photo, that initial information is in a raw, or unprocessed, state. Under normal shooting conditions, it receives some amount of processing in the camera and is then saved as a HEIC or JPEG file, depending on the camera app you are using. A raw file contains much more color and tonal information than a processed file. This means that you have more possibilities for making an image look better, especially if it was shot in challenging lighting conditions, such as low or high-contrast light (**Figure 57.1**).

57.1 It can be difficult to make underexposed images look good in post-processing. Shooting in raw captures more tonal information, which means you have more to work with when adjusting the image. This typically provides a better result than if you'd used a standard file. In this example, the scene was captured in both JPEG and raw, but after I processed both, the raw file yielded a much better result.

I shoot in raw if I know the important details in a scene may be challenging for a normal camera exposure to capture due to tricky lighting. Based on many years of working with raw files from my larger cameras in programs such as Adobe Lightroom and Photoshop, I know that a raw file provides a better starting point if I need to try to salvage a less-than-ideal exposure.

The app I use most often for capturing raw photos on my iPhone is Adobe Lightroom CC for mobile (**Figure 57.2**). It uses the Digital Negative (DNG) format for raw capture and even offers HDR capture in DNG. A new technology preview added as this book was finished provides a Depth Capture mode with dual-camera iPhones that creates a depth map you can use for selective edits. It also offers excellent image-adjustment tools and anything I do syncs automatically with the Lightroom CC catalog I use for my mobile images on my desktop computer.

There are other camera apps that offer raw capture and raw processing, including

57.2 Adobe Lightroom CC for mobile is my preferred app for shooting in raw on my iPhone. It captures images using the DNG file format and can even use this raw format for its HDR capture mode.

Camera + 2 (**Figure 57.3**) and ProCamera (**Figure 57.4**). Both of those apps also provide ways to edit the raw files they create (Snapseed can also edit raw files). Because I already use the Lightroom ecosystem in my own photography workflow, I find that Lightroom CC for mobile provides the best and easiest path to having access to my mobile raw files on my computer. This way, they're available on my computer if I need to work with them in some of my other imaging programs.

If you are new to photography and digital image processing, then shooting in and processing raw files may not be for you. The files do take up more space on your device and typically require some extra attention in the processing phase to get them looking their best. But if you're already familiar with digital image processing in Photoshop or Lightroom, definitely consider shooting in raw for those images where lighting may be challenging, or where you just want to get the best image information possible (**Figure 57.5**).

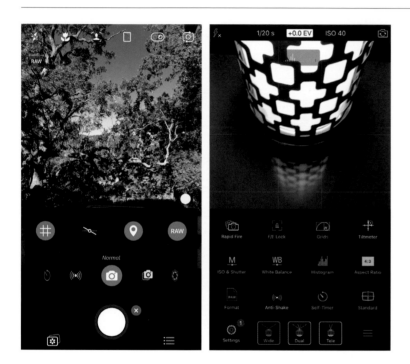

57.3 Camera + 2 offers a wide range of capture and processing features including the ability to shoot in raw and edit those raw files right in the app.

57.4 ProCamera allows you to shoot not only in raw, but also in several other image formats, including Raw + JPEG.

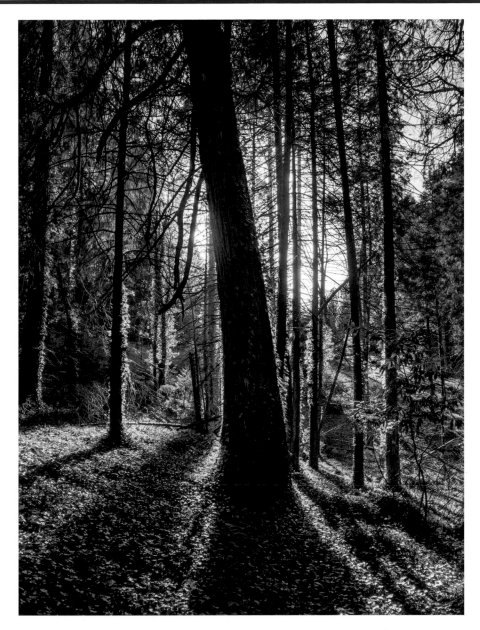

57.5 If I see a scene or composition that I know will result in a really good image, or if I am dealing with challenging lighting that will require some serious processing intervention, I'll shoot in the DNG raw format in Lightroom CC for mobile. Then I can either process the raw information right in Lightroom on my iPhone, or sync the file to Lightroom on my desktop computer for more in-depth processing.

8

SHARE YOUR PHOTOS

CHAPTER 8

Photography is a visual language that transcends spoken and written language. It allows us to communicate with other people by sharing what we see and experience. In order to do this, we have to free those photos from the iPhone or the Cloud and send them out into the world. Fortunately, the iPhone makes it easy to quickly share your photos in a variety of ways: privately, among a small group, or publishing them for the world to see via social media platforms.

58. UNDERSTAND THE IOS SHARING FEATURES

iOS PROVIDES A variety of ways to access sharing features. Even if you're not connected to a network of various social media sharing sites, you can still share photos with your immediate family and close friends.

Sharing with Family and Friends

The quickest way to share either an individual or a group of photos is via the Share/Export button (**Figure 58.1**). If you are viewing a single image, this option will appear in one of the corners of the screen (it will be in a different place based on whether the iPhone is in a vertical or horizontal orientation).

To share a group of photos, view the images in thumbnail view and tap Select in the upper-right corner. Now tap on the photos you want to select. You can also drag continuously across a row, or even diagonally to select several at once (**Figure 58.2**). With the images selected, tap the Share/Export button.

With the iPhone in a vertical orientation, the top row below the image preview on the Share/Export screen shows nearby Macs or iOS devices that can be accessed via AirDrop. The middle row shows other apps you can export the photo to, such as texts, email, and a variety of social media apps, such as Instagram, Facebook, Twitter, etc. (the apps you see will depend on what you have installed on your device). The bottom row displays other actions that can be applied

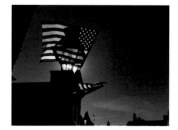

58.1 Follow the arrow to the Share/Export options.

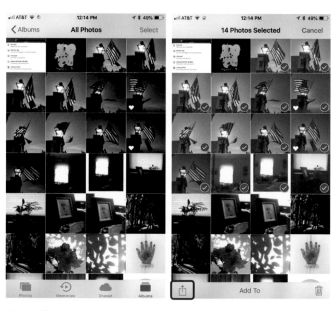

58.2 After tapping Select, swipe and drag to select multiple images at once.

to an image beyond basic image sharing (**Figure 58.3**).

Swipe on the middle row of sharing options to display more—on the far right side you'll eventually find three dots. Tap these to see a list of the different apps that are visible in this row. To change the order of these apps, touch the three lines to the right of the app's activation switch and drag the app where you want it (**Figure 58.4**). You can do the same with the options in the bottom row.

If you're viewing the phone in a horizontal position, tap Next to see the sharing/export options (**Figure 58.5**).

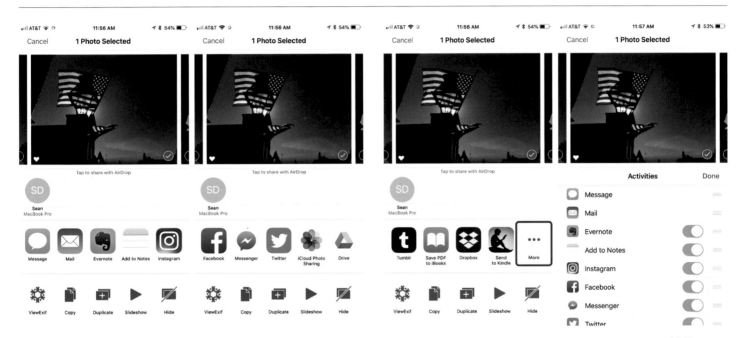

58.3 Sharing and Export options: Swipe to the left on the middle row to see additional apps and services you can export to. The bottom row contains options for other actions that can be applied to the selected photos.

58.4 Tap the three dots at the end of the middle or bottom rows to configure what appears in the menu and in what order.

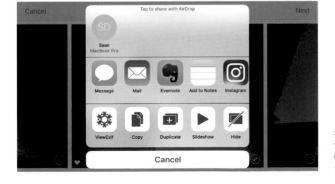

58.5 After choosing Share/Export when viewing in a landscape orientation, tap Next in the upper right to see the options.

Shared Albums with iCloud Photo Sharing

As part of its iCloud services, Apple lets you set up albums that can be shared with people you know who also have an iCloud account. To enable this feature, go to Settings > Photos and turn on iCloud Photo Sharing (**Figure 58.6**). With this turned on, you will see a shared cloud icon below the thumbnail view of your photos in the Photos app (**Figure 58.7**).

In the shared screen, tap the plus symbol to create a new shared album (**Figure 58.8**). On the next screen, enter the emails or phone numbers of the people you want to share the album with. In a shared album, people you've invited can also post their photos to the album, and like and comment on photos in the album. This can be a very convenient way for family members or a group of friends to share images from a trip or event, and to interact within the group about the photos they are sharing. (**Figure 58.9**).

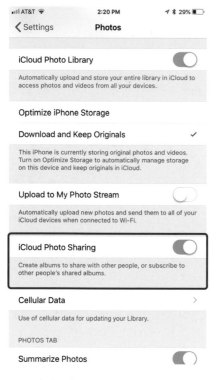

58.6 iCloud Photo Sharing lets you create albums that can be shared among a group of your contacts. You can turn it on in Settings > Photos.

58.7 When iCloud Photo Sharing is enabled, a Shared option will be added to the usual ways of viewing your images via Moments, Memories, and Albums.

58.8 Creating a new shared album: iCloud Photo Sharing is a good way to share photos among a small group of people, such as family, friends, or fellow adventurers on a shared journey.

Saving Shared Images to Your iPhone

If you want to save a copy of images that have been uploaded by other people to a shared album so you can have them on your iOS device, tap the Share/Export icon and then choose Save Image in the bottom row of options (you may have to swipe a bit to find that command) (**Figure 58.10**).

58.9 Click on the Comments link under the image to either view comments or add one of your own.

58.10 Saving a copy of an image in a shared iCloud album to your device.

59. SHARE ON SOCIAL MEDIA

IT'S HARD ESCAPING social media in the everyday landscape of our lives. For many it provides an important way to keep in touch, not only with friends and family but also with the larger community spheres that you are a part of in your local area. Social media is an onramp to connecting your photographs with a global audience. There are many social media platforms or channels available. In this section we'll take a quick look at some of the more omnipresent contenders.

Instagram

The 800-pound (or perhaps much heavier than that!) gorilla on the social media photo scene is Instagram. The mechanics of Instagram are pretty basic: share your images, perhaps apply some adjustments or filters using the in-app editing features, add hashtags to make them more visible to the wider Instagram community, follow and comment on other people's images, and grow your Instagram stream.

If you're new to Instagram, then your stream of followers and those you follow may be focused on people you know, or photographers you admire. If you want to keep your Instagram circle close and carefully curated, you can always choose to have a private account that allows you to approve the people who follow you.

The default image format with Instagram is a square. When you tap the plus to add a new image it will always show it with a square crop, but you can tap the small expand icon in the lower left to show the full image with no cropping (**Figure 59.1**).

Instagram Stories

In addition to sharing your images in your Instagram feed, you can also post images and video to Instagram Stories, which are visible for only 24 hours after you post them. This can be a fun way to chronicle the events of a day or a trip in a way that feels more immediate. However, it's also more raw and ephemeral. Because you are posting updates of a work in progress (i.e., whatever you happen to be doing that day), there is less of a sense that the image or video needs to feel finished or be perfect. You can also add text labels, tag other people with their Instagram names, or even add a survey where viewers can respond to a specific question (**Figure 59.2**).

In keeping with its "current events" theme, in the first view of your photos after you begin or add to a story, Instagram Stories will only show you images in your Camera Roll from the past 24 hours. Swipe vertically on the thumbnails and you will eventually move beyond this time period and into the Camera Roll. To access photos in any of your albums, tap on the location header (e.g., Last 24 Hours or Camera Roll).

Keep in mind that Instagram Stories are designed to be presented in a vertical format, though recent modifications to the app will now show horizontal images against a field of color sampled from the photo. Later in this chapter, in the section on jazzing up your posts, we'll explore some apps that let you add design templates to your Instagram Stories.

Share Your Photos on Facebook

Instagram may be a large gorilla in the social media photo landscape, but so is Facebook. In addition to posting updates describing the latest happenings in your day, you can also post individual images to your stream. You can also organize groups of photos into specific albums. As with Instagram, you can share images to Facebook directly from the Photos app by tapping the Share/Export button below the image (**Figure 59.3**), or above if you're viewing it horizontally. As with Instagram (and any social media app), you can also choose a photo for a post from within the Facebook app. Sharing to Facebook is a great way to access the followers you already have—either people you know in your immediate social or professional network, or to followers of your business or professional Facebook page.

59.1 The Instagram default format is a square. After selecting an image, tap the expand button in the lower-left corner of the image preview to show it without a square crop.

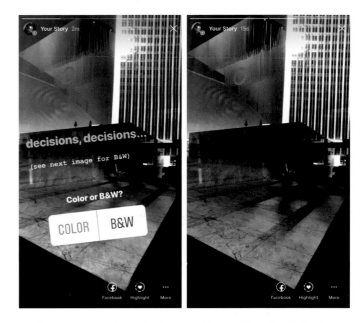

59.2 Two pages of an Instagram Story. The first features a title and a poll question that viewers can respond to.

59.3 You can share to Facebook from within the Photos app or from within the Facebook iOS app.

Tweet Your Photos on Twitter

Twitter is a bit of a different beast than Instagram or Facebook simply because of the limit of what you can add to your post. As well, the sheer volume of posts on the app can quickly push your post down "below the fold." Depending on your number of followers, and how many people they are following, your post may be a flash in the pan in their Twitter feeds, a momentary impression that is quickly lost to the ever-updated flow of the Twitter stream. But, as you build your network of followers, you'll be able to reach the people who follow you with regular posts.

A good way to expand the reach of what you can say on Twitter (currently limited to 240 characters) is to first make your post in some other medium or platform, such as an Instagram or a Facebook post, where you have more room to say all that you want to say. Then include a link to that longer post within your Twitter post. I typically post an image and the first sentence or two of a longer post, then add a link to it in the Twitter post. I will also sometimes post an image and a link to something that I am promoting, such as a mobile photography workshop or a new episode of my LinkedIn Learning series "Mobile Photography Weekly" (**Figure 59.4**).

EyeEm, the Instagram Alternative

As mentioned earlier Instagram has a very large footprint in the social media photo-sharing world, but there are alternatives to explore if you want to reach a different audience. One of those is EyeEm, a sharing platform that is similar to Instagram but without so many cute cat videos and puppy photos (not that there is anything wrong with such subject matter!). EyeEm features regular "missions," contests where you can enter photos that interpret a certain theme for a chance to win prizes or have your photos featured. It also offers the option to license your images for sale on its internal marketplace (**Figure 59.5**).

Snapchat

The photos, video clips, and chats that you send with the Snapchat app are designed to be of the moment, rather than just a collection of good images you've taken. Plus, they are ephemeral, disappearing a short time after they have been viewed. Rather than an Instagram-like feed that you can peruse at any time, Snapchat is more of a texting and photo messaging service where you share things as they are happening. There is also a My Story feature, which is similar to Instagram Stories (in fact, Snapchat is where Instagram got the idea for its story feature).

If you really want to embrace your silly side, you can add fun and whimsical extras to the photos you post, including face-morphing effects and add-ons such as cute animal ears and noses. You decide who to send your snaps to: you can send your snap or video to an individual, a group of people, or you can broadcast it to all of your followers. Once someone else views your post on Snapchat, it will expire (disappear) from their feed (but keep in mind that recipients can always take a screenshot of whatever you send). Many people use Snapchat as a way to connect to their followers on a more immediate, in-the-moment way than platforms such as Instagram and Facebook allow.

59.4 This Twitter post (tweet) includes a photo and a link to another social media platform or website with additional information.

59.5 EyeEm offers features similar to Instagram, but with a more refined approach. Users can also sell images on the internal marketplace.

WHEN YOU POST your images on social media channels such as Instagram, Twitter, and Facebook, you can extend their reach by making them discoverable through adding hashtag terms to the post. This involves adding a word (think of it as a keyword or search term) that is preceded by a hashtag, which is the pound symbol (#). The presence of a hashtag term with your post means that it will show up in the results whenever someone searches for that hashtag. For instance, if you find yourself exploring the photographic genre of street photography, adding *#streetphotography* to your post will make it visible to other fans of that genre who take the time to search for images with that hashtag (**Figure 60.1**). This will make your photo visible to an audience beyond your usual followers and could result in picking up new followers who discover your photography. Hashtags are commonly used to identify where a photo was taken (#santafe), the name of a specific event (#marchforscience), or even for humorous purposes (#notcomingbacksendmythings).

Hashtags are also commonly used if you want your images featured in an Instagram image hub that is focused on a specific genre of photography, such as landscapes, animal photos, or views of a city. By adding the hashtag designated by the group, your image will show up as a submission, and the curators might choose your photo to be featured.

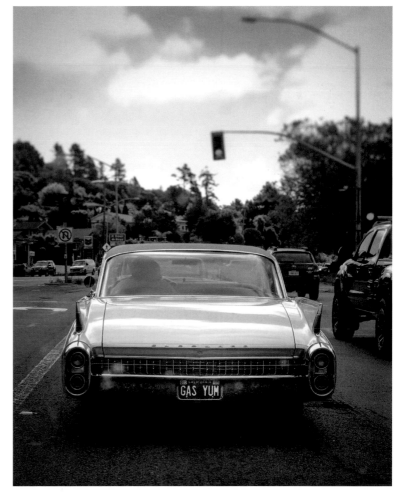

60.1 I added the following hashtags to this image of a classic Cadillac with a humorous license plate: #car #automobile #gasguzzler #cadillac #licenseplate #vanityplate #fossilfuels #gas #gasoline #energy #carculture.

61. JAZZ UP YOUR POSTS WITH DESIGN

FOR SOME TYPES of image posts, especially those that promote a business, a product, or an event, you may want to investigate apps that let you use design elements to add text, color styling, or multiple photos to your post (**Figure 61.1**). Adobe Spark Post is a free app that provides a quick way to easily use professionally designed text styling so you can have your message look its best.

If you have an Adobe Creative Cloud account, you can also set up the app so you can use your own logo for customized branding of your posts.

I've seen it used quite successfully, not to promote something, but to add text as either a design element or a creatively placed caption or unfinished sentence that adds to the story of the image.

Another app that I find very useful is called Unfold. This app is centered on clean and modern image layouts that can be used in the vertical format of Instagram Stories. Text can also be added, and planning out an Instagram Story using these templates elevates the posts to another level with a simple, elegant look (**Figure 61.2**).

61.1 Adobe Spark Post offers a wide variety of pre-designed templates that are organized into categories such as seasonal, travel, business, lifestyle, food, and craft. You can re-mix the templates to add your own images and text.

61.2 The Unfold app is designed to help you add simple layout and design sensibilities to the vertical format of your Instagram Stories. The app comes with basic page templates, and more can be purchased for a small fee.

62. PHOTO CARDS AND BOOKS

IT'S NOT UNCOMMON for most of our photos to exist in a purely digital state on our phones, tablets, or computers. While viewing your images in your Instagram feed or in a Facebook album is an easy way to find your photos and enjoy them, you can develop a whole new appreciation for your images when you liberate them from the pixels on your iPhone and turn them into real, tangible objects you can hold in your hands and experience in the non-digital world.

Photo Cards

Turning your photos into photo cards is quite satisfying because you can send them to other people to brighten their day. There are a number of notecard and greeting card apps for the iPhone that let you do this right on your mobile device—no computer required!

Touchnote, Ink Cards, and Photo Card by Bill Atkinson are three apps I've used to make cards from my images (**Figure 62.1**). Each offers a range of styles and sizes, and they will take care of mailing the card to your recipient. Payment is handled by purchasing credits ahead of time.

62.1 Touchnote offers simple layouts and themed illustrative designs. Ink Card has a wide range of professional design templates. Photo Card by Bill Atkinson allows for a classic presentation of your photo (plus you can use another image as a "stamp" and add a variety of fun stickers).

Depending on the app you use, there may be professionally designed seasonal greetings you can add your images to, or you can go the simple route with just a nice postcard that displays your photo on one side, and your personalized message on the reverse side.

Photography is one of the main activities I do with my iPhone. Creating cards from my images that I can send to family and friends is a really fun way to enjoy my photography and share it with others (**Figure 62.2**).

Photo Books

While we're on the subject of liberating photo pixels, consider making a photo book from some of those wonderful images on your phone. Having a good-quality book made from some of your best photos, or to commemorate a vacation or a special event, can be very satisfying.

Some book services have you handle the book creation process from your computer, while others let you do so from your iPhone or iPad. Books that you create on your computer, using a web-based app or a software program you download from the book vendor, will typically offer more layout and page styles than books you create on an iOS device. As with many services and products you can order from your iPhone, there are a variety of apps you can choose from.

Ordering Books from Your iPhone

The Simple Prints app lets you create 8x8-inch or 12x12-inch books with a minimum of 20 pages right from your phone (**Figure 62.3**). They are available in hardcover or softcover. Layout options are limited, but the quality is good and it's easy to create a book from images on your iPhone during a trip or vacation (**Figure 62.4**).

62.2 Sending photo cards from your iPhone is not only a great way to share your images with friends and family, it's also an excellent way to brighten someone's day when they pick up their mail.

62.3 The Simple Prints app offers an easy way to design a book right on your iPhone.

62.4 A 12x12 hardcover book made using the Simple Prints app.

Ordering Books from Your Instagram Feed

Another way to create a photo book is to use images that are already in your Instagram feed. For a lot of people, this way of choosing photos might make a lot of sense. By posting them to Instagram, you've already chosen them as images you like, so it might be easier to quickly find the ones you need, especially because images are presented in chronological order.

Apps and services that let you access your Instagram feed for content will vary in terms of features and whether or not they are available from a mobile device. In the past, I've used Blurb books for these projects and have accessed my Instagram photos from my computer.

You might be wondering if photos pulled directly from your Instagram account are of a high enough quality for a book? Based on my own experience, I would say they certainly are (**Figure 62.5**). Of course, the larger the page size, the more likely that there may be issues with image quality, but for an 8x8-inch book, they should be fine. The quality of the printing can also be affected by how much image processing has been applied to the image, how much the photo has been cropped, and other factors, such as the original exposure and the level of (or lack of) sharpness.

Another thing to keep in mind is that if you apply watermarks to your photos for use on the web, these will show up on each image in the finished book. For that reason, I gather my non-watermarked images from my mobile device or my image archive on my computer and use a web-based service to create the book. It's not as quick and easy as doing it right from the phone, but I feel it results in a better book.

62.5 A 7x7 softcover Blurb book made from images pulled directly from my Instagram feed. The quality was excellent for a book this size.

IF YOU MAKE images with your iPhone every day, or even ever other day, chances are that you probably have a lot of interesting images on your phone, and even some really good ones. As satisfying as it is to see your images on the small screen, or even on the somewhat larger screen of an iPad or your computer, you'll gain even more satisfaction and enjoyment from your photography when you have good, quality prints made from your mobile photos.

How Large Can iPhone Images Be Printed?

You've probably seen the Apple billboards advertising the iPhone with an excellent image reproduced very large and visible from a long distance away with the simple caption: "Shot on iPhone" (**Figure 63.1**). And you might be wondering, is that for real? Can iPhone photos really be printed that huge without loss in quality? Well, keep in mind that when you get up close with a billboard, the dot pattern in the photo is very large and the image would look quite rough and coarse. But from a couple of hundred feet away as you drive by on the highway, it looks great!

Fortunately most of us don't have to worry about making prints that big. But let's take a look at what's possible from iPhone images in terms of image quality and reproduction size. There are a number of variables that can affect image quality when you have prints made.

Image Size and Resolution

How many megapixels (millions of pixels) does your iPhone's camera capture? More pixels in a photo means more information, which means that a photo can usually be printed larger (while maintaining good quality) than a photo with fewer pixels.

The iPhone 5 and 6 were 8-megapixel cameras, while the 6S and later are 12-megapixel cameras. Of course, the quality of the pixels

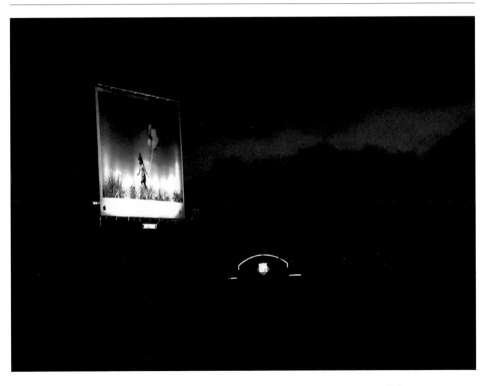

63.1 As seen on a highway near you: one of Apple's "Shot on an iPhone" billboards.

captured by the camera also matters, but fortunately the iPhone's image sensors and on-board image processors are very good.

Here's a good rule of thumb: For an image to be printed at 300 dpi (a common, industry standard for quality print reproduction) at 10 inches on the long edge, it would need to be approximately 3000 pixels wide or tall (300 dpi x 10 inches = 3000 pixels). So, if the native resolution (pixel dimension) of the photos your iPhone creates is at least 3000 pixels, then you can easily make an 8 x 10-inch print with no problem. The good news is that for many photo labs and print vendors, you can get by with less than 300 dpi, which means larger prints from your iPhone images. My 12-megapixel iPhone captures photos that are 4032 x 3024 pixels, from which an 11 x 14-inch print could be made with no problem. And, depending on image quality (more on that in a bit), even larger prints are possible.

The image of a Japanese maple in **Figure 63.2** is a sharp, well-exposed original with minimal image processing. I've had 20x30-inch prints made from this file and it looks great! A practiced and photographically experienced eye might be able to tell that it was not made by a high-end digital SLR camera, but most people, myself included, would just be very pleased to have such a beautiful print hanging on the wall.

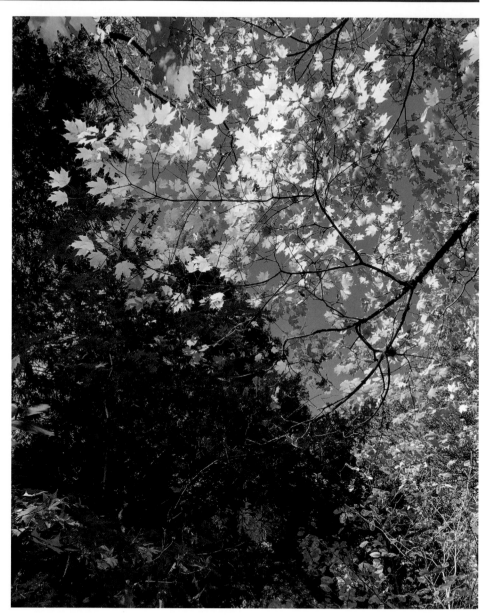

63.2 This photo of autumn leaves has been printed very large, and it holds up very well. Key factors in good print quality include a sharp and well-exposed original photo and post-processing that enhances the image without being too heavy-handed.

Exposure Issues

Beyond the basic number of pixels in the image, exposure can also affect the quality of an image. Is the photo well exposed? Or was it shot in low-light conditions resulting in a dark and underexposed photo? Underexposed shots will typically not result in as good a print as well-exposed photos, especially if you try to lighten the image to reveal details that are hard to see. Noise, a rough, mottled pattern similar to film grain, may also be much more visible in the unexposed areas of the scene (**Figure 63.3**).

Images taken in low light may also exhibit traces of motion blur or camera shake due to the longer exposure time required to make the photo in darker conditions. For some images, a slight motion blur may not be a big deal, and can even add to the mood of a photo; but for scenes where sharpness is important, motion blur can be a deal breaker that yields an unsatisfying print. Any deficiency in a photo will be much more noticeable when a large print is made.

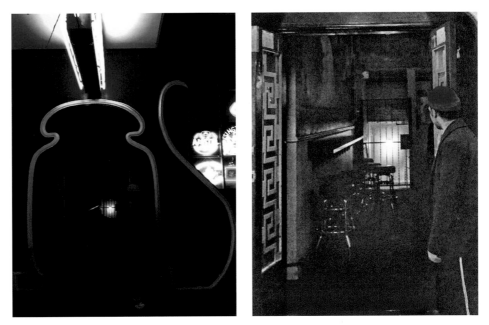

63.3 Photos that are underexposed and too dark may reveal ugly digital noise when they are lightened in a photo-processing app. This can detract from the quality of a print.

Post-Processing

Finally, the degree to which an image has been processed in photo apps, and the quality of those image adjustments, can also affect print quality. Significant cropping from the original size will reduce the number of pixels in the image, which will affect detail quality when larger prints are made (**Figure 63.4**).

Excessive manipulation of the tonal qualities in a photo can lead to rough transitions between tones, especially those that occur gradually. Shadows can get blocked up, forcing subtle shadow details to a total black; highlights can suffer a similar fate, blowing out the details in bright highlights, such as the fluffy texture of clouds, to total white with no image detail (**Figure 63.5**).

Enjoy the Performance of Your Images!

The great landscape photographer Ansel Adams famously compared the photographic negative, what was captured in the camera, to a musical score, and the print as the performance of that score. It's certainly an apt comparison because the same image can be printed (i.e., performed) in many different ways. How you choose to edit your images will depend on the scene you're working with, the mood you hope to convey, as well as your own personal aesthetics. Adding to the performance factor of a print is the fact that you can have the image printed on a variety of interesting surfaces, from fine-art watercolor paper, to actual canvas that is stretched around a wooden frame, to sleek metal prints.

Having quality prints made from your iPhone pictures will greatly add to the enjoyment that you get from your photography (**Figure 63.6**). So start reviewing all those images that are tucked away on your iPhone, and make an album in the Photos app of ones that you think would look good as a print. Then take the next step and order some prints, and free those colorful pixels from the hard drive in your phone so they can portray the image you created in a larger form.

63.4 Be careful with how much you crop. Cropping reduces the total number of pixels in the photo, which can affect how large the image can be printed while maintaining good quality. Applying the crop shown here to isolate the Griffith Observatory in Los Angeles would reduce the pixels of this image from 4032 x 3024 to only 900 x 900. I could get a nice 3x3 or maybe a 5x5-inch print from that pixel count, but the details would get soft if I tried to make the print any larger.

63.5 If you apply too much processing to an image you could end up with a loss of detail in the shadows or highlights, or rough, uneven tonal transitions. In this photo, the highlights in the clouds, which had plenty of good detail in the original shot, have been blown out to total white.

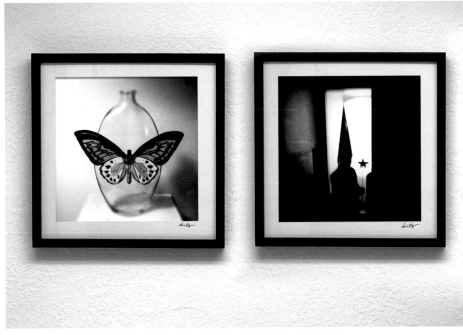

63.6 Printed and framed photos are some of the best ways to enjoy your photography.

INDEX